The Fine
Art of Fashion
AN ILLUSTRATED HISTORY

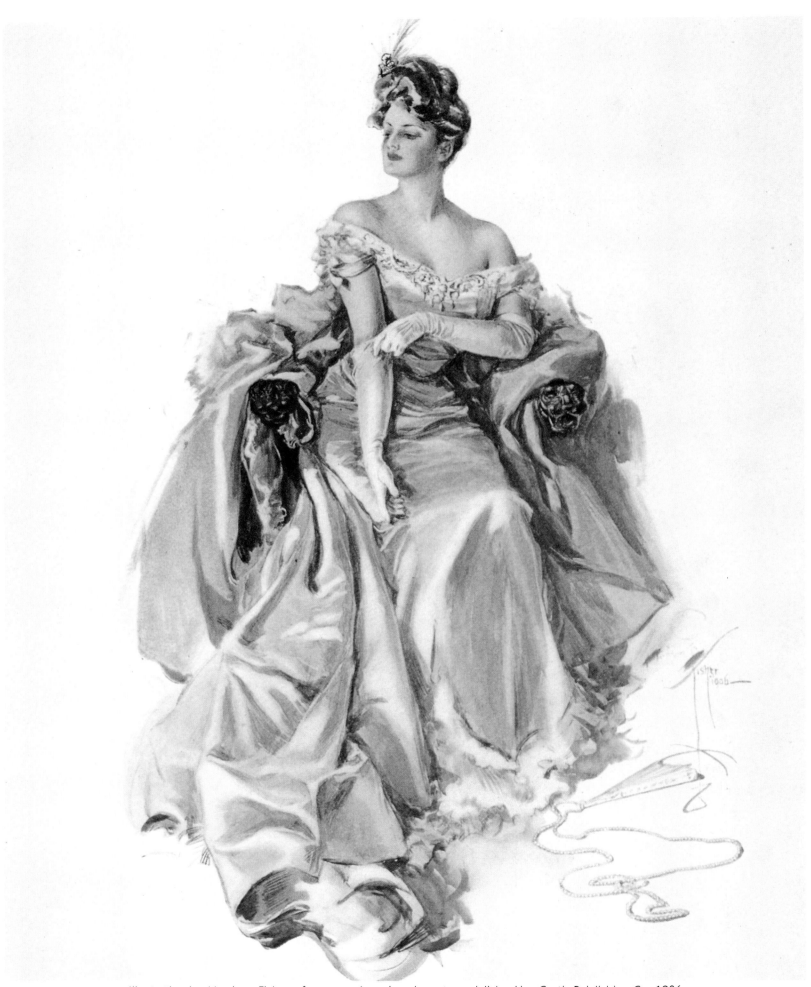

Illustration by Harrison Fisher of a young American beauty, published by Curtis Publishing Co. 1906.

The Fine
Art of Fashion
AN ILLUSTRATED HISTORY

JULIAN ROBINSON

BARTLEY & JENSEN
Publishers
New York • London

I dedicate this book to my three children, Charlotte, Xavier and Georgina,
to their marriage partners, to their children and their children's children.
Also to my very good friend Lazimova
and those students who it has been my good fortune to meet and to teach
during the past thirty-five years.

Published by Bay Books
61–69 Anzac Parade,
Kensington, NSW, 2033
Australia

© Julian Robinson
National Library of Australia
Card number and ISBN 1 86256 3020

Designed by Susan Kinealy
Typeset by Savage Type Pty Ltd, Brisbane
Printed in Singapore by Toppan Printing

CONTENTS

Preface 6

Our fashion inheritance 10

Dress through the ages 32

Twentieth century styles 56

Creating the illustrations 88

Designing the fashions 144

The reasons for change 178

Index 206

\mathscr{P} REFACE

\mathscr{T}wenty-five years ago, whilst working in Paris, I chanced upon a large collection of rare eighteenth and nineteenth century fashion publications, complete with their numerous hand-coloured illustrations. Many of these publications were the popular fashion magazines of the time — *La Belle Assemblée*, Ackermann's *Repository of Arts*, *Godey's Lady's Book & Magazine*, *The Englishwoman's Domestic Magazine*, *Le Journal des dames et des modes*, *Le Magasin des modes nouvelles françaises et anglaises*. I found myself the possessor of a complete set of von Heideloff's *Gallery of Fashion*, many early copies of *The Lady's Magazine*, dating from 1770, a complete set of the very first French fashion magazine *Le Cabinet des modes ou les modes nouvelles*, published in 1785–86, and numerous rare Art Deco publications such as *La Gazette du bon ton*, *Modes et manières d'aujourd'hui* and *La Guirlande d'art et de la littérature*. Also included were many rare volumes of fashion illustrations that dated from the sixteenth and seventeenth centuries, and boxes full of early issues of such noted twentieth century fashion periodicals as *Femina*, *Harpers Bazaar*, *L'Art et la mode*, *Très Parisien*, *Vogue*, *La Femme chic*, and *Excelsior Modes*, together with books on perfume and cosmetics, hats, hair styles, shoes, lingerie, jewellery, men's and children's clothes, ethnic modes of dress and adornment, anthropological surveys, sartorial theories and numerous other closely related subjects.

This good fortune led me to research the origins of Western fashion and fashion illustration. I found that the story of fashion as told at the time was in many respects quite different from the history generally related in today's publications, and that many of the illustrations used in these histories were of a poorer quality than the subject matter warranted.

I have written this book in order to set the record straight and to clearly demonstrate that fashion at its best is a legitimate form of aesthetic expression embodying all our hopes, aspirations and dreams. It is worthy of a place alongside many other forms of artistic endeavour in the major art galleries and museums of the Western world.

I also wish to show that many of the images used to illustrate and promote this endlessly changing array of fashionable apparel are themselves wonderful examples of aesthetic expression. In the past they were the work of many noteworthy artists — Desrais, Watteau, Vernet, Delaunay, Lepape, Drian, Martin, Erté, Picasso, Braque, and many others. These masters did not simply produce line-by-

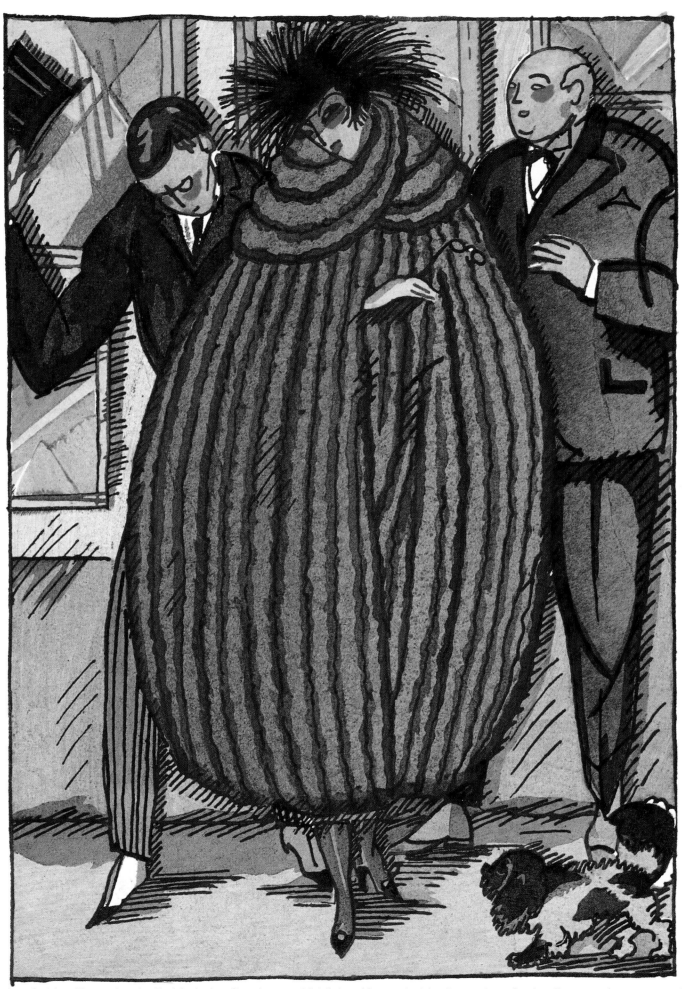

Woodcut fashion illustration *La Pimbèche* by Guy Arnoux, highlighted in *pochoir* by Devambez, for *Les Femmes de ce temps.* 1920.

line representations of the new modes as they issued from the great couturiers and dressmakers of the day; instead, each one of them attempted to capture the true spirit of the new fashions and to portray them in an individual manner, capturing the mood and hopes of the time.

The work of these artists conveys this message in a much more telling way than words do, and so the main emphasis of this book is on their illustrations, the literary substance highlighting the changing ways of life and attitudes, and the styles of journalism and philosophical observation with which each new fashion was surrounded. In this way one can more fully understand the reasons behind these changes.

May the reader be persuaded to linger over this illustrative oeuvre, the creative and aesthetic brilliance of which I suggest may never be surpassed.

Julian Robinson.

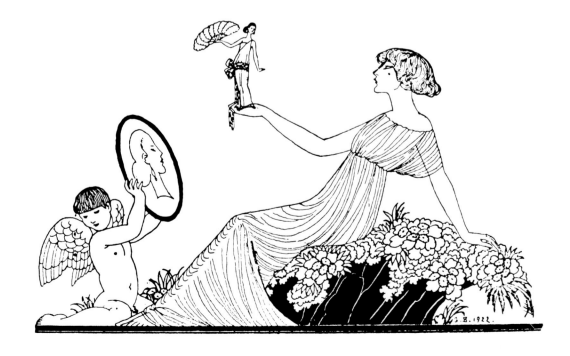

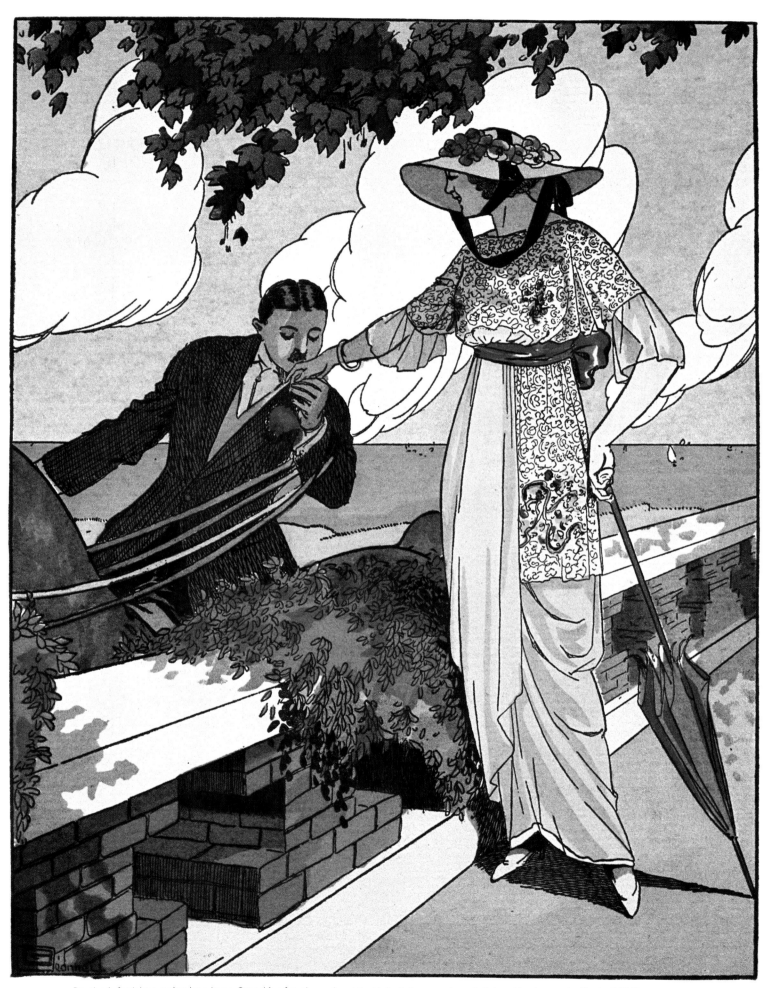

Pochoir fashion print by Jean Saudé of a dress by Martial et Armand, published in *Luxe de Paris.* 1913.

\mathscr{O}UR \mathscr{F}ASHION \mathscr{I}NHERITANCE

\mathscr{F}or most of this century, twice a year, the fashion collections of Paris, Rome, London and New York have been the focus of journalistic interest throughout the Western world. Sometimes the reports of these collections carried a clear message that a particular way of dressing would be 'the fashion' for the next six months or so and women everywhere aspired to dress in that particular mode, whether it suited them or not. At other times 'the fashion' appears to have been far from obvious: some commentators would advocate the wearing of one particular style; others would promote something quite different; and many people were left to wonder just what was appropriate. And all the while fashionable images abounded, featuring all manner of modes, from see-through blouses and figure-hugging minis to all-concealing styles. These continually changing fashions and the images that were used to promote them are the subject of this book.

It was not just women's fashions that drew attention. Menswear was also the focus of great interest: some reports advocated a more relaxed and sporty mode of dress than had been the fashion during the latter part of the nineteenth century; others suggested a more 'adventurous' style and promoted the wearing of velvet jackets, brocade waistcoats and lace-trimmed shirts; still others were adamant that a man of fashion should continue to favour a traditional, restrained mode of attire.

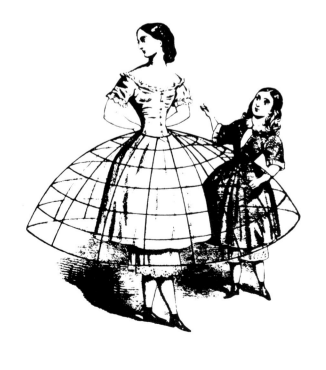

Sociologists, psychologists, anthropologists, moralists, prelates and politicians were eager to comment on fashion, as were costume archivists and art historians. Their often controversial views provided a grand insight into the times and the attitudes that helped to create the vast and changing array of contemporary styles. There are those who have regarded this fickle array as symptomatic of a lack of prudence; they say the changing styles demonstrate an insidious dissatisfaction with the present and reveal an almost feverish desire for change simply for the sake of change. Some go as far as to declare that such change has been used as a tool of oppression, a weapon wielded against the poor to remind them that the privileged members of society were not merely rich but also better and they wore on their backs the proof of their superiority.

When one reads such sermonising one is tempted to conclude that the mere suggestion of change automatically brings forth condemnation, just as has so frequently happened in the realms of music, painting, sculpture, dance, and all other areas of human expression. In fact, few words in our language have become

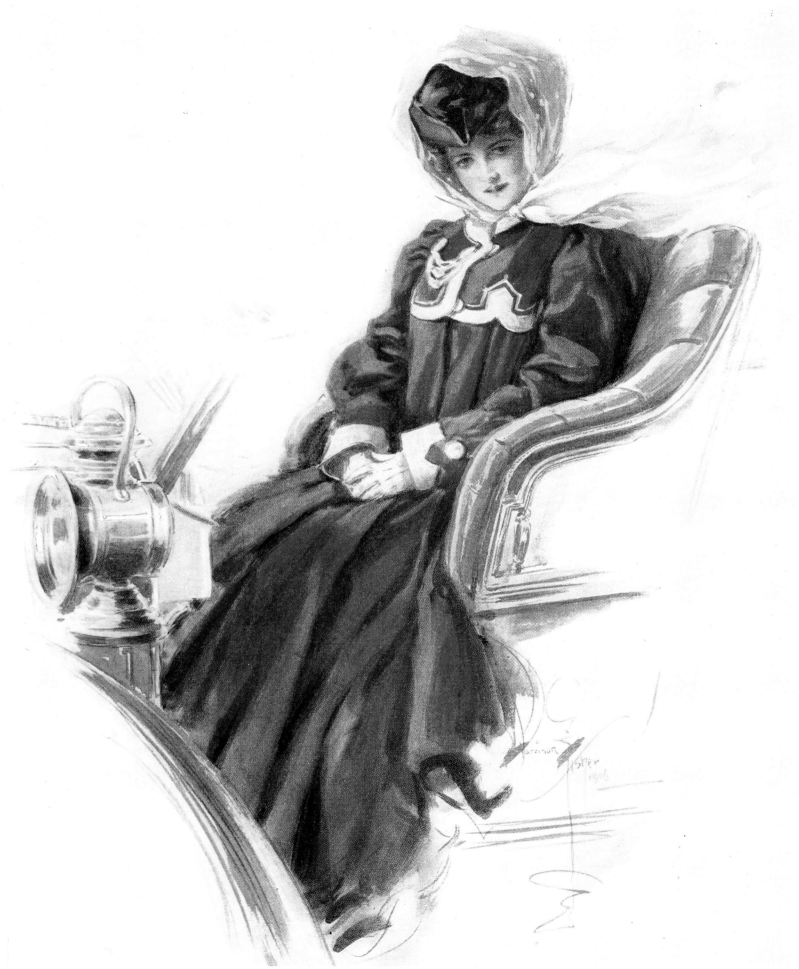

Magazine illustration *The Automobile Girl*, by Harrison Fisher, Curtis Publishing Co. 1907.

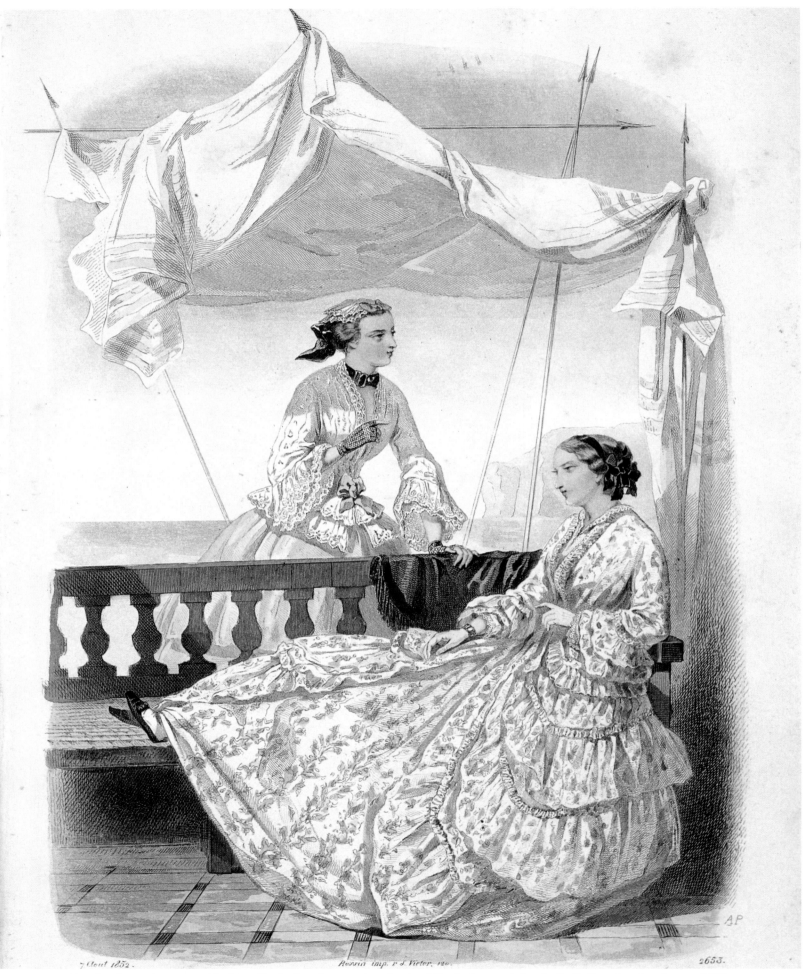

Hand-coloured engraved fashion illustration from a drawing by Mlle A. Pauquet, for *Le Petit Courrier des dames*. 1852.

so loaded as the word 'fashion' in its connection with our clothing styles. Few words carry such extreme connotations of displeasure and contempt, regardless of the facts, and few words are so misused and misunderstood.

During the latter part of the nineteenth century, however, no such semantic confusion troubled the haut monde of Europe, the British Isles, South Africa, Australia and the Americas, who were the patrons of fashion and regularly travelled to London and Paris to purchase their wardrobes. This was the flamboyant era of the Belle Epoque, when luxury and extravagance reached their zenith. The dress styles followed by the haut monde during this period were inspired by the free-flowing shapes and oriental detailing of what we now call the Art Nouveau style of design. The Paris couturiers who were responsible for the new styles used metre upon metre of the finest silk crepe de Chine, satins and taffetas, embroidery and sequins, gold lamés enriched with expensive bead work and ornate cording, sumptuous brocades edged with furs and marabou, soft cut velvets trimmed with flounces of the finest pleated chiffon, layers of ruching, smocking and finely sewn hand-tucking, and huge quantities of exquisite lace, rare furs, exotic feathers and priceless jewels.

The tailors of London's Savile Row, on the other hand, the arbiters of men's fashions during the Belle Epoque, were much more conservative, believing that the man of fashion should be correctly attired, rather than flamboyantly bedecked, on all occasions. They spent many days cutting and sewing each suit so that it fitted perfectly, with each detail impeccably finished. The haut monde

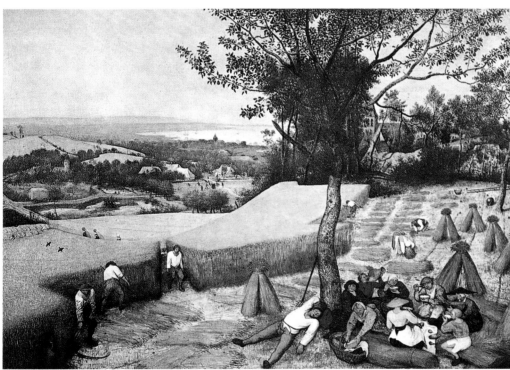

The Harvesters by Pieter Bruegel the Elder. c. 1565. (Courtesy of The Metropolitan Museum of Art, New York).

of London had their gloves individually made so that they fitted each hand perfectly; their shoes were individually lasted by the best shoemakers of Old Bond Street; the master-craftsmen of Conduit Street made hats to fit the precise curve of their client's head; and the shirt-makers of Piccadilly and Hanover Square tailored these garments to suit individual requirements, the seamstresses paying great attention to the collar and cuff detailing and to the crest or initials that were invariably embroidered on the front.

Generally, however, the haut monde stayed only briefly in London: they preferred Parisian society. Paris was the acknowledged cultural centre of the Western world, attracting like a magnet not only the wealthiest members of society, but also the finest craftsmen of Europe to work in its ateliers, theatres and restaurants. Indeed, the cultural and artistic supremacy of Paris had been recognised for many generations. Even before Peter the Great the merchants of Paris took works of art and fashions to Moscow, Berlin, Vienna and the other capital cities of Europe. Their unique wares astonished and delighted the courtiers and wealthy citizens of these great cities, paving the way for future generations to travel regularly to Paris for their every need. And it is said that these merchants adorned not only the heads, bodies, courts and homes of the aristocrats, but also the minds of all the nations with which they came into contact.

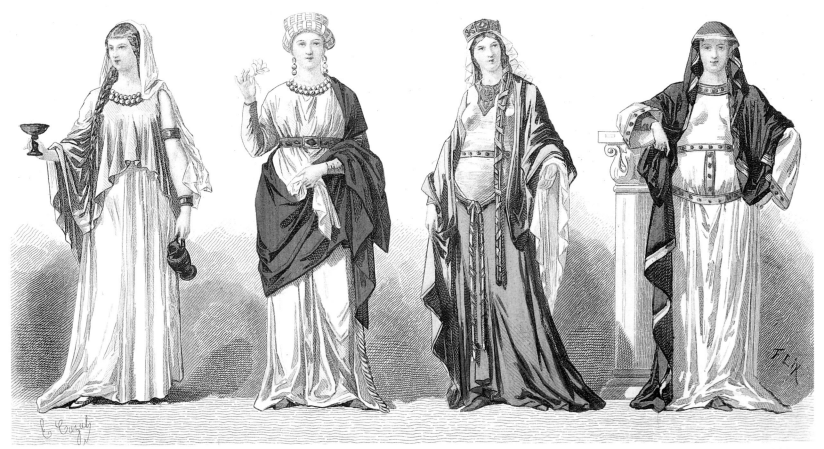

Hand-coloured steel engravings of historic costume by Marie Preval, for *The History of Fashion in France* by M. Augustin Challamel. 1882.

The twenty-five years between 1905 and 1930 saw the Paris artists, designers and craftsmen arrive at the height of their artistic and creative achievements: nowhere else in the world could there be found so much talent and expertise devoted to the designing, making and promoting of beautiful artifacts — and nowhere else, before or since, could there be found such an abundance of talented designers, craftsmen and illustrators dedicated to the embellishment of the female form and to the promotion of each new fashionable idea.

Even during World War I when the invaders' guns could be heard in the streets of Paris, the leading couturiers who were not actively involved in the war were helping the ailing French economy. They continued to produce their seasonal collections which were still being purchased by the haut monde from throughout the free world. These couturiers even staged a spectacular exhibition of their latest designs at the Panama Pacific International Exhibition held in San Francisco in 1915, whilst smaller exhibitions of their new fashions were also displayed in New York and Chicago.

The skirts of the new fashions were shorter than those worn before the outbreak of hostilities. They openly displayed the ankles and were condemned as 'obscene', 'lewd', 'vulgar', and 'immoral' by religious leaders and moralists of the period. But the haut monde and many of the young women who were now

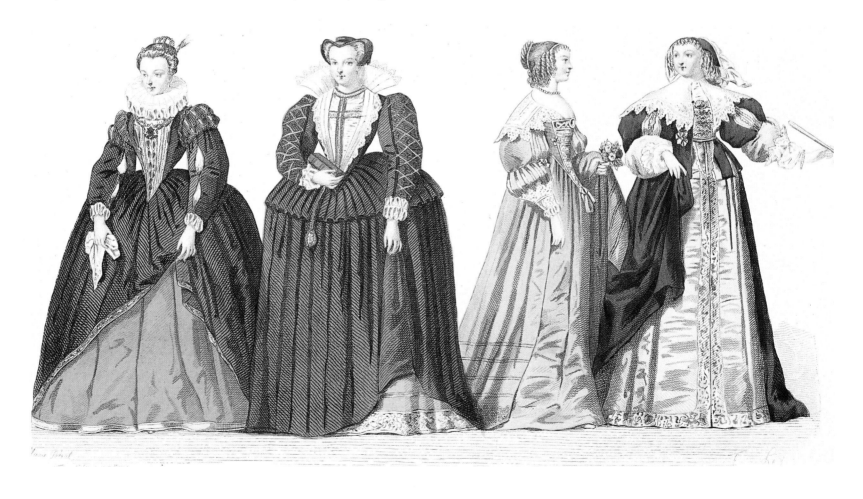

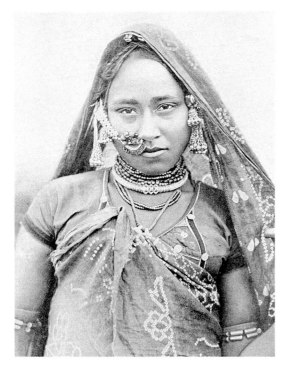

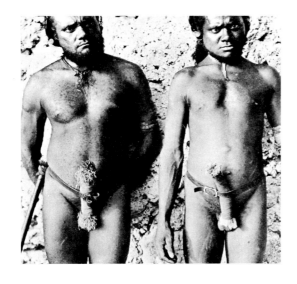

working in armament factories began wearing the adventurous new styles, and during the next ten years the skirts became shorter and the condemnation more vocal. Eventually it seemed that the condemnation was guaranteeing the success of each new shorter and more revealing fashion.

But long before Paris became the fashion centre of the Western world our ancestors were adorning their bodies in strange and wondrous ways, and the critics always found something to condemn. We can read in the Old Testament of the varying dress styles worn by the Hebrews and of how the religious leaders denounced such vanity and wantonness and threatened damnation. 'And moreover,' Jehovah is recorded as saying,

Because the daughters of Zion are haughty and walk with outstretched necks and wanton eyes, walking and mincing as they go, and making a tingling with their feet, therefore the Lord will smite with a scab the crown of the head of the daughters of Zion, and will lay bare their secret parts. On that day the Lord will take away the beauty of their anklets, and the cauls and the crescents, the pendants and the bracelets and the mufflers, the headtires and the ankle chains, and the sashes and the perfume boxes, and the amulets, the rings and nose-jewels, the festive robes, the mantles, and the shawls, and the satchels, the hand mirrors, and the fine linen, and the turbans and the veils. And it shall come to pass that instead of sweet spices there shall be rottenness; and instead of a fine girdle, a rope; and instead of well set hair, there shall be baldness; and instead of a fine robe, a girding of sackcloth.

Throughout history kings, philosophers and parliaments have criticised and attempted to prevent people from wearing styles with which they disagreed.

In 1292 a law was passed in France to regulate the amount of expenditure permitted for the various members of society, with dukes, earls and barons who owned large amounts of land being allowed four new garments a year as were their wives. Knights and nobles with less land were allowed only two new garments a year and people with no title were restricted to just one garment a year. Similar laws were introduced throughout the British Isles, Germany, Spain and most other European countries at that time.

During the reigns of Edward II and Edward III in England and Charles IV and Philip VI in France many new laws were passed which specifically forbade all but the ruling class from wearing any form of ornate or expensive fabric, or from embellishing their garments with precious stones, silk thread or threads of gold or silver. The use of any fur other than that of a cat or rabbit was also outlawed. Other edicts specified which members of the ruling class were allowed to trim their garments with ermine or pearls, the length of the train of a dress, the colour combinations, the height of the heel of a shoe, the amount and value of lace trimmings, the hair styles allowed at court, and so on. These restrictions meant that each stratum of society could be easily recognised according to its mode of clothing and adornment.

During the fifteenth century many of the styles reserved for the ruling class were still forbidden to the affluent merchants, mercenaries and their families. To establish their prestige as wealthy citizens they began to introduce an ever-

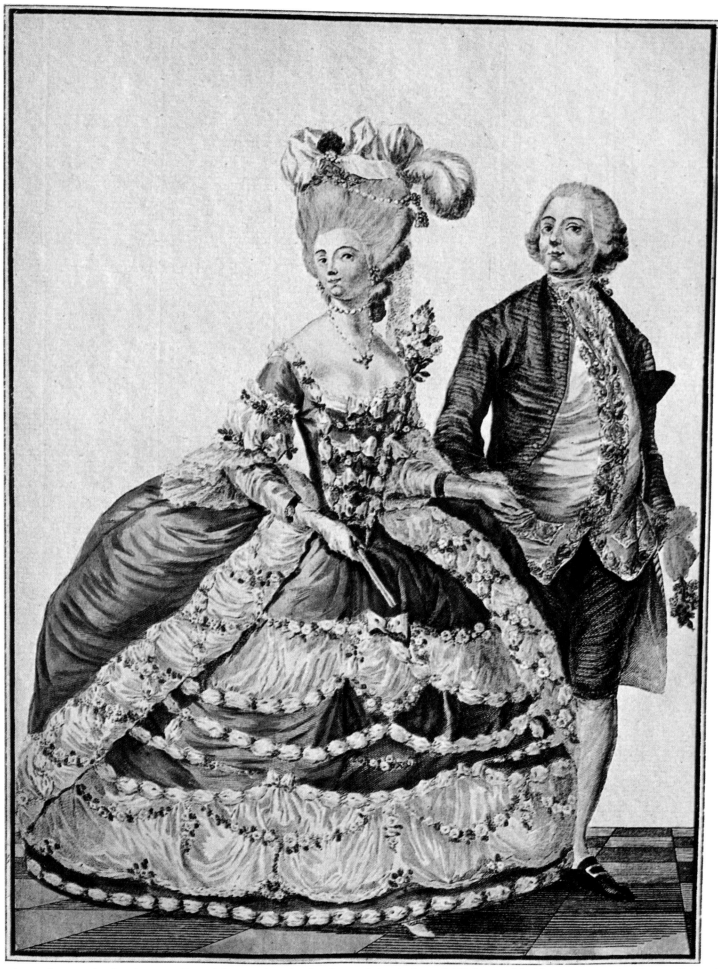

Hand-coloured engraving by Jacques Esnaut from a drawing by François-Louis-Joseph Watteau of fashions worn at the Court of Versailles.
c. 1775.

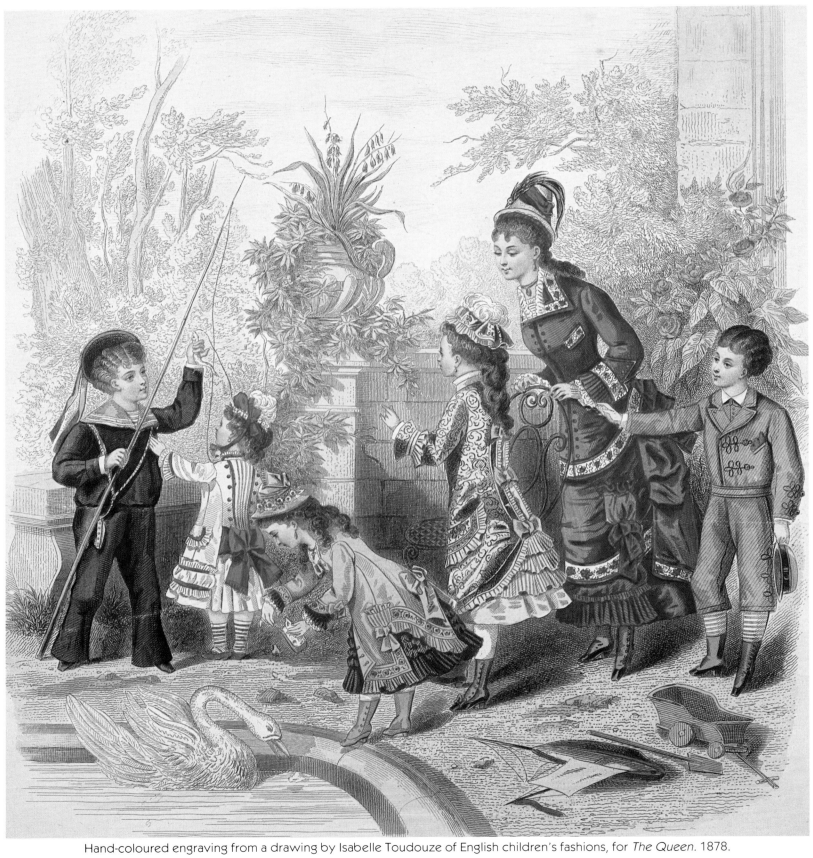

Hand-coloured engraving from a drawing by Isabelle Toudouze of English children's fashions, for *The Queen*. 1878.

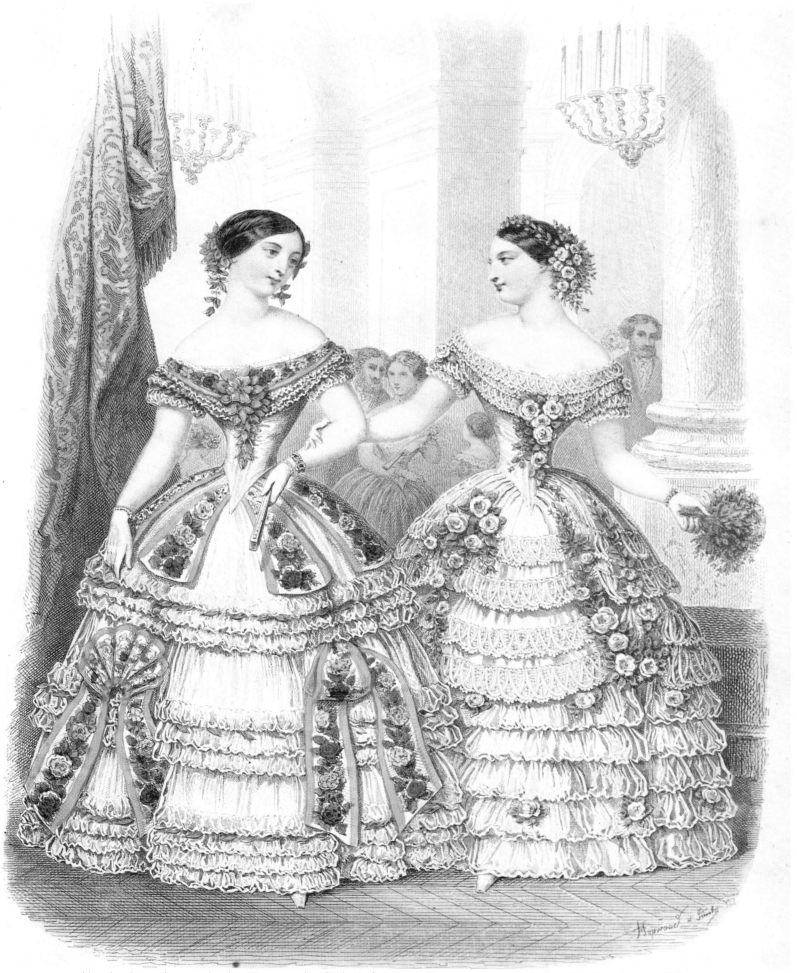

Hand-coloured engraving by Hopwood et Perival after A. de Taverne, for *Le Petit Courrier des dames*. 1853.

changing array of novelty garments which today we refer to as fashion. These fashion garments did not actually break the laws of the period but they did distinguish these merchants from the lowly masses.

The early sixteenth century fashion for slashing is an example. This expensive mode of dress is thought to have originated around 1510 in Germany and Holland where the affluent were restricted to using fabric below a certain value in the construction of their garments. To overcome this rule they had their garments made from fabric to the value allowed and then they had them slashed all over at regular intervals so that a more costly fabric, not technically part of the garment construction, could be pulled through the slashes. This clearly demonstrated their contempt for the law as well as displaying their wealth. Interestingly, this fashion was avidly copied by the ruling class.

Adorning both the male and female forms has always been essential to human culture. It is believed to pre-date all other forms of aesthetic endeavour, such as dance, cave painting, religious ceremonies and music, by many thousands of years. Each day as we prepare to meet the world by donning some form of body covering or adornment we are upholding a tradition so fundamental that it appears to have become an instinctive human trait.

This desire to change our natural, naked body in some way by putting on a cotton dress, a pair of trousers and a shirt, or a business suit has become such an important part of our daily lives that any attempt to modify the practice brings forth howls of protest. And, judging from the volumes of such protest written over the past 500 years about even the slightest change to what was perceived as the correct mode of dress for the time, it would seem that our forebears, like ourselves, believed that they had been ordained by their Creator to dress in precisely the mode of dress that they were currently wearing, and that all other modes which exposed or drew attention to parts of their bodies that they preferred to hide were the invention of the Devil and his foolish followers.

In order to understand why a change in our own or other people's styles tends to bring forth such hostile reactions, we need to understand why it is we wear the clothing styles we do, instead of going about our daily lives naked as Nature intended. We must acknowledge that our view of nakedness is a Western convention based on nothing more than our own prudish ideas of the human body, and that our ancestors, and many people who live in other parts of the world today, view the naked human form quite differently.

The inhabitants of parts of Borneo, the Amazon jungle, and Ethiopia and Tanzania wear very little clothing in the Western sense: most of us would consider them naked. But they adorn and decorate themselves according to the custom of their ancestors, and they often find our Western mode of dress and adornment most immodest. The main reason for this obviously different attitude appears to be that, whereas we have been born into a traditionally clothed society that aims to conceal the more obvious male and female characteristics, they are born into a traditionally decorated society which tends to enhance rather than conceal

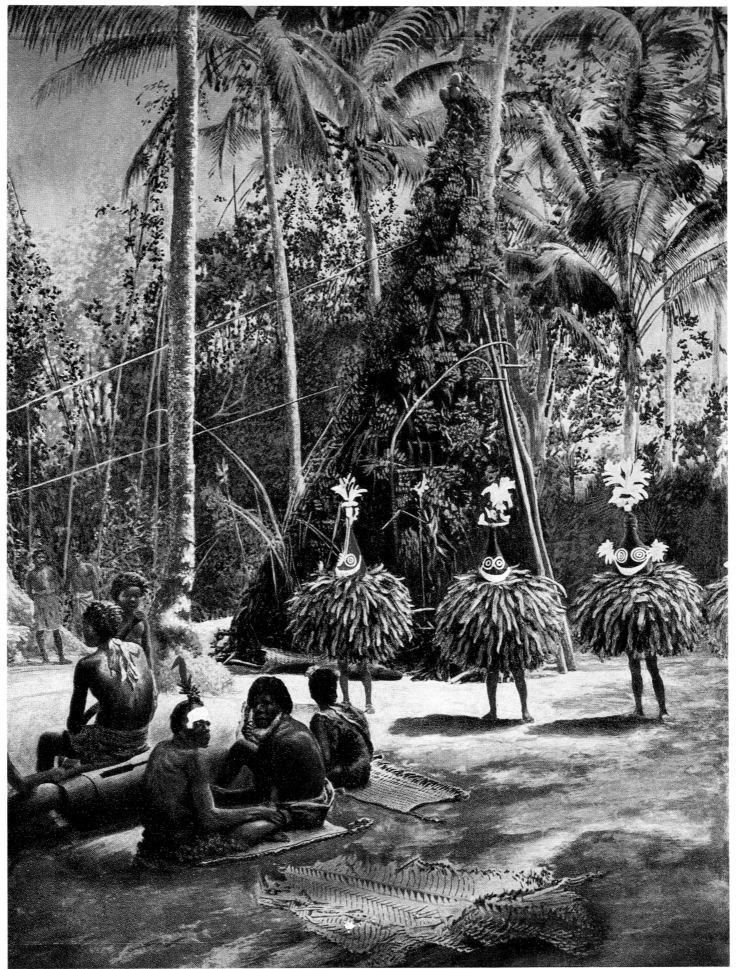

Hand-coloured photograph by Ernst von Hesse-Wartegg of the Duk Duk initiation ceremony in the Bismarck Archipelago, Melanesia. Early twentieth century.

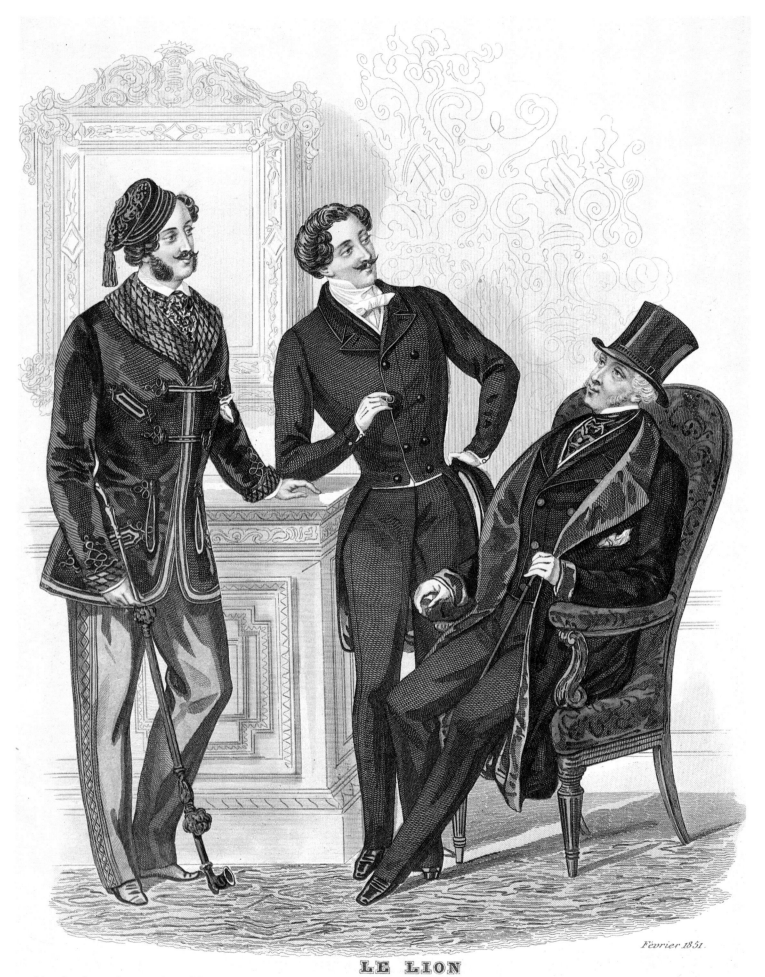

Février 1851.

LE LION

Hand-coloured engraving of French menswear by Réville from a drawing by François-Claudius Compte-Calix, *Le Lion*. 1851.

these sexual differences. There are numerous accounts of sexually concealing modes of dress being worn by members of such societies only during festive occasions and when courting, in order to excite members of the opposite sex into the generative act. In some areas it is only the village whore who wears concealing clothing since this creates great lust in the minds of potential customers. Many experts believe that this was probably the original intention of our own modes of dress, but over time what was originally intended to be a provocative mode of dress has become one of total concealment.

Even our own ancestors were not always of our opinion. If we look back through the history of our clothing styles we find many instances of sexual display.

In the fourteenth century, for example, rich men and many male members of the ruling class openly displayed their reproductive organs and bare buttocks below a short tunic. If their features were not worthy of display they had them padded and fitted into tight, stretchable *nether-hosen* and a leather *braquette*, to give the illusion of an erect penis and firm buttocks. Calf and thigh pads were also often added to heighten the look of virility, as was padding for the chest and shoulders. At other times, men wore decorated codpieces, high-heeled shoes, long curly wigs, lace collars, satin knickerbockers and fine silk stockings, facial make-up, metal and leather corsets decorated with gold and precious jewels, and other adornments that today we would find either effeminate or provocative.

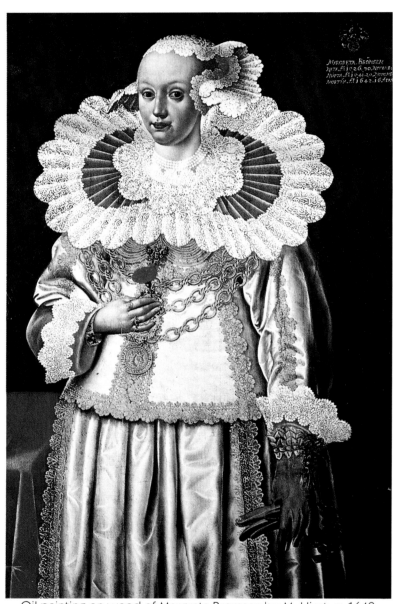

Oil painting on wood of Margreta Bromsen by M. Hiert. c. 1642.
(Courtesy of St Anne Museum, Lubecq).

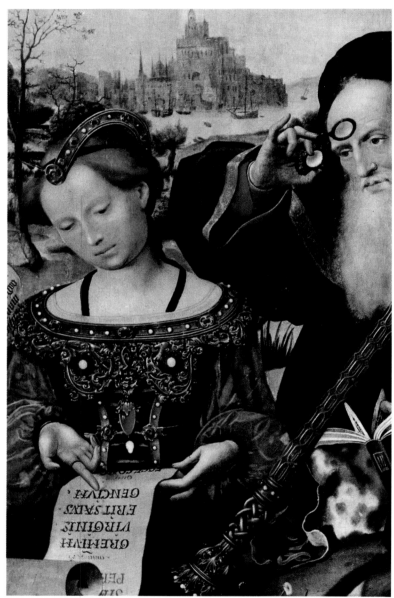

Detail from *Coronation of the Virgin* by Jan Provost.
(Courtesy of The Hermitage, Leningrad).

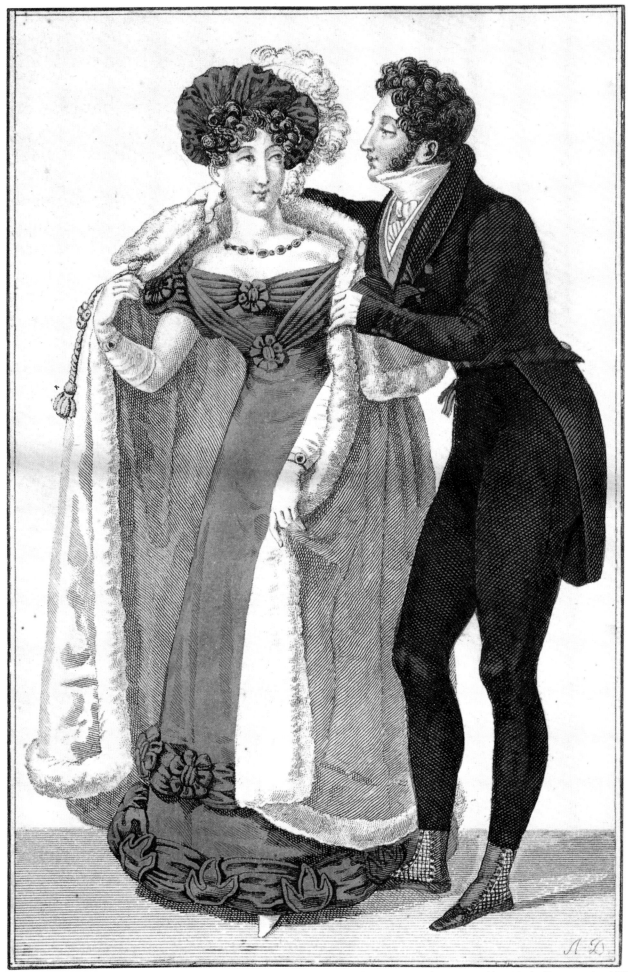

Illustration for *Le Journal des dames et des modes*, hand-coloured, drawn and engraved by M. A. Desmarais. 1824.

Our female ancestors also indulged in a variety of sexually oriented modes of dress, to draw attention to or openly display their erogenous zones. For instance, between the thirteenth and seventeenth centuries it was periodically the fashion in many parts of the Western world for younger women to display the full rounds of their breasts and their rouged nipples as a sign of their virginity and hence marriageability. At other times it was the fashion to wear a tightly laced corset in order to display a trim waist which emphasised both the bust line and the derrière, or to wear breast padding and a bustle to enhance the appeal of these female characteristics. At times women wore elaborate wigs, huge lace neck ruffs, high-heeled shoes, large hats, facial make-up, and a wide variety of perfumes. At other times they decorated their pubic hair; or removed all their body hair and wore various fetish garments.

Quite often, history's ideas of appropriate modes of dress differ markedly from the ideas of our time, just as appropriate modes of dress vary among cultural groups today. Our understanding of our clothing inheritance is further complicated by the subjectivity of our perception of the way we clothe ourselves and the belief that our current mode of dress is the result of an evolutionary process and therefore perfectly suited to our lifestyle. We view our mode of clothing as

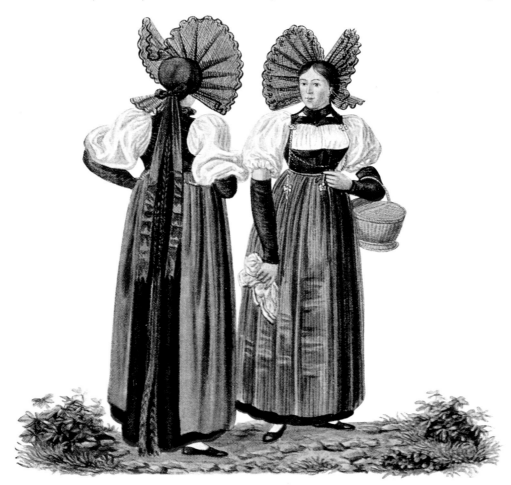

Illustration of the traditional dress of Berne by D. A. Schmid, for *Trachtenfibel: the costumes of Old Switzerland*. 1937.

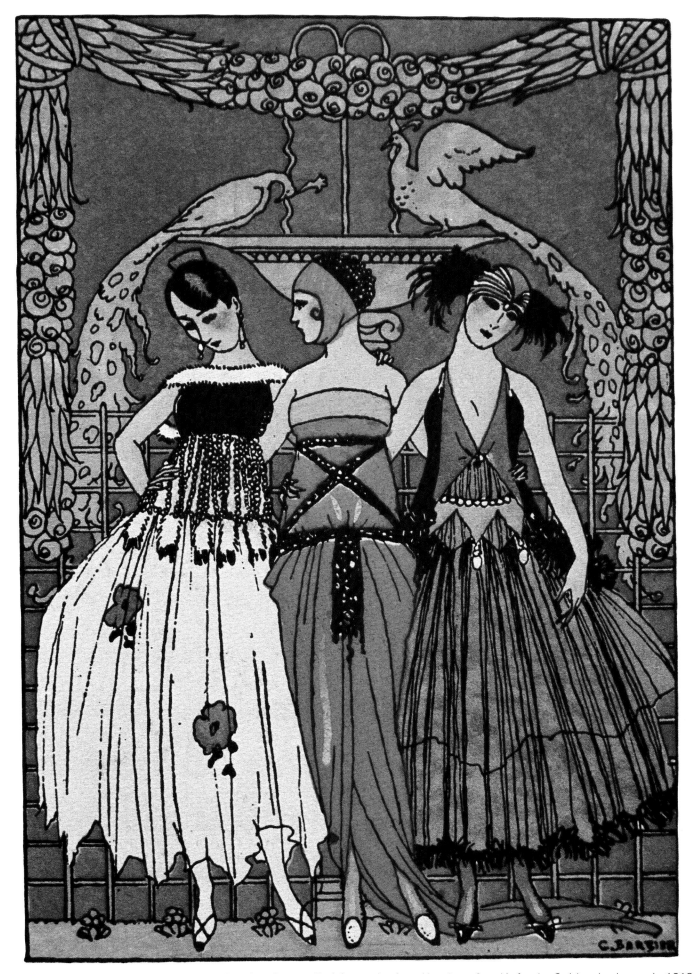

Pochoir fashion illustration *Les Trois Grâces* by George Barbier and printed by Jean Saudé, for *La Guirlande des mois*. 1918.

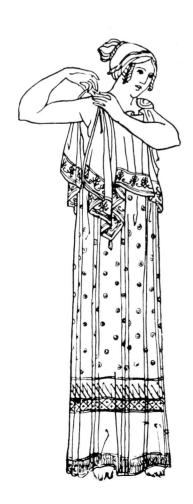

an extension of ourselves — our visible skin — as a sign of our individuality and a sign of our belonging to a particular cultural group. This very personal response makes it almost impossible for us to view unusual styles objectively. Even before we can decide if there is something about these different styles that appeals to us, aesthetically or for some functional reason, we have decided whether or not we would like to wear them. We also quickly evaluate whether they would enhance our physical attributes or social standing, be suitable for our particular lifestyle, be comfortable to wear or easy to maintain, and we cannot conceive that other people could possibly think differently about such styles. We belong to a clothed society. The act of clothing our bodies is so much a matter of habit that we scarcely think of this social convention as having a beginning. Originally, though, all humans went naked. Since the time of Socrates social commentators and philosophers have pointed out that all humans, wherever born, are complete in their natural naked state, and that if our Creator had really intended us to be clothed and to conceal our gender-signalling areas he would have arranged at least a fur covering for us, as is the case for other primates. The fact that we are born wearing only a thin covering of skin, which, although fragile, adequately serves to keep our blood in and water out, indicates in evolutionary terms that this must have given our ancestors some special advantage that enabled them to survive and thrive as a species.

Why, then, have so many human societies discarded this obvious evolutionary advantage? Why do they insist on dressing and adorning their bodies? And why is it that the very thought of being naked, except in our most intimate moments, embarrasses us, so that we call on our lawmakers and religious leaders to protect us? This embarrassment is obviously unnatural, but perhaps the fact that we are born into a clothed society prevents us from accepting our naked bodies as they really are.

The phobia about nakedness is engendered in each new generation not only by keeping our children completely clothed on almost all occasions, but also by teaching them that only a clothed person is a complete person, the clothing being an actual extension of the body. Everywhere in the Western world the emphasis on enveloping the body in various styles of clothing is overwhelming. And our children learn at every stage of their development that it is by means of this clothing that they can identify both themselves and others.

Because of this cultural indoctrination our Western-style clothing has become one of our most enthralling gestures of social evaluation, personal identification, cultural enunciation and artistic expression — in many cases it is the only visual medium used by ordinary people to make an aesthetic statement. It is the medium through which we express our ideas about social status and gender and through which each new generation hopes to establish its own identity, its members seeking out those styles that clearly differentiate them from all previous generations. These new styles, although capable of voicing cultural dissent and deviance, also allow their wearers to state very clearly that they are nevertheless

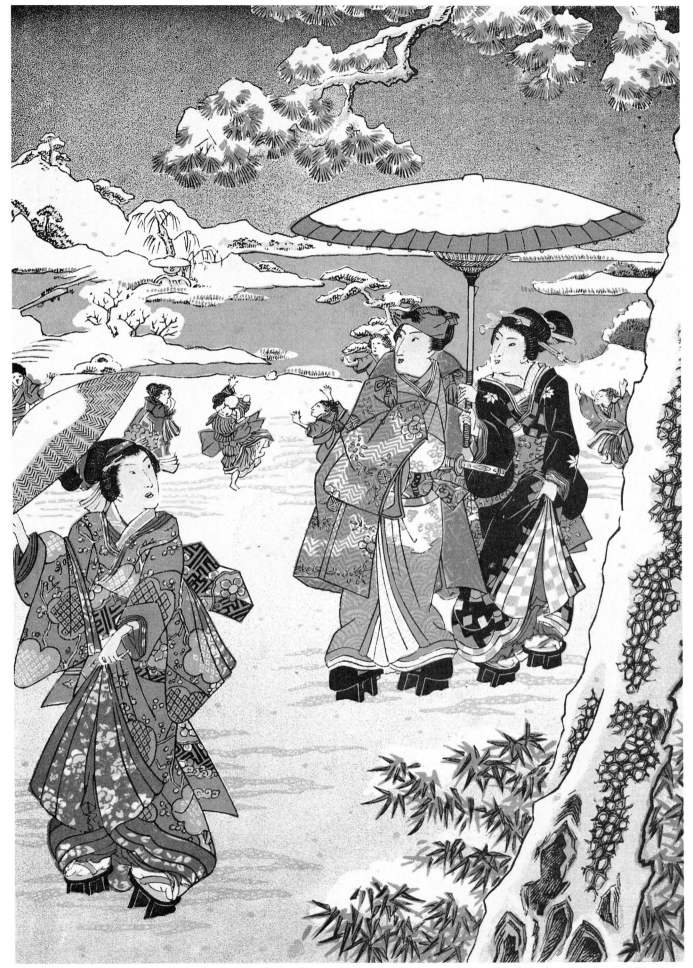

Chromo-litho illustration by Kronheim & Co. from a Japanese *ukiyo-e* print, for *The Girls Own Annual*. 1880.

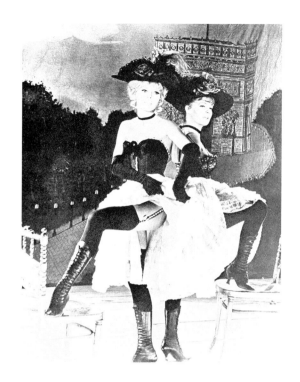

Illustration by Guy Sabrain, for *Au Fil vos heures Mesdames par Renault* published in Paris. 1939.

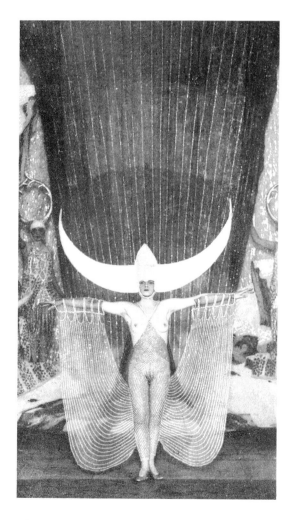

members of an egalitarian society which, thankfully, allows them the freedom to express their own wishes, aspirations, sexual choices and modes of life whilst still remaining within the confines of a clothed society.

This is why the history of our clothing styles, once the exclusive province of the costume archivist, now receives the close attention of political scientists, economists, sociologists, psychologists, anthropologists and art historians. The best of the fashion images used to promote each changing style have also come under close scrutiny: it is now realised that they are an important aesthetic statement by many of the best pictorial artists of the period as well as being important expressions of Western culture. Many of these images exist quite separately from the fashions they purport to represent: they are about new modes of dress that people wish to 'see and to dream about wearing' without necessarily purchasing or wearing them. This is an important aesthetic and cultural distinction because, although these styles may never have been worn by the people who admired them, they did open the doors to change and in many instances they more fully represent people's aesthetic dreams than do the clothing styles that were actually worn.

Illustration by Antonio Lopez for *Elle* magazine, from designs by Emmanuelle Khanh. 1967.

Major art galleries and museums throughout the Western world are now avidly purchasing copies of the best of these images and the best examples of fashionable clothing, to display alongside other items of artistic merit. Specialist galleries devoted solely to fashionable forms of dress and costume and associated material are being opened in Paris, London, New York and other major capitals. It has been my good fortune to advise, value and acquire such collections for a number of institutions and to speak on the subject in many great cities. I have been pleasantly surprised to discover a large number of individuals who are devoted to collecting a variety of such items and publications. It would seem that their interest is helping to re-establish this ancient art form as a worthy medium of artistic expression that would rank alongside fine paintings, sculpture, and artistic objects of all descriptions, as true expressions of our cultural heritage and inventive talents.

DRESS THROUGH THE AGES

*D*uring the past five thousand or so years, since the establishment of the early Mesopotamian and Egyptian civilisations, a great number of pictorial artists, scribes, philosophers, poets, social commentators, explorers, anthropologists and archaeologists have brought together a mass of information about the clothing styles and modes of body decoration with which our ancestors adorned their bodies. This information supplies ample evidence to support the view that our hunter–gatherer ancestors of 25 000 to 50 000 years ago were the originators of many of these styles.

This view is supported by such writers as Hilaire Hiler and Professor J.C. Flugel, who believe that the adornment of the human body was certainly among the oldest of all aesthetic activities and, in company with the earliest forms of dance, music and religion, laid the foundations for all the arts of modern civilisation. Both these writers, and James Laver, Havelock Ellis, Elizabeth B. Hurlock, Desmond Morris, and many others, have also stated that most of our ancestors' clothing styles and modes of bodily adornment did not originate for any utilitarian purpose; rather, they seem to have originated for rituals associated with magic, fertility and sexual maturity. Most authorities agree that even our current forms of clothing originated from the desire of sexually active men and women to make themselves mutually attractive, to enhance their virility and sex appeal, thereby improving their chances of sexual fulfilment. But there are other reasons, too, such as display of status and wealth, and protection and modesty, although most authorities see these as less important.

Charles Darwin wrote of seeing 'Fuegians standing naked whilst the driving sleet froze upon their bodies, seemingly causing them little or no inconvenience'. Many other travellers and explorers made similar observations about the people they saw, noting also that it was rare to find them totally unadorned. In *Sartor Resartus*, published in 1833, Thomas Carlyle discussed the miserable conditions under which many aboriginal peoples lived but noted that 'once the pain of hunger had been satisfied' the society's 'next step was not comfort but decoration'. Carlyle also wrote of the influence of clothing and decoration upon politics, religion and mores, stating that even in his day society appeared to be founded on nothing more than 'our current forms of clothing'. He observed: 'Man's earthly interests are all hooked and buttoned together and held up by their clothes'.

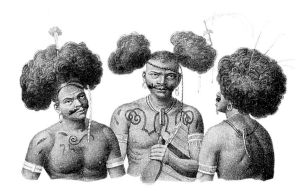

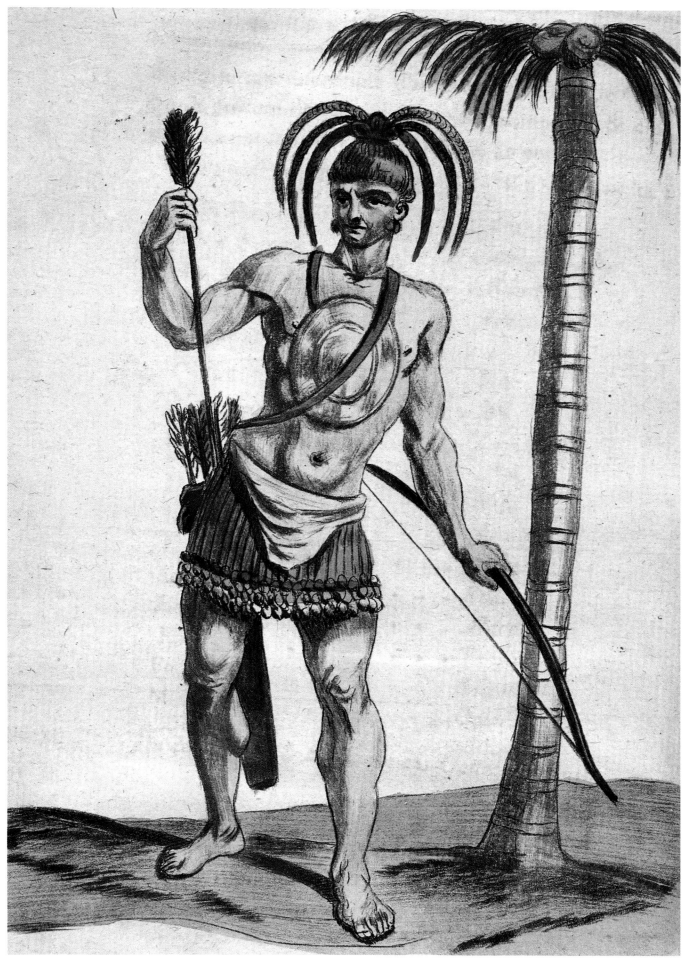

Hand-coloured engraving of native costume by Duhamel after Claude-Louis Desrais, from *Costumes civils actuels de tous les peuples connus.*
1787–88.

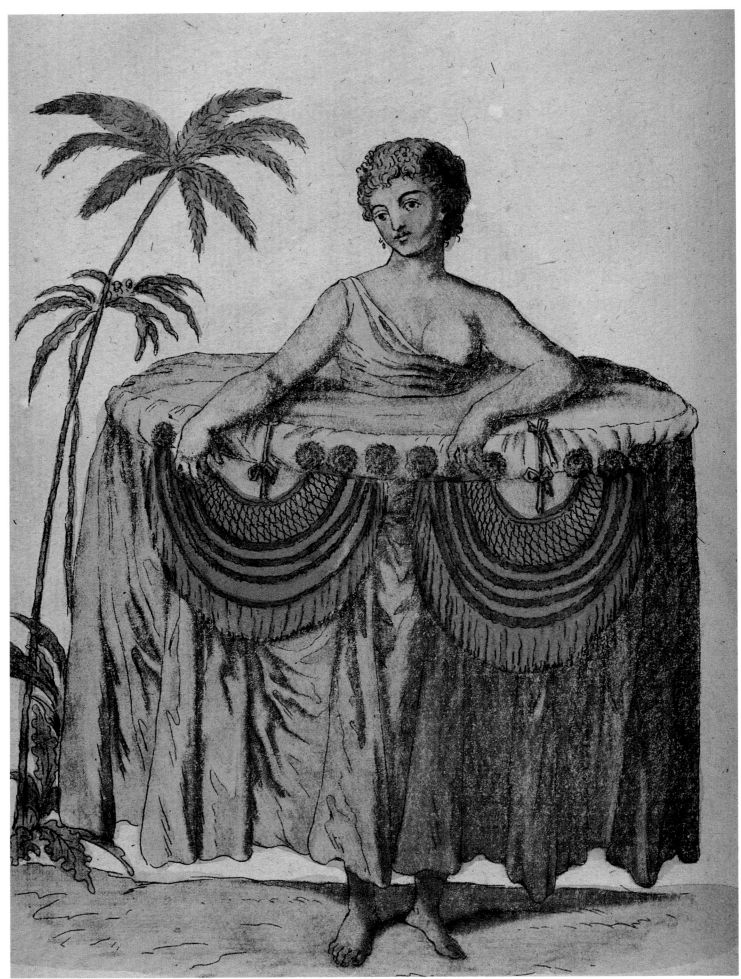

Hand-coloured engraving of native costume by Duhamel after Claude-Louis Desrais, from *Costumes civils actuels de tous les peuples connus*.
1787–88.

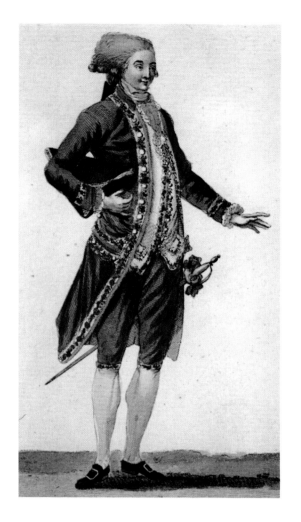

In his introduction to *The Importance of Wearing Clothes* (1959) by Lawrence Langner, noted art historian James Laver wrote,

> *Without the invention of clothes and all the psychological consequences that have flowed therefrom, civilization would never have progressed as far as it has. It is clothes that have made it possible for governments to obtain obedience, religions reverence, judiciaries a respect for the law, and armies discipline.*

Langner himself went further:

> *Clothing has altered the direction of man's more recent evolution, and the human race, as it now exists in countries where clothing has been worn for many thousands of years, has been modified to some extent in both its physical and mental characteristics by wearing clothes.*

This, Langner believed, was particularly the case in matters relating to human sexuality and the artistic expression thereof. He also theorised that clothing, 'by focusing attention on the face, shoulders and breasts, resulted in a change in the later evolution of mankind' and quoted from Professor J.B.S. Haldane's *Daedalus* (1926): 'Of the biological inventions of the past, four were made before history: the domestication of animals; plants; fungi (for the production of alcohol); and a fourth invention, clothing', which he believed was of more far-reaching import-ance in the Western world than the other three 'since it altered the path of sexual selection, focussed the attention of man as a lover upon women's faces and breasts, and changed our idea of beauty from the steatopygous Hottentot to the modern European . . .'

In fact, if we examine our ancestors' modes of dress we can see that the clothing styles worn by Western men and women before the 1920s have nearly always attempted to focus the observer's attention on the face and upper torso, with fashionable excursions being made from time to time to other secondary erogenous zones such as the ankle or derrière. This focus on the face and upper torso had a distinct reproductive advantage: in his book *Bodywatching* (1985) anthropologist Desmond Morris explains how in the course of evolution our eyes, cheeks, ears, neck, lips and facial expressions have all become sexually charged and clearly signal our moods and availability. Our ancestors learnt to accentuate these features by the use of a wide range of cosmetics and adornments.

The majority of contemporary theorists agree that there is a very close con-nection between human beauty and human sexuality, particularly in the case of the female form, and that our notion of such beauty is intimately linked with the idea of carnal pleasure. We also attach the idea of feminine beauty to everything that particularly characterises our race's conformation. Explorers and travellers point out that to most people, no matter where they live, the woman who most completely embodies the particular characteristics of her race is considered the most beautiful.

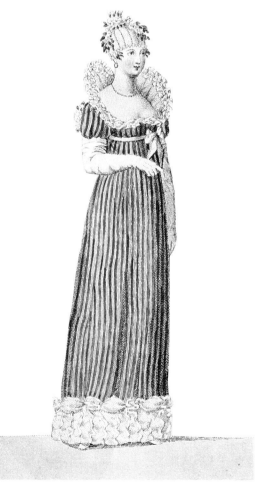

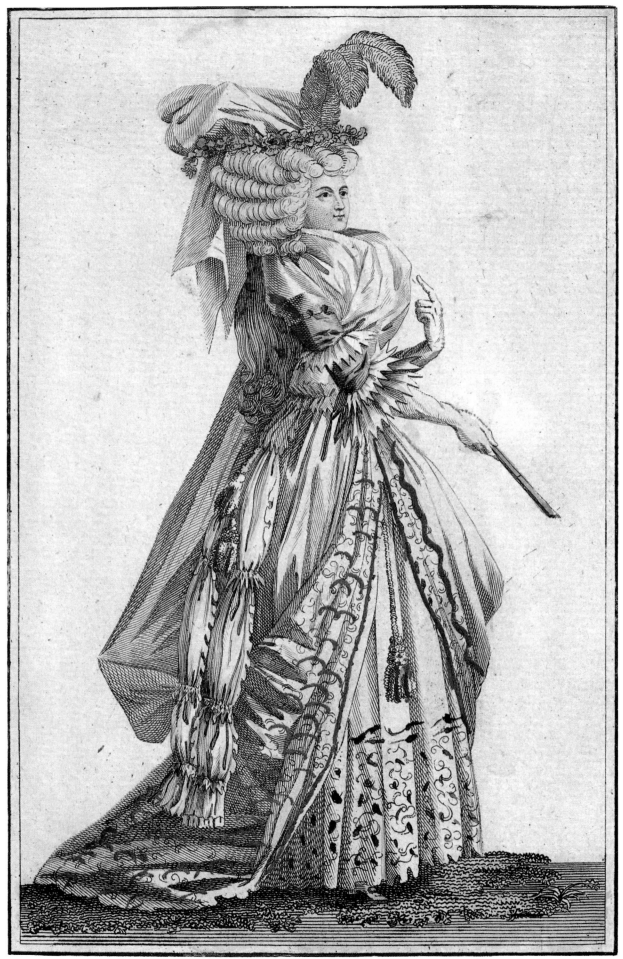

Hand-coloured engraving of the *Fashionable Full Dress of Paris* by an unknown engraver, from an illustration by Pierre-Thomas Le Clèrc originally published in the *Magasin des modes nouvelles françaises et anglaises* but in this instance published in *The Lady's Magazine*. 1789.

In the Western world we do not think of masculine beauty in quite the same way as we think of feminine beauty, but elsewhere masculine beauty can be considered far more desirable than that of the female. Langner stressed the importance of this to our civilisation and to the adaptation of our racial type. It was, he said, 'the progressively increasing emphasis which the wearing of clothes removed from the physical to the mental man — from brawn to brain' that made the difference. One might also note the importance of wealth and social position, which has always been clearly signalled in masculine fashions. This is because males have traditionally been viewed in terms of their ability to afford and sustain a household.

And so Western man emerged as he is today — because his forefathers were thinkers, doers and owners, and openly displayed this in the clothing styles they wore. Life would be very different had muscular strength alone influenced the female's selection of a mate.

During the past 250 years an important change has taken place in the average person's clothing: all but the very poor are now able to afford to change their clothing styles at regular intervals or whenever some new garment takes their fancy. Before the mid-eighteenth century the ability to change one's mode of dress had been restricted, first by sumptuary laws (laws regulating personal habits) and then by wealth, to the ruling class and the upper echelons of society. It was the Industrial Revolution that brought change on a large scale. From that time an increasing number of ordinary people were able to partake in the pageant of sartorial splendour: they were beginning to earn the necessary money to purchase the array of garments required. The styles worn by the royal families and the aristocracy did, however, remain important, particularly those worn at the court of Versailles.

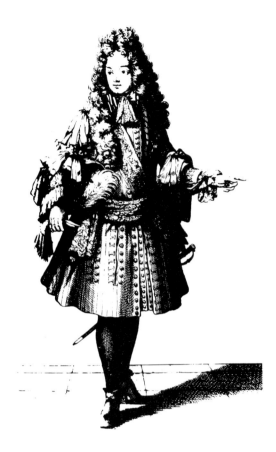

During this time of transition a number of men's and women's monthly fashion magazines were introduced to provide guidance for the growing middle class, to tell them of the latest dress styles of the French and English courts. It is through the pages of such magazines that we can best follow the sartorial and social changes then taking place. For instance, an early-1770s edition of *The Gentleman's Monthly Magazine*, which came complete with two illustrations of the latest designs in menswear and one of a fashionable carriage, informed its male readers,

> For morning dress frock-coats will be prevalent; those of an olive-green hue, with a black velvet collar, will be the most universal. Fancy waistcoats of all kinds of manufacture may be worn with this kind of coat; but fashion ordains the invariable use of dark blue or light-coloured kerseymere pantaloons, and half-boots. The boots must rise somewhat higher in the leg than has lately been the custom, and the hair should be styled à'la Titus, and not powdered.

In an edition of *The Lady's Magazine* also published in the early 1770s we read that it is by means of regular hand-coloured fashion illustrations that the publisher will 'endeavour to inform our most distant readers with every innovation that is made in the female dress' and that

> Dress is to the body what learning is to the mind; it displays the beauties of the person to the greatest advantage, and conceals or corrects the errors of nature, by a happy substitution of art. But as in literature a forced parade of knowledge constitutes pedantry, so in dress the extremes of fashion, instead of being ornamental, are ridiculous.

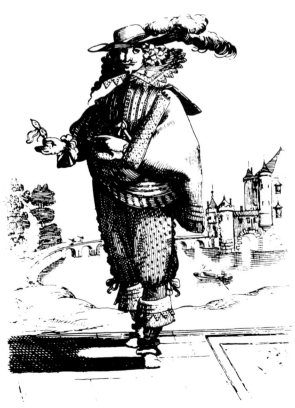

Interestingly, one soon discovers from these magazines that during the period between 1750 and 1789 it was the men, rather than the women, of fashion who wore the most fanciful styles. They devoted much of their time to dressing and making up: 'Fashionable men have their toilettes set out with washes, perfumes and cosmetics, and will spend a whole morning in scenting their linen, dressing their hair and arching their eyebrows'. They also wore beauty patches, rouge, padded hose, powdered wigs, high-heeled shoes and the finest, almost invisible, chicken-skin gloves.

In an article entitled 'The effeminacy of the new male fashions', published in another early edition of *The Lady's Magazine*, we read that 'although it is the Ladies who are frequently treated with severity for making use of rouge and all manner of toilettries, today it is the English fops who do not think that they are properly dressed unless they are highly daubed'. And in another article, 'The art of male toiletry is prodigiously improving in this island',

> Painting and Fashion came smiling hand in hand and threw their captivating glances around them, and Luxury, Vanity, Idleness, Foppery, Debauchery and Fornication have made up their wanton suite; and by degrees have so fascinated our youth that carmine and white lead, Adultery and Les Liqueurs are now no more than a mere daily how d' ye do.

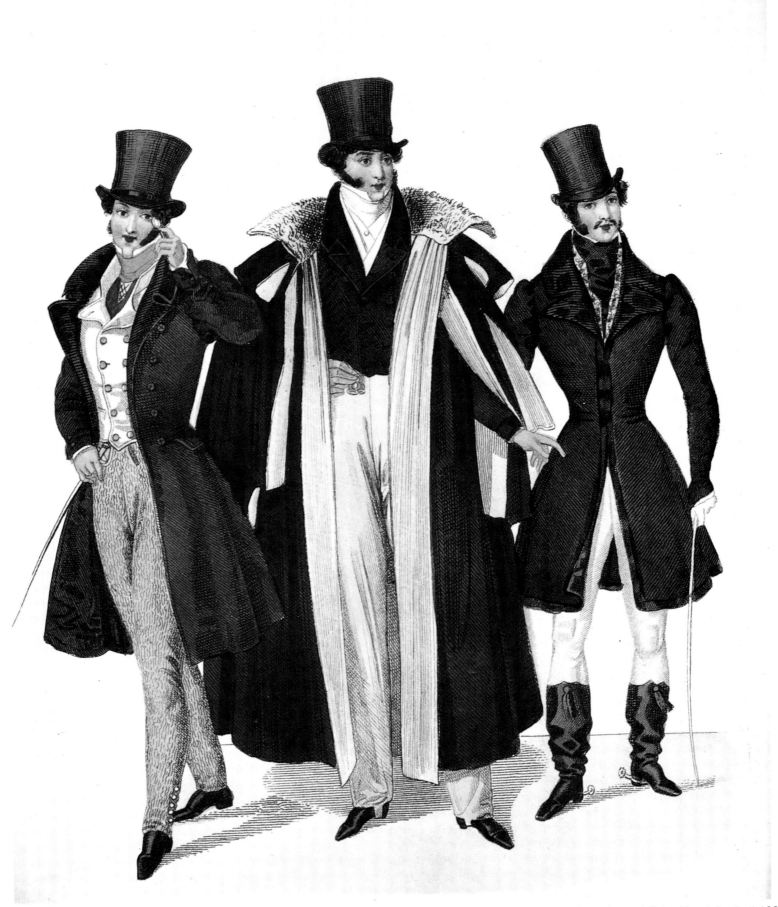

Hand-coloured engraving of English menswear by William Wolfe Alais, for *The Gentleman's Magazine of Fashion* published by John Bell. 1829.

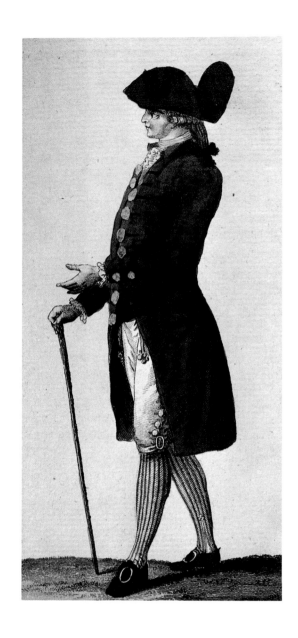

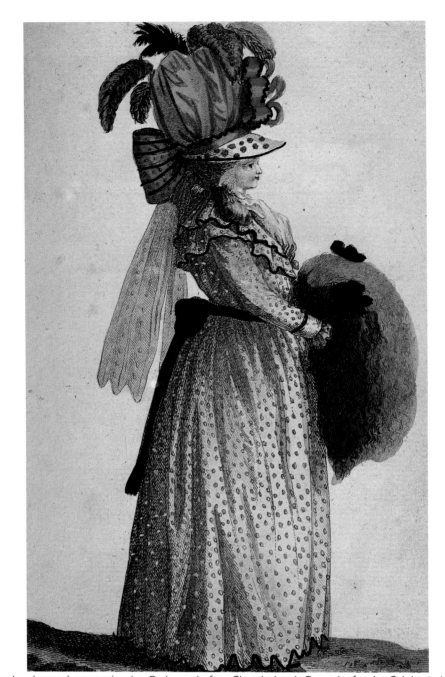

Hand-coloured engraving by Duhamel after Claude-Louis Desrais, for *Le Cabinet des modes ou les modes nouvelles*. 1786.

During the late 1770s and the 1780s the number of fashion magazines featuring both men's and women's clothing styles increased. Among the most interesting were *Le Cabinet des modes ou les modes nouvelles*, which first appeared in November 1785, and *Le Magasin des nouvelles françaises et anglaises*, which started publication the following year. In both of these magazines fine hand-coloured fashion plates and illustrations of the latest designs in furniture, carriages and all other items of a fashionable nature were drawn by eminent artists such as Le Clèrc, Duhamel and Desrais and it was the influence of illustrations of this kind that first brought French fashion to the notice of the nouveau riche and aspiring middle class. Also of interest were the twice-monthly issues of *Costumes civils actuels de tous les peuples connus*, which during 1787–88 formed three complete volumes of the clothing styles of the world, with 284 hand-coloured illustrations.

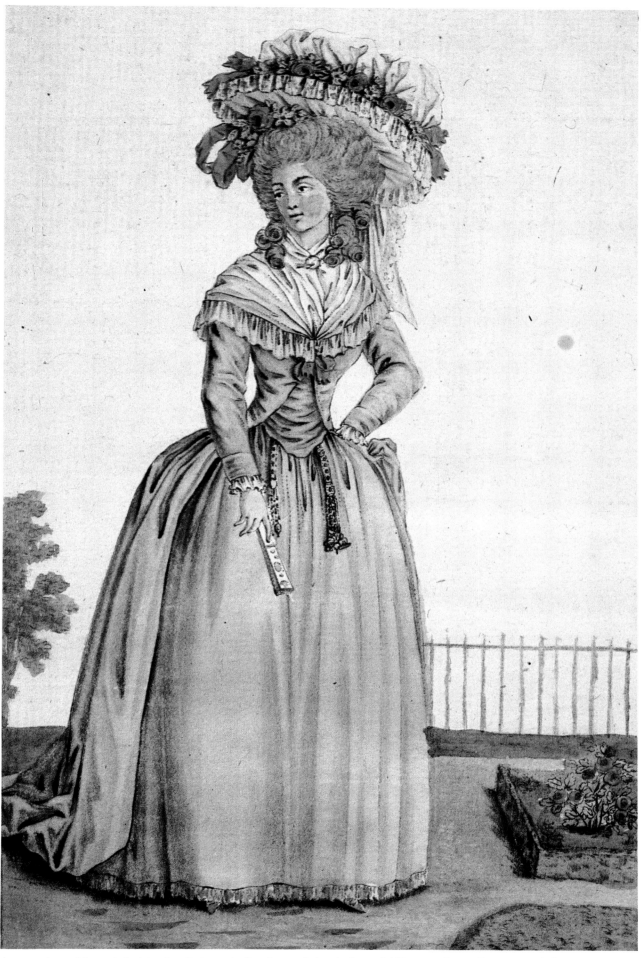

Hand-coloured engraving of French fashion by Duhamel after François-Louis-Joseph Watteau, from *Costumes civils actuels de tous les peuples connus.* 1788.

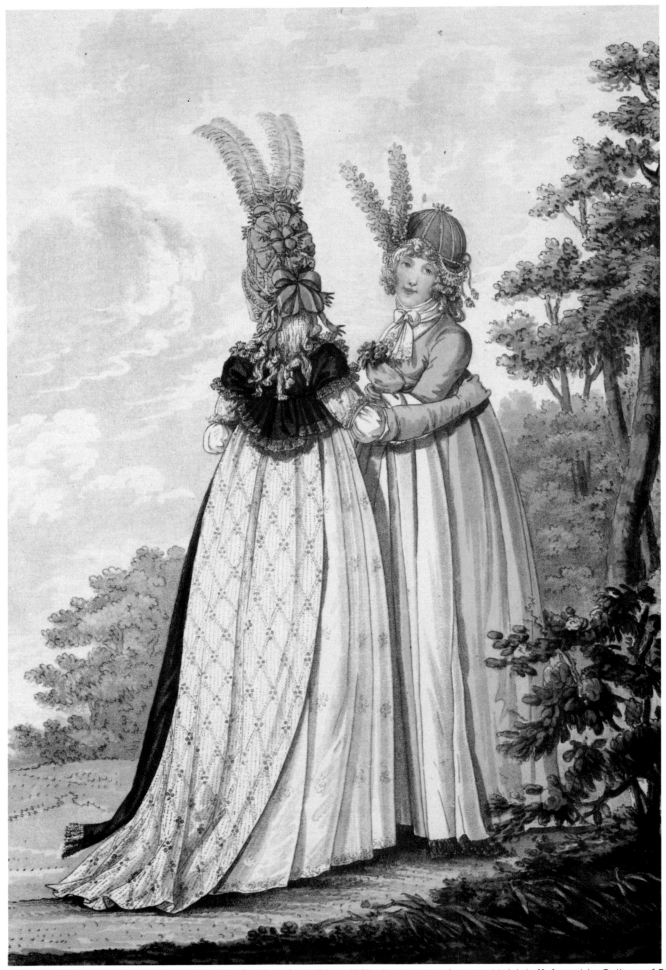

Hand-coloured aquatint from an illustration of English fashions by Niklaus Wilhelm Innocentius von Heideloff, from his *Gallery of Fashion*. 1796.

The paintings and fashion plates illustrate well the excesses of the time. Marie-Antoinette, for example, disposed of a vast amount of money in acquiring a stream of new dresses and exotic hats from her Paris dressmaker Rose Bertin, yet she continually complained that she had 'nothing new to wear'. In 1787 her excesses resulted in a crisis within the Ministry of Finance, a matter temporarily resolved by increasing the tax on salt and other consumer items, which caused great anger among the French population and eventually led to her execution. The official records of Finance Minister Calonne clearly show his dislike of Mademoiselle Bertin, whom he dubbed 'The Queen's Minister of Fashion':

> Nothing can equal the impertinence and arrogance of this lady since she has been admitted to intimacy with the Queen, to whom she lays down the law ... The extravagant notions and far-fetched combinations of Mlle Bertin have been the cause of enormous expenses which the Queen has not succeeded in concealing and which the King hates to be seen squandered on mere frills and feathers.

The French Revolution brought an end to the extravagances of courtly life and the sumptuous clothing styles that had dominated Western fashion since the 1750s. By 1795 simplicity reigned. The female dress was reduced from panniers 1.5 metres wide to an unstructured robe of fine undecorated Indian muslin that looked as if it had been draped directly on to the naked body in the Grecian style. The fashionable male costume became an adaptation of the style previously worn by the French proletariat. Wigs, silken fabrics, embroidered waistcoats, knee breeches, padded hose, fine leather shoes, elaborate toiletry and ostentatious jewellery were discarded by the aristocrats and their imitators, for fear that they might be apprehended as 'enemies of the people'.

The original intention of these new simple clothing styles was to help create an egalitarian society, free from the ostentatious display of wealth and power that so characterised previous regimes. A society was sought which was based upon the humanist principles that had begun to be widely publicised during the latter part of the eighteenth century. Social commentators and magazine proprietors drew their readers' attention to the writings of Jean-Jacques Rousseau, who, when attacking the extravagant fashions of the mid-eighteenth century, had declared, 'The love of extravagant fashion is proof of a vulgar and inconstant mind' and 'Ugly women almost always introduced a new fashion, and pretty women were foolish enough to follow them'.

The new 'revolutionary' fashions were illustrated in such magazines as Pierre La Mésangère's *Journal des dames et des modes* and Vernor & Hood's *Ladies Monthly Museum*, with aquatints and fine hand-coloured engravings. The proprietors of these unique publications were of the opinion that at long last ordinary men and women had been freed from the tyranny of the extravagant modes of dress that had dominated Western fashion for so long. To support their proposition that the new mode should be universally adopted they quoted extracts from the works of Plato, Homer, Persaeus and others who 'would have been in

favour of the new near-naked Grecian style'. One magazine editorial from the early 1800s suggested that the diaphanous fabric used for the new near-naked fashion

> . . . animates the feminine figure and gives it all the embellishment that is needed . . . displaying the true beauty of our young women to the greatest possible advantage . . . Never were our fair females so sparsely dressed, covered with nothing more than transparent shawls that float and flutter over their breasts, which are clearly seen through them, and with a robe so fine that the wearer seems almost naked.

Many fashion historians have commented on these post-revolutionary fashions, objecting to their lack of decency and decorum. For instance, Elizabeth B. Hurlock concluded in *The Psychology of Dress* (1929) that 'after the Revolution there was such a reaction in clothing that the period will go down in history as one of the most immoral in the annals of fashion'. Of course, there was nothing immoral in it: these clothing styles were simply saying, in the most obvious way, that society had changed and freed itself from the repression of the past.

There was contemporary criticism, too. Numerous letters of complaint were published in English journals, one writer pronouncing,

> The present disgusting fashion owed it origins to a nation monstrous in all its pursuits. Levity, indeed, of manners has long been the prominent characteristic of France, but she now gigantically exults in trampling upon decency, and removing all restraints . . .

In France, however, there was little complaint: the new fashions at last allowed the nubile daughters of the bourgeoisie, and even of the lower classes, to vie in manner of dress with the wives and daughters of the nobility and the wealthy, to improve their social position and display their charms on an equal footing.

But this success was short-lived for, with the coming of the First Empire, Napoleon Bonaparte reintroduced all the etceteras of sartorial splendour, giving rise to what has become known as the Empire style. Napoleon insisted that the new Empire fashions be worn at every social event; to one lady of influence he is reported to have said, 'What a delightful gown you are wearing. But I thought it was even more delightful the first time I saw it.'

The First Empire reinstated stratified women's fashion. The new wealthy class of France, those who had managed to make money out of the Revolution, wore styles that showed their newly acquired wealth but that could not be confused with past aristocratic modes. New modes of furniture and interior design were also introduced. They were Grecian in inspiration, aimed at complementing the dress styles of the period; after the successful French military campaign in Egypt design features from that ancient civilisation also became fashionable. By the end of the decade, women's bodices were once again becoming quite fitted, requiring a laced-up corset to push up the breasts, a feature that was to typify fashions throughout the nineteenth century. If the required roundness of breast could not be achieved by tight lacing, flesh-coloured wax was used to provide what Nature had not.

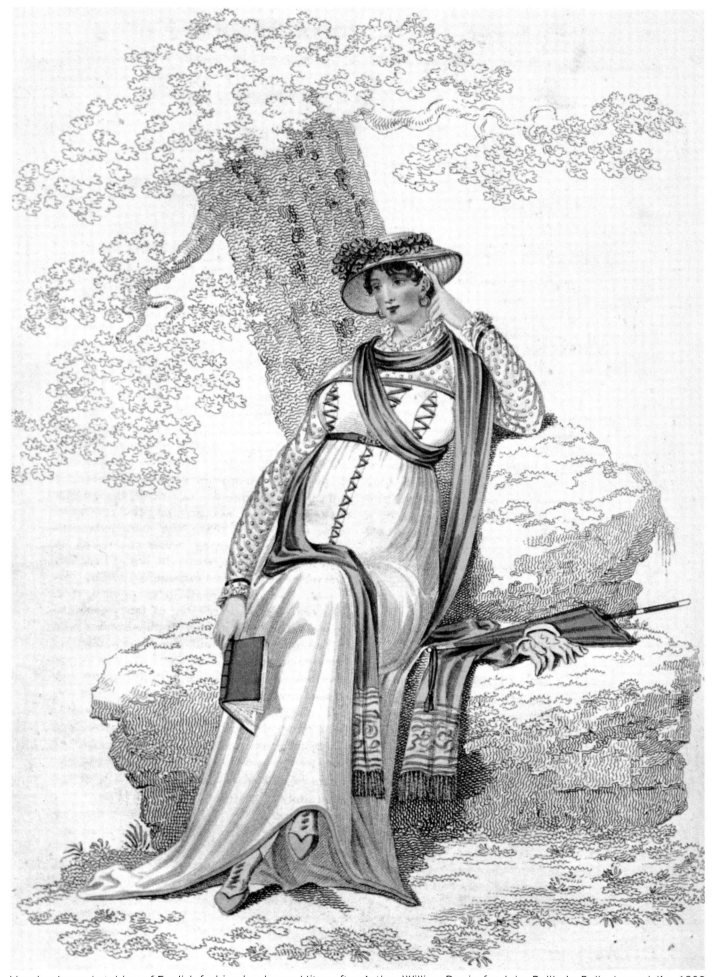

Hand-coloured etching of English fashion by James Mitan after Arthur William Devis, for John Bell's *La Belle Assemblée*. 1809.

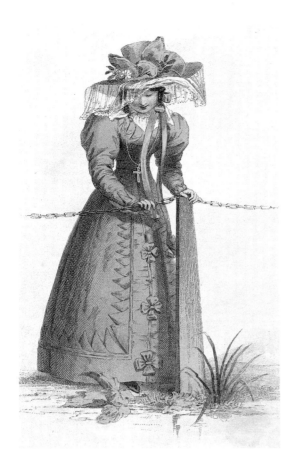

The women of fashion, who had both the time and the money to make the most of the new modes, were also advised that

> Next to the charms of a beautiful face and a perfect figure, a woman has the right to be proud of the advantages of small hands, slender feet and slim arms. But whereas a handsome figure may be found amongst the common people, a fine hand or a slender foot scarcely ever comes from that class. Thus from a sight of the hand alone, or a glimpse of a well-turned ankle, it is possible to judge to what class she belongs. Thick fingers, a large broad foot or a muscular arm announce an obscure birth.

By the end of the first decade of the nineteenth century the influential fashion magazine *La Belle Assemblée*, which had commenced publication in 1806, reported that 'the more wealthy classes of society are constantly devising new modes for marking the artificial distinction between themselves and those who are not so rich in worldly possessions, by a difference in dress'. This trend continued throughout the century, the fashions gradually becoming larger and more ornate until they rivalled those of the recently deposed court of Versailles. Another copy of *La Belle Assemblée*, this time from 1812, published a report on the prevailing fashions in the European courts:

> Just thirty years ago the ladies wore high heels and high feathers, silks of substance and trains of great length, and by their mode of dress alone they sought to please the eye of the company at a fashionable gathering. But, on lately entering a soirée, I behold groups of young belles with bare heads and bare bosoms, wearing gossamer gowns . . . Even in St Petersburg upon entering the Grand Salon of the Royal Palace, the ladies are wearing the Grecian mode, but they are the most sumptuous that can be imagined . . . the most excessive extravagances have been used to contribute to the ladies' adornments, and it seems that whole fortunes have been lavished upon a single dress.

In menswear, there was a distinct difference between pre-Revolution court fashions and those that emerged afterwards. Before the Revolution, male aristocrats who had inherited their wealth (as opposed to having to work for it) were able to display their inheritance by dressing in what is best described as a 'foppish style'. By wearing these foppish styles — powdered wigs, velvet jackets, silk pantaloons, embroidered waistcoats, lace trimmings, padded hose and facial make-up — the aristocrats could be clearly seen to come from a different and superior class. Their foppery was not emulated by the 'working rich' (the merchants, bankers and manufacturers) because they found it effeminate and were unable to wear such styles successfully.

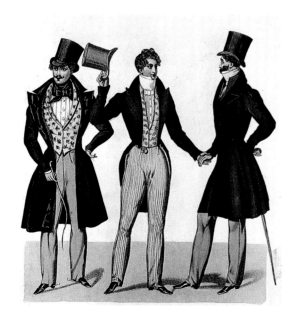

By the second decade of the nineteenth century, however, the wealthy merchants, bankers and manufacturers were beginning to control male fashions and, being rather prudent self-made men, they established a style that symbolised their wealth and new social position. They adopted a form of three-piece suit, with a cut-away jacket reminiscent of a tailored hunting jacket, proletarian trousers and a short waistcoat. Such a design could be easily adapted to the individual's

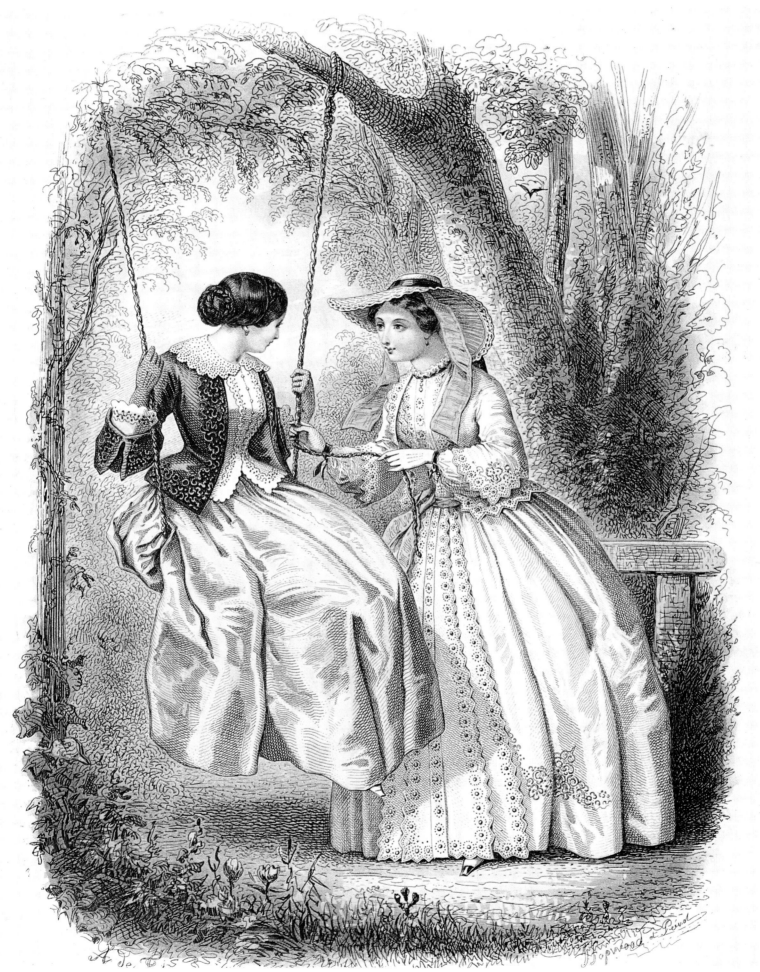

Hand-coloured steel engraving of French fashions by Hopwood et Perival after A. de Taverne, for *Le Petit Courrier des dames*. 1853.

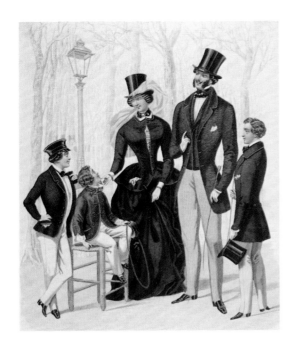

physique, and the tailors who had specialised in hunting gear for the aristocracy had no difficulty making the garments. Soon this three-piece suit, the jacket made of a good quality black woollen fabric and worn with grey striped trousers and a grey waistcoat, became the obligatory mode for all men of wealth and good standing.

The wives and daughters of these wealthy merchants, bankers and manufacturers were, however, unwilling to adopt such a controlled style of dress and between 1810 and 1860 their fashions became ever more ornate and costly. The laced-up corset had been reintroduced in France around 1805, to push the bosom upwards and to slim the waist, and by 1815 English and American women were beginning to wear the steel and whalebone contraption, which became tighter and tighter as the years progressed. Skirts were becoming increasingly large to offset the narrowness of the waist, until they measured more than 6 metres around the hem and had to be held out by a metal and whalebone petticoat generally known as a 'crinoline'. The waistline itself could measure as little as 38 centimetres. By the 1860s the fashionable melee had reached the point of endless extravagance about which La Bruyère had complained nearly two centuries earlier: 'One fashion has scarcely destroyed another, when it is itself abolished by one yet newer, which in its turn makes way for that which follows it, and this will not be the last; such is our fickleness . . .'

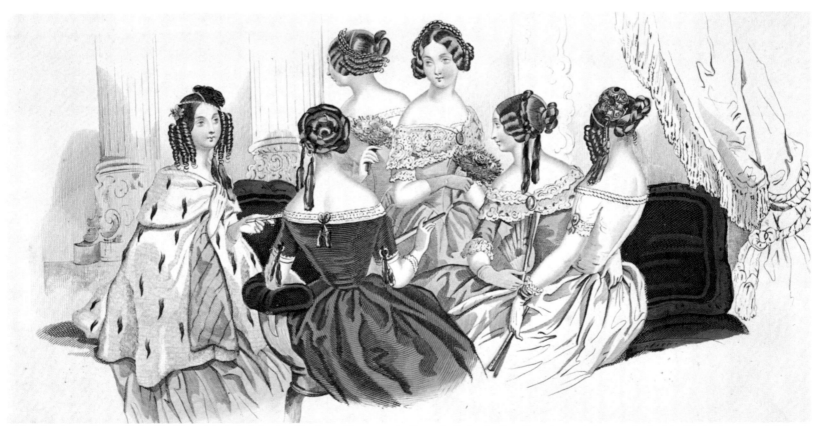

Hand-coloured aquatint of fashionable hairstyles by Madame Florensa de Closménil, for *Le Bon Ton: journal des modes* but in this instance published in *Blackwoods Lady's Magazine*. 1844.

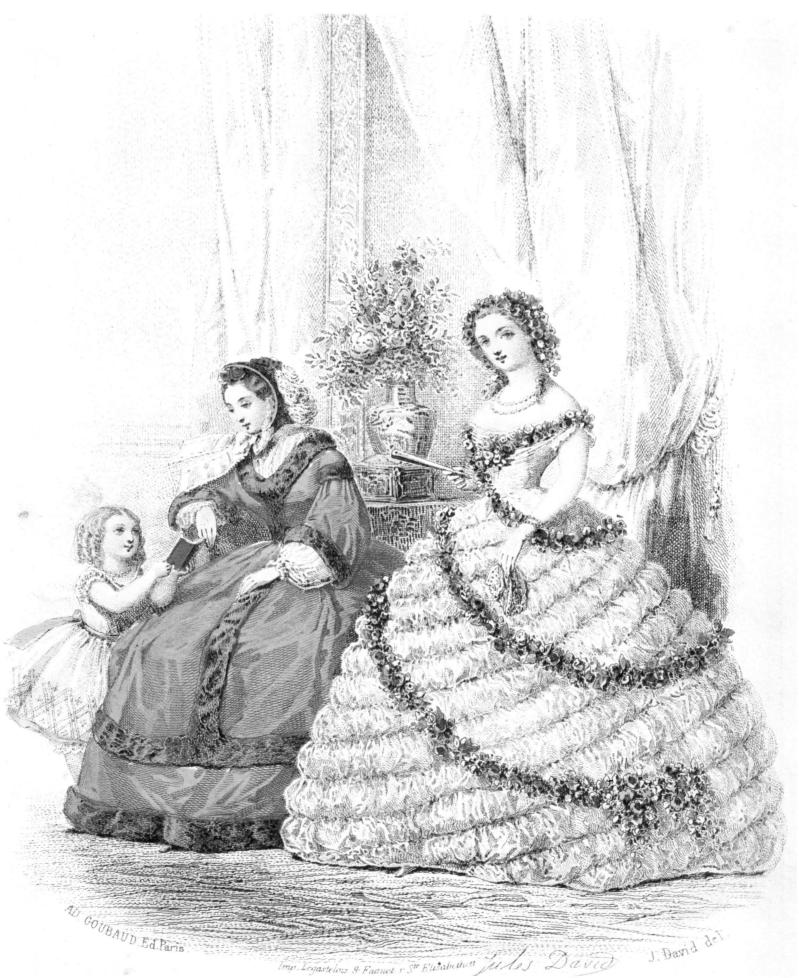

Hand-coloured steel engraving of the latest crinoline fashions by A. D. Goubaud after Jules David, for *The Englishwoman's Domestic Magazine*. 1861.

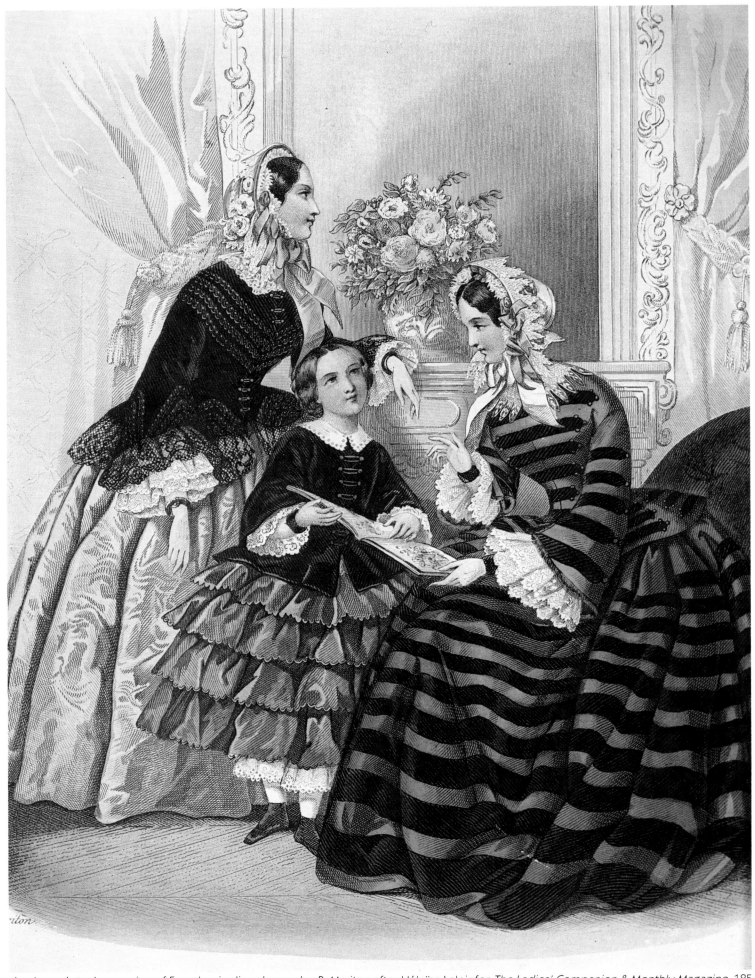

Hand-coloured steel engraving of French crinoline dresses by P. Mariton after Héloïse Leloir for *The Ladies' Companion & Monthly Magazine*. 1854.

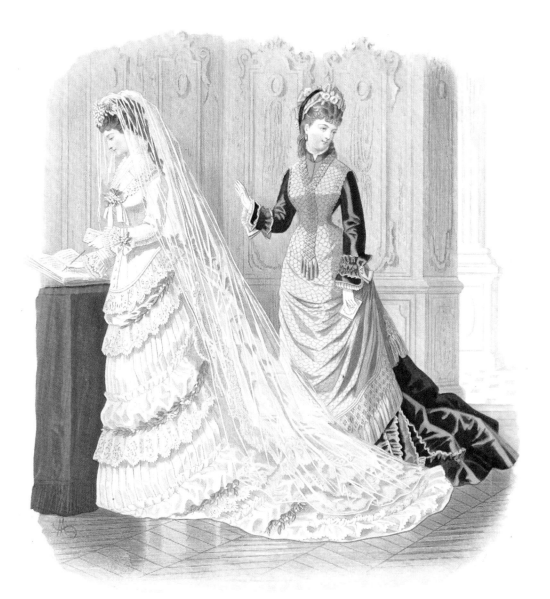

Hand-coloured steel engraving of a wedding and bridesmaid's dress by E. Cheffen after Marie de Solar, for Marie Schild's *Journal des modes & Court Magazine.* 1877.

During this period many aspects of the lifestyle of the nouveau riche changed dramatically. Their fortunes enabled them to build splendid townhouses that they filled with ornate furniture, and as an increasing number of workers crowded into the towns and cities the nouveau riche built themselves opulent country retreats. New forms of transportation were developed to transport goods and people between the major cities. Sporting pastimes became fashionable, requiring new kinds of garments. Books became much more widely available and cheaper. Steamships were opening up new trade routes around the world and they returned with a brilliant array of unusual merchandise. Explorers were visiting previously inaccessible countries and returning with strange tales of previously unknown peoples whose lifestyles were totally different from anything known in the Western world. Great exhibitions were held, displaying a vast collection of manufactured merchandise. And the fashion magazines told of the myriad changes taking place.

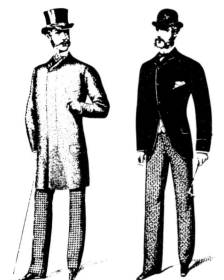

Many of the inheritors of mercantile wealth began to reject the prudence of their forefathers, whose attire had symbolised allegiance to bank and boardroom, and they adopted a style of dress that revealed their wealth and the fact that they did not need to work to maintain it. Some wealthy women, on the other hand, were beginning to forgo the finery of ornate dressing and taking on a style of costume previously reserved for men. This turn of events created great confusion in the popular press: the new female mode was under continual attack, as was that worn by the male dandies. In a copy of the *Pall Mall Gazette* of the mid-1850s we read,

> In all ages it has been asserted that the ambitious and unfeminine members of the fair sex have, in their struggle for power, contended for the wearing of those articles which formerly characterised the male costume, and they have been properly dealt with by due process of law; but it has been reserved for our present enlightened society to reverse this affair by young men trenching upon the petticoats, stays, starched linen, and pouting-pigeon bodices of the females . . . Today's dandy is now so bolstered up in collars and frills, so lost in baggy trousers, so pinched in the middle by whalebone stays, that he can neither have an expansion of heart nor fair use of limb . . . These walking male hour-glasses, however, form a fine contrast to the new breed of masculine dames who drive curricles entrenched in manly coats, and who promenade the streets in Turkish trousers, instead of skirts and petticoats . . . Time was when it could be said of England that her men were valiant and her women fair, but now we can only hope that there will be an indifference of the true female sex towards lady-like gentlemen, and a new contempt of the male sex towards man-like ladies that will speedily bring back each to their proper sphere in life, that will once again render them the envy of all foreign nations.

Simultaneously, members of the press were attacking the female mode of dress for displaying too much femininity. In a copy of the *London Daily News* of the mid-1850s we read,

> The taste for indecent costume on and off the stage which at present is the fashion here is no less apparent in Paris and New York. The power of management to draw crowded houses is in exact proportion to the number of sparsely dressed females he employs, and how much of their naked forms are presented on stage in bold relief to the gaze of the spectators, which, of course, is echoed in the mode of dress worn by many of the females in the audience. This is especially true of the garments being worn by the ladies of leisure, whose excesses in display have reached a point of wantonness only rivalled by the styles worn by those filthy Can-Can dancers who are beginning to invade our theatres and music-halls.

Before 1855 most ladies of fashion were quite naked under their crinolines; this steel and tape invention had been specifically designed to replace the previously fashionable four or five petticoats:

> The practice of wearing this crinoline and discarding the linen and flannel petticoats worn hitherto has resulted in the increase of several diseases such as rheumatism, paralysis, cramps etc, induced by the warmth being kept away from the lower part of the person, and by the cold draughts of air which are admitted when the wearer is out walking.

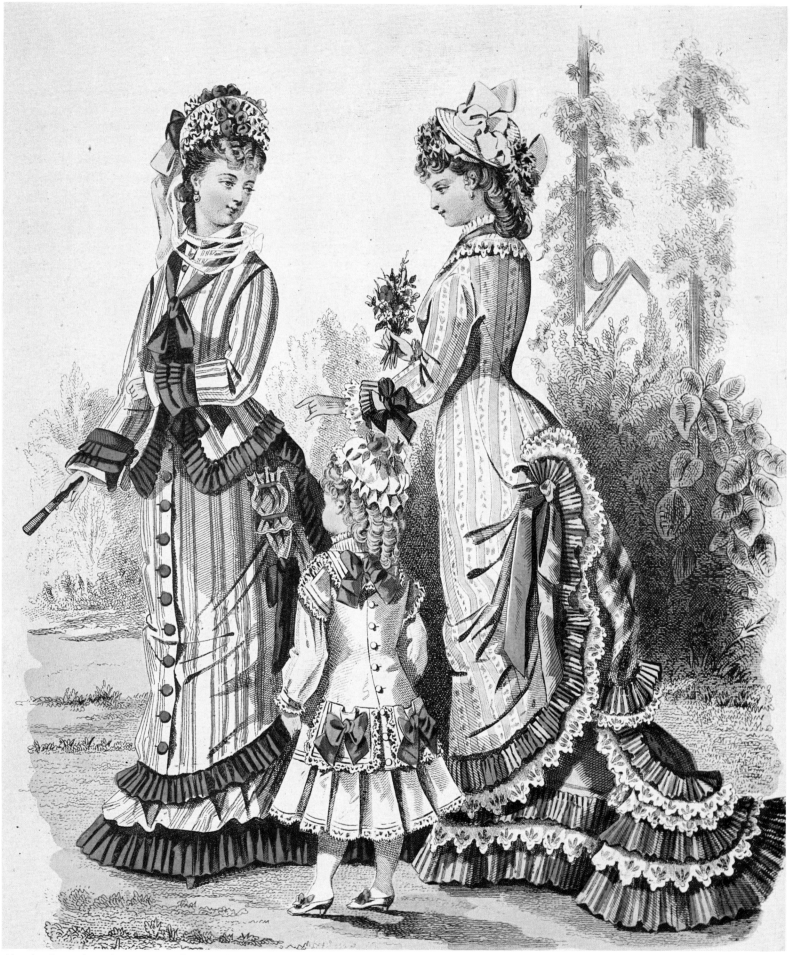

Hand-coloured steel engraving of French bustle-style dresses by A. Chaillot after P. Deferreville, for *Le Journal des demoiselles et petit courrier des dames.* 1876.

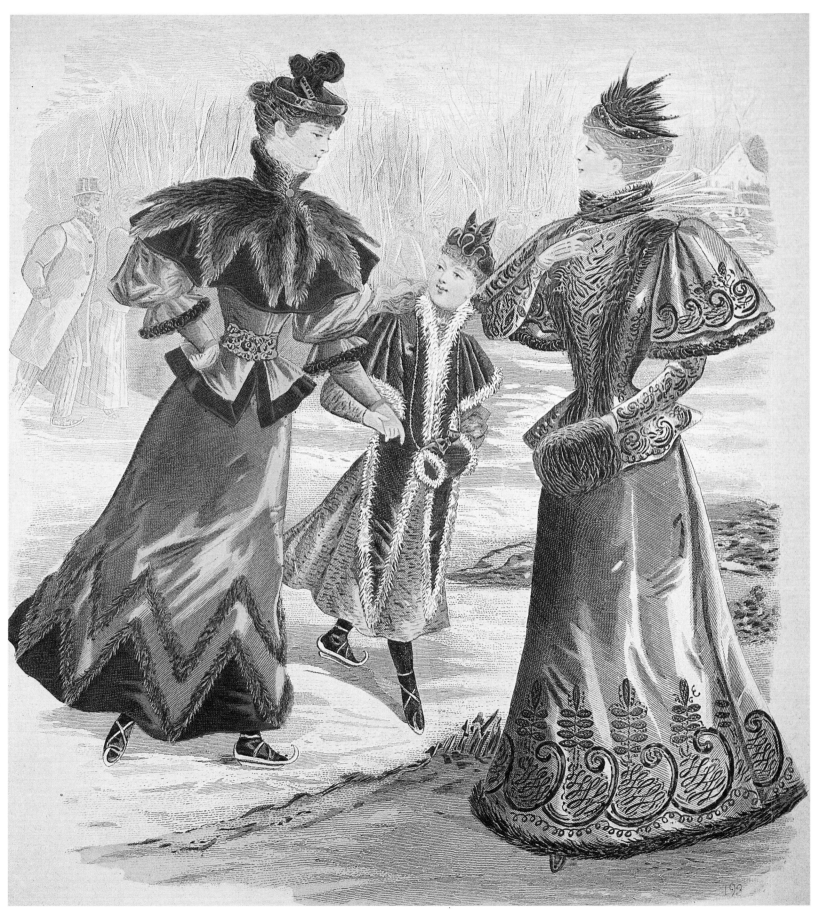

Pochoir coloured steel engraving of fashionable ice-skating clothes by A. Portier after Jean Dieu Sandoz, for *The Ladies' Gazette of Fashion*. 1894.

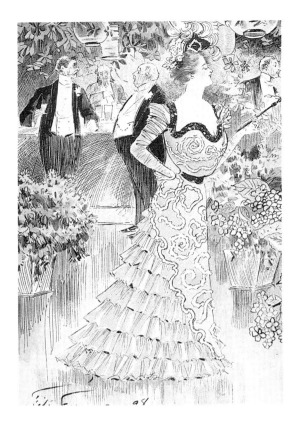

Of course, this fashion brought great joy to the cartoonists of the time.

To ward off the threat of rheumatism and cramps many women of fashion began to wear a form of bifurcated underdrawers. This habit soon became the focus of much argument and remained so until the end of the nineteenth century. Clergy, moralists and doctors condemned such garments as 'unhygienic', 'unfeminine', 'against the laws of God', 'lascivious', 'lewd' and 'lustful' and 'only fit to be worn by harlots, strumpets and prostitutes'.

The ornate styles of the 1850s and 1860s called for tightly laced corsets to narrow the waist and to push up the bust line so that the maximum amount of breast was on display. It would appear that many ladies of fashion received a degree of stimulation from the corsets themselves, the tight lacing encouraging pelvic tumescence and creating a degree of labial friction. The insides of their thighs were also being stimulated by wearing the newly introduced 'unmentionables', or 'underdrawers'.

Most high-kicking dancers prior to 1850 had also been naked under their frilly petticoats, but as such dances increased in popularity short open-legged drawers began to be worn, trimmed with lace frills for titillation. It is clear from the critics of the 1850s and 1860s that the open underleg allowed more of the dancers' feminine charms to be seen than most dancers today are willing to display, even at 'strip joints'. Towards the end of the century, however, social pressure led to the closing of the underleg seam.

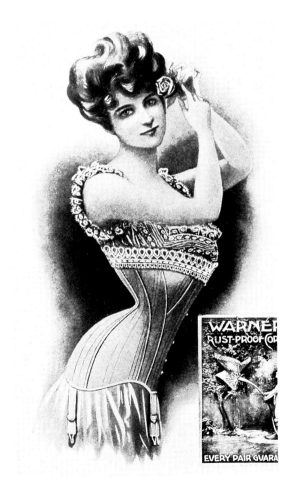

By the end of the nineteenth century women's outergarments were being increasingly influenced by the orientally inspired Art Nouveau style of design, which had been growing in importance since the great Paris Exhibitions of 1878 and 1889 and the Exposition Universelle of 1900. At these exhibitions there were extensive exhibits from many oriental countries, but particularly noteworthy were the displays of traditional Japanese kimonos, fabrics, *ukiyo-e* prints, lacquer work and a great number of artifacts and other works of art that were to transform the aesthetic ideals of many of the young designers and artists who were then working in Paris. These designers and artists had grown weary of the overly ornate mid-nineteenth century style and even before the exhibition of 1889 they had begun to incorporate many of the ideas of the Japanese craftsmen into their own work. The result was a revolution in both fashionable design and the fine arts.

TWENTIETH CENTURY STYLES

The Paris Exposition Universelle of 1900 was a triumph for the protagonists of the Art Nouveau style of design — a celebration of the pastel colours, free-flowing forms and curvilinear shapes created by the great French designers, each of whom had utilised the prevailing Japanese influence in an individual way. Their products reaffirmed French supremacy in the world of art and design. There were also striking exhibits by Charles Lewis Tiffany from New York, Paul Kruger of Berlin, Jacob Baden of Copenhagen, Mademoiselle Karlickova of Prague, Gustafsberg of Stockholm, Niedermoser of Vienna, and paintings by such artists as James Abbott McNeill Whistler, Edgar Degas, Auguste Renoir, John Singer Sargent and Thomas Gainsborough. The exhibition also contained many items from Japan, Turkey, China, Persia and other oriental countries whose styles of design had been influencing European designers and artists during the latter part of the nineteenth century.

Hundreds of thousands of people from all over the world flocked to Paris to see the work of the twenty-one nations and their colonies that participated in the exhibition. Whilst in Paris many of these visitors also made a point of going to see the latest fashionable clothing styles created by the *grands couturiers* of the period — Doucet, Doeuillet, Worth, Paquin, Redfern, Chéruit and Callot Soeurs — each of whom ran a large *maison de couture*. Many also visited the forty or so smaller couture houses and a similar number of milliners, furriers, jewellers and elite shops that specialised in the newly fashionable lingerie and *robes déshabillé*.

The larger establishments always showed their latest collections twice yearly, in February and August, when their regular clientele would travel from throughout Europe, South Africa, the Americas, Australia and the United Kingdom to select their peignoirs and simple dresses for morning wear and more ornate ones for shopping. They also selected their dresses for morning visits, for luncheon, for afternoon walks and for receiving visitors. And there were always long lists of more sumptuous and ornate dresses for special occasions: official ceremonies, family gatherings, sermons and lectures, artistic receptions, first nights, dinner parties, concerts, visits to the opera or to a ball. Then there were dresses for a visit to a restaurant, theatre or cabaret, not to mention the races, visits out of town, holidays at the seaside or the mountains, weddings, christenings and funerals, and long train journeys or sea voyages. Nothing could be left to chance.

Pochoir fashion illustration with silver highlights *Le Rendezvous dans le parc* by Paul Méras of an evening dress by Worth, for *La Gazette du bon ton*. 1912.

LES MODES

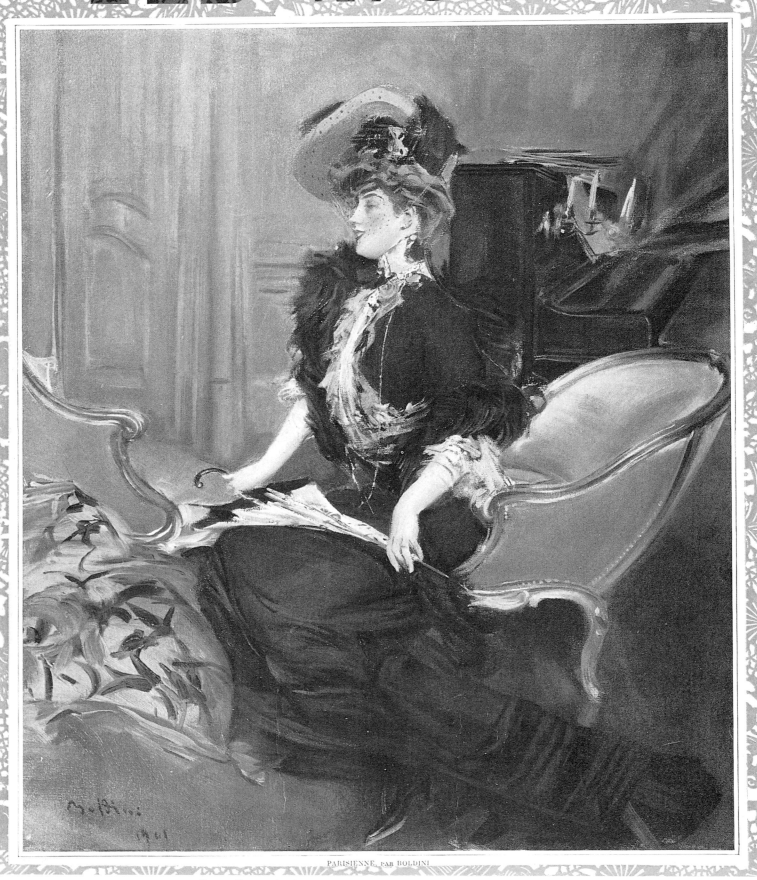

PARISIENNE, PAR BOLDINI

Cover illustration by Boldini of a Parisienne, for *Les Modes*. 1901.

Whilst in Paris the haut monde also visited the famous ateliers run by designers and master-craftsmen such as Gallé, Lalique, de Feure, Grasset and Gaillard, who were continually producing new ideas in glassware, ceramics, tapestries, carpets, silverware, furniture, china, lacquer work, deluxe edition books and objets d'art. They also visited the specialty houses of Montmartre, where the madams offered every conceivable variety of sexual delight, whilst on the streets and boulevards young girls and attractive gigolos plied their trade. The fashionable demi-mondaines were the elite in this most ancient profession.

The demi-mondaines had risen to prominence in the French court at the middle of the nineteenth century; by 1870 their power was so great that they had succeeded in totally removing the stigma of prostitution from their profession. They exerted great influence over the princes, aristocrats, industrial barons and millionaires who competed for their favours. Even in the first decade of this century the most famous demi-mondaines aroused great interest among the general public, who avidly followed their amours and copied their fashionable styles; they engendered the same interest, admiration and following that many film stars enjoyed during the 'golden age' of Hollywood.

The famous Paris couture houses often used the demi-mondaines to promote their fashions, dressing them for little more than cost price so that they would be able to sell similar styles to their established clientele, who were always anxious to be à la mode. There was intense rivalry among these 'professional beauties' and they and the couturiers exploited the situation in sensational manner. 'Respectable' women of society clamoured for the slightly risqué and avidly copied the fashionable styles worn by the demi-mondaines.

The theatre and music halls also played an important part in setting the new fashions: many of the leading actresses were used by the couturiers to set new trends, both on stage and by acting as fashion models for new French magazines such as Les Modes. The styles they wore scandalised, amused and captivated Western society, and their private lives seemed as outrageous as their public lives were glamorous.

But other events were beginning to change people's attitudes to this self-indulgent way of life: strikes, riots, attempted revolutions, assassinations and bomb attacks were besetting many of the major cities of Europe. In Serbia, King Alexander and Queen Drago had been killed in a bloody uprising. In Russia, hundreds of civilians had been killed in riots against the Tsar. In Turkey the hereditary monarch had been deposed after months of rioting. In Portugal the King and the Crown Prince had both been assassinated. And everywhere suffragettes were becoming increasingly insistent in their demand for the right to vote.

By the end of the first decade of the twentieth century, as Western society began to change in response to the changing times, a new style of design was emerging. This new style was initially based on the theories of the eighteenth century industrial philosophers, who had advocated abandoning all forms of 'pecuniary-style beauty', which they considered had plagued European design

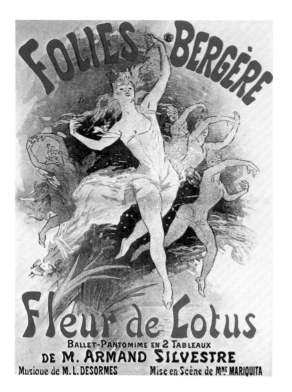

since the beginning of the Industrial Revolution. The new designers declared, 'From now on traditional forms of beauty will no longer be an essential ingredient of manufactured objects, as the eventual aesthetic attractiveness of such objects will now be the result of the observer's perceived relationship between the object and its function'. Within a very short time the pastel colours, flowing lines and curvilinear shapes of the Art Nouveau style had given way to a new style that emphasised angular geometric shapes, crisp vibrant colours, refined detailing and superb craftsmanship. Today this new form of design is referred to as Art Deco, a term first used in the mid-1920s to describe designs typical of the leading French artists and designers who exhibited their work in the famous Exposition Internationale des Arts Décoratifs et Industriels Modernes, held in Paris in 1925.

By 1910 Art Deco's angular shapes and clear colours were beginning to find favour with the younger and more intellectual members of the haut monde. The Art Nouveau style lingered on for several more years, gradually degenerating into an applied stylism that no longer reflected its oriental origins. During its brief flowering it had fulfilled a valuable liberating function by allowing its protagonists to discard many of the outdated conventions and strictures of the nineteenth century. But, having shaken off the compulsions of unthinking manufacturers, these protagonists began to experiment with the simpler relationships to be found in the forms of Art Deco, which they eagerly combined with their continuing admiration for the oriental ideals of quality and superb craftsmanship.

In women's fashion two young French designers, Madeleine Vionnet and Paul Poiret, both in their early thirties, and their mentor Jacques Doucet, who had been a couturier since 1871, spearheaded the attack on the passé Art Nouveau styles. By 1912 they had succeeded in banishing the whalebone corset from their customers' wardrobes. Their designs were promoted throughout the Western world by a new style of deluxe fashion magazine featuring the expensive *pochoir* method of hand colouring for its illustrations, which were the work of artists such as George Barbier, Charles Martin and Georges Lepape. The most famous of these magazines were *La Gazette du bon ton*, *Le Journal des dames et des modes* and *Modes et manières d'aujourd'hui*. The glossy magazine *Les Modes* also helped to promote the new style, as did *Art et décoration*, which in 1911 had reproduced photographs by Edward Steichen of Paul Poiret's *Directoire*-inspired designs, which were soon attacked for their sensuality in allowing the natural sway and shape of the wearer to be seen, without being confined in a corset.

Madeleine Vionnet's designs were also attacked for revealing the natural shape of a woman's body, but the attacks gave to the new designs a sort of allure and hint of exoticism that was precisely what the younger women of fashion wanted in order to break away from the kinds of dresses worn by the previously fashionable dowagers and older demi-mondaines. Speaking of these designs in 1975, shortly before her death, Madeleine Vionnet said, 'I have never been able to tolerate corsets myself so why should I have inflicted them on other women?'

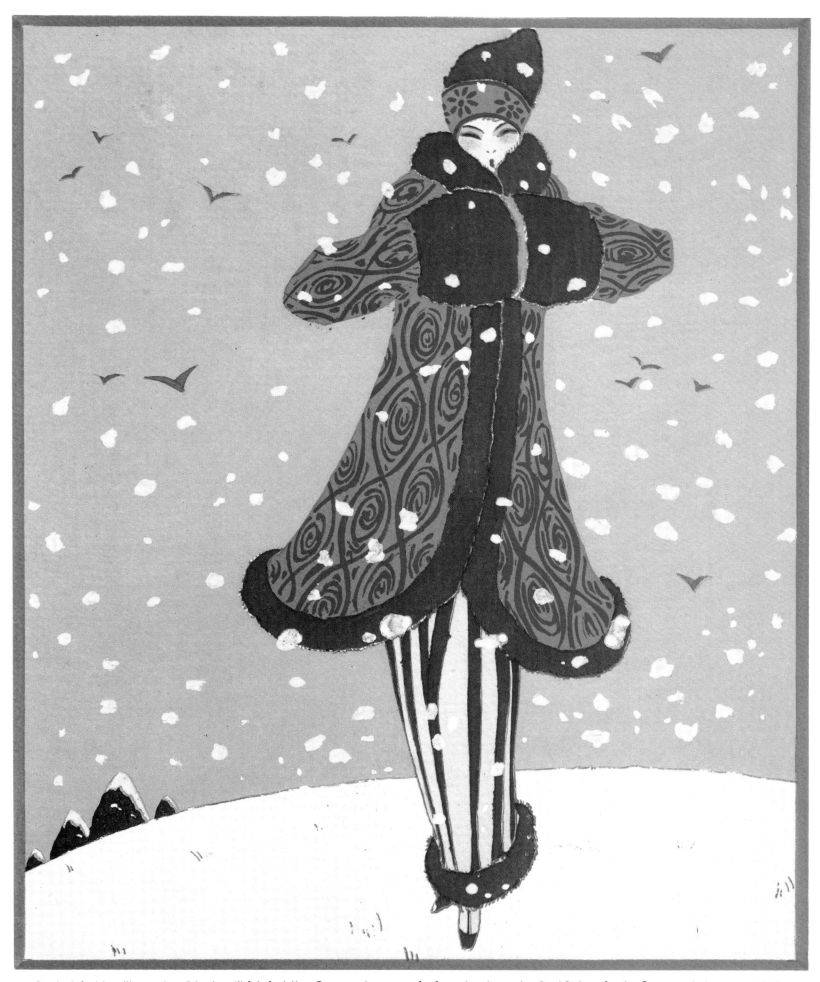

Pochoir fashion illustration *Dieu! qu'il fait froid* by Georges Lepape of a fur-edged coat by Paul Poiret, for *La Gazette du bon ton*. 1913.

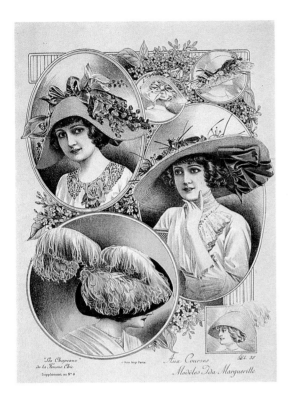

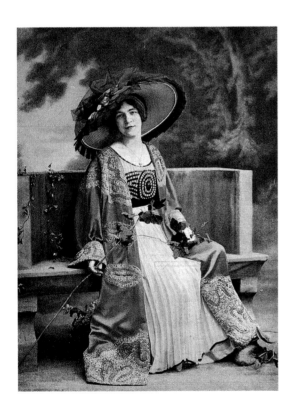

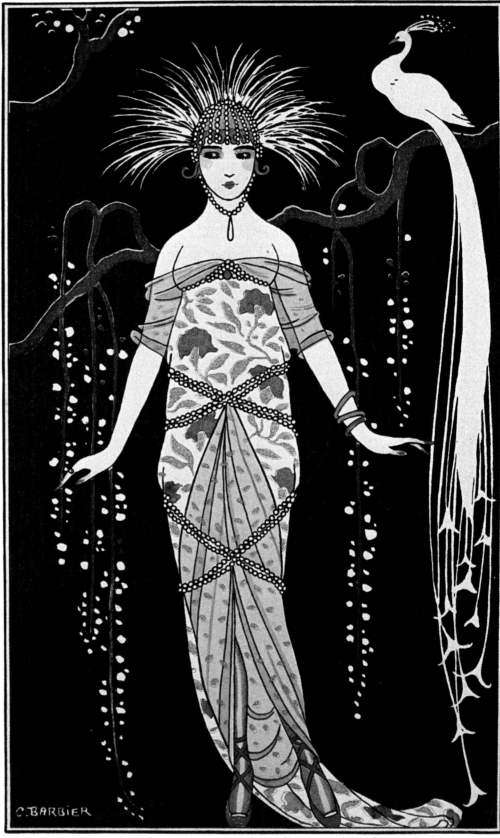

Engraved fashion illustration highlighted in *pochoir* by George Barbier,
for *Le Journal des dames et des modes*. 1914.

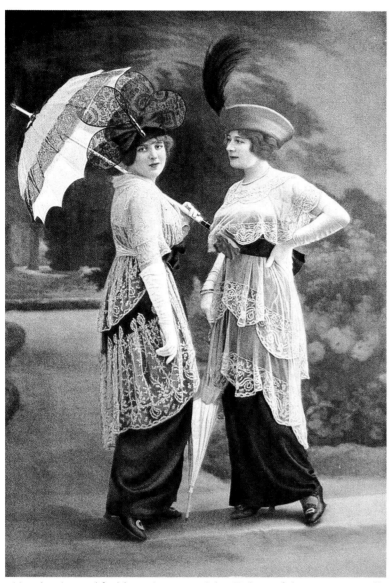

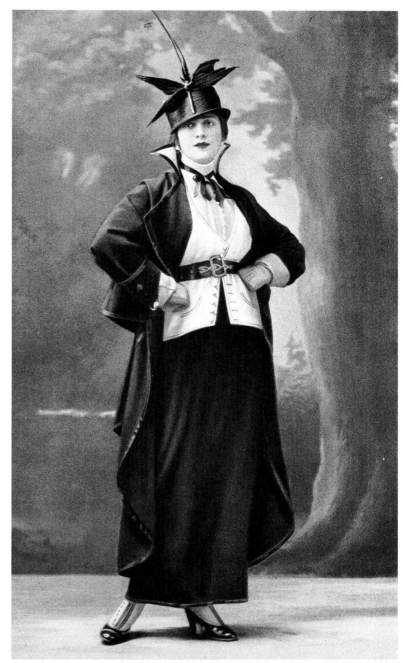

Hand-coloured fashion photograph by Talbot of the actresses Mlle de Gonet and Mlle Alice Guerra in dresses by Drecoll, for *Les Mode*. 1913.

Hand-coloured fashion photograph by Reutlinger of the actress Mlle Jacqueline Forzane in a tailored suit by Jacques Dukes, for *Les Modes*. 1914.

Paul Poiret attempted to dispose of corsets in his designs at around the same time as Vionnet. In his autobiography *King of Fashion*, published in 1931, he spoke lovingly of 'the natural shape of a woman's body' and the 'Botticelli-style small breasts' of the young women of fashion he was dressing at that period. He asked, 'Can anything be more captivating than this beauteous roundness?'

The styles of 1910 to 1914 took their inspiration from an earlier period in fashion, the period of the Grecian style, which was at its height between 1795 and 1810. Although the new Art Deco dresses were never as blatantly sexual as those of the earlier period, they did start the twentieth century trend away from the stereotyped shape achieved by the use of whalebone corsets and towards a much more natural and relaxed style, which reached its peak of immodesty in the mid-1920s.

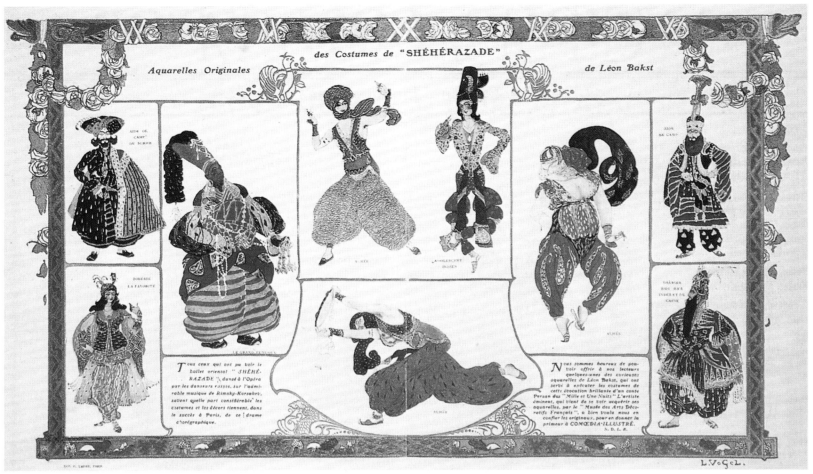

Offset litho illustration by Léon Bakst of his costumes for the Ballets Russes production of *Schéhérazade*. Theatre program designed by Lucien Vogel. 1910.

The designs of Lev Samoilovich Rosenberg — better known as Léon Bakst — were also the object of strong criticism in this pre-war period, especially the costumes worn by Russian dancers Ida Rubinstein and Vaslav Nijinsky in Rimsky-Korsakov's ballet *Schéhérazade*, which was first performed in June 1910 at the Grand Opéra in Paris. This extravagant and sensual ballet featured a wild orgy scene of near-nude dancers, lavish oriental sets and blatantly erotic costumes. Many critics were outraged, saying the production was 'barbaric' and 'vulgar', but the audiences were ecstatic.

Schéhérazade had been brought to Paris by the Russian-born entrepreneur Sergei Diaghilev, as part of the repertoire of his newly formed dance company the Ballets Russes. His dancers had been selected from the famous imperial dance companies of St Petersburg and Moscow — Anna Pavlova, Tamara Karsavina, Ida Rubinstein, Vaslav Nijinsky and Michel Fokine — and during the 1909–10 seasons they performed ten new ballets: the *Polovtsian Dances*, *Cléopâtre*, *Les Sylphides*, *L'Oiseau de feu*, *Giselle*, *Le Festin*, *Les Orientales*, *Le Pavillon d'Armide*, *Le Carnaval*, and *Schéhérazade*. *Schéhérazade* was the undoubted climax of the Paris 1910 cultural season, and it was also a catalyst in popularising the new mood and fashionable styles of the time, finally and irrevocably severing the remaining ties with the nineteenth century.

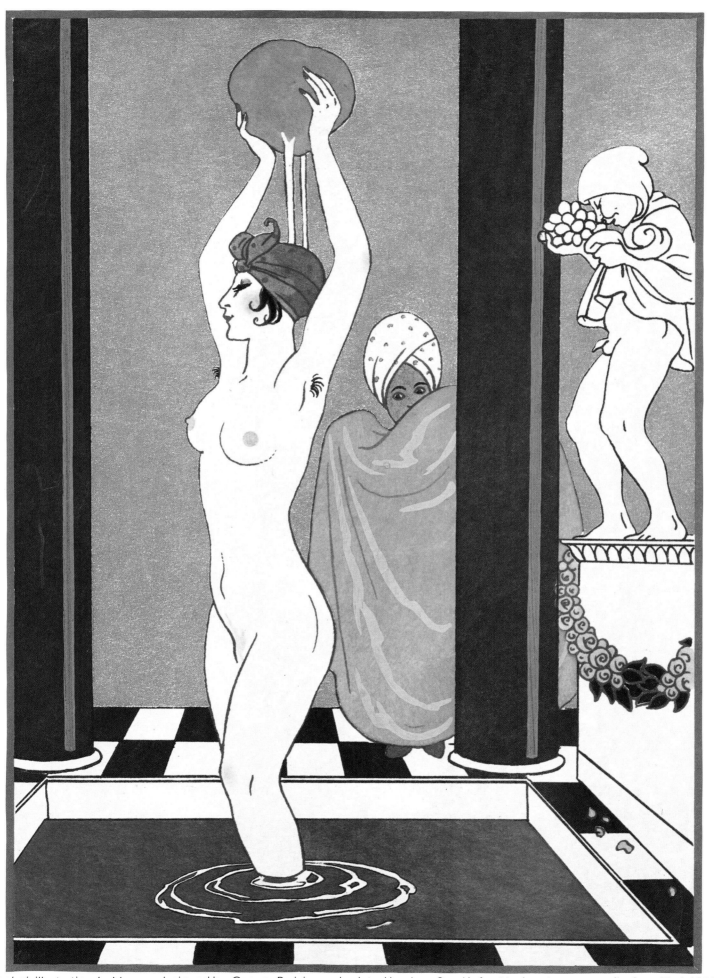

Pochoir illustration *La Vasque* designed by George Barbier and printed by Jean Saudé, for *Modes et manieres d'aujourd'hui.* 1914.

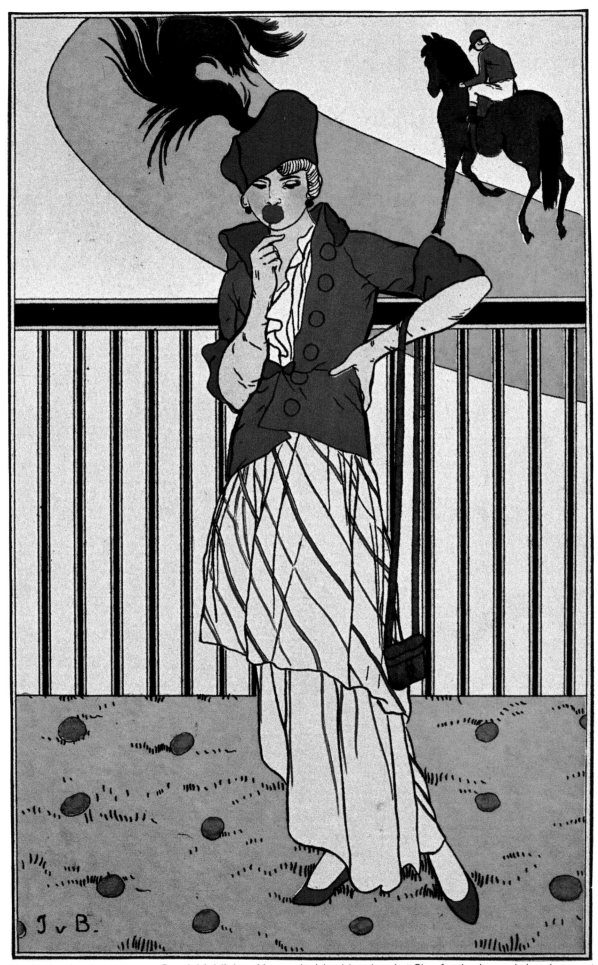

Engraved fashion illustration by Jacques van Brock highlighted in *pochoir* by Vaugirard et Cie, for *Le Journal des dames et des modes*. 1913.

Older members of society watched with increasing horror as they saw 'respectable' women wearing the new figure-revealing dresses and painting their faces in the mode of actresses and demi-mondaines. To make matters worse, these women were also pressing for freedoms such as the right to vote, to smoke in public, to dance the forbidden 'turkey trot' and tango, to engage in active sports and to wear the more comfortable ankle-revealing skirts. When war broke out some even joined the armed forces. It was during that war that young women at last won the right to dress as they pleased, in a style that suited them, free from the bigotry and suppression that had so bedevilled fashion during the latter part of the nineteenth century.

The Great War changed many aspects of Western life, for all levels of society: the way people thought, the way they looked, the way they lived. And for the pre-war haut monde, who had travelled the world enjoying luxury and leisure, life no longer seemed to follow the tradition of unquestioned authority and privilege. There was also a noticeable change in attitudes towards the opposite sex. The turmoil and bloodshed brought freedom from the constrictions of middle class mores; men of marriageable age became accustomed to living mainly with other men and the young women learnt to do without them, often forming relationships with older men or other women. An increasing number of women also began to work and this brought with it exhilarating independence.

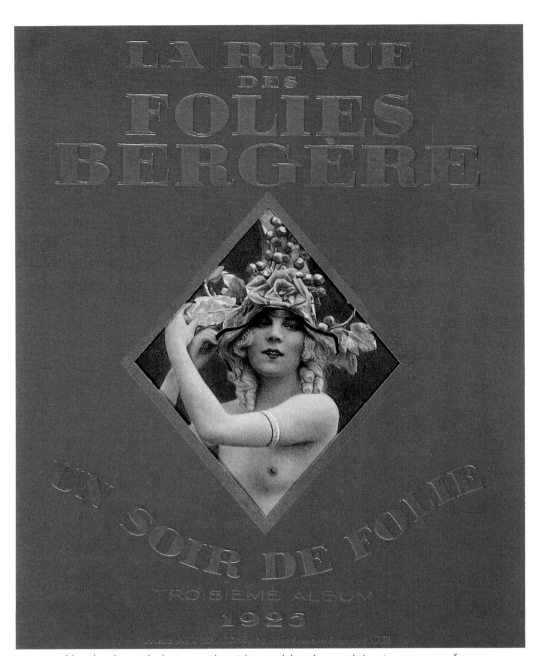

Hand-coloured photograph set in a gold embossed theatre program for the *Folies Bergère*.1925.

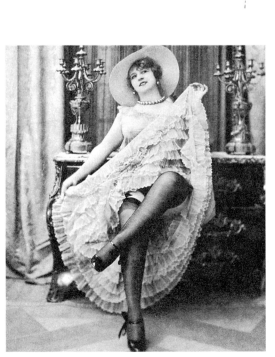

Sexual attraction was exploited at the cinema, in such films as Cecil B. DeMille's *Male and Female* and *Forbidden Fruit*. Photographs of near-naked starlets at casting sessions were published; sex scandals and reports of licentiousness abounded in popular magazines; the feminine form was openly displayed at the Ziegfeld Follies and the Folies Bergères. All forms of homosexual relationships were still illegal, and therefore risqué, novel and fashionable, and this made all sorts of love affairs and sexual liaisons prevalent and socially acceptable. Many young women discarded the traditional sexual livery of modesty, since it had no part to play in their relationships and, indeed, with a shortage of eligible young men, was decidedly inconvenient and harmful. Many young women also left their small sheltered communities in search of the work then being offered in the larger cities, where clothing styles and the way a girl looked played a more important role. All these factors resulted in a fashion explosion that changed the appearance of women.

The earliest films, by Thomas Edison, Georges Méliès and the Biograph Company, had been shown in 'penny arcades' and 'kinetoscope parlours' in the larger cities of North America and Europe during the latter part of the nineteenth century and the early years of the twentieth century, but they were of only passing interest since most of them ran for just a few minutes. As techniques of filmmaking improved, though, 'moving picture theatres' became increasingly popular. Films began to dramatise the newest fashionable ideas for millions of average people who lived in the smaller cities, country towns and villages throughout the Western world. For the first time in their lives these people saw the latest in fashionable clothing on young actresses and attractive model girls. Before this the average person had been able to keep in touch with the latest styles only by studying newspapers and magazines, but when halls in every city, town and village were converted into the first cinemas and moving pictures began to boom, the newest feminine fashions could be seen by anyone who had a few cents for an entry ticket.

At the beginning of the boom, the films shown were still quite short, with actors and actresses flickering across the screen in varying dramatic situations interspersed with newsreel footage of natural catastrophes and social events. By 1912, however, feature films starring Mary Pickford, Pearl White, Blanche Sweet, and even established theatrical actresses such as Sarah Bernhardt, were regularly being shown, together with newsreel footage that frequently included the very latest fashion news. Occasionally a special fashion film was shown, with footage of a famous Paris fashion parade and the inside of a couture house being the climax.

During the war the film industry grew dramatically: people flocked to the cinemas to see the latest war news and to relax after a hard week's work in the munitions factories or whilst recovering from a stint at the front. By the early 1920s a weekly visit to the cinema had become commonplace in most of the Western world. The star system was well established; stars such as Lillian and Dorothy Gish, Mabel Normand, Gloria Swanson, Theda Bara, Pola Negri, Nazimora, and Clara Bow were beginning to rely on extraordinarily luxurious, and often very innovative and daring film fashions as a major part of their allure. Everything about their wardrobes was larger than life: their jewels were bigger, their furs thicker, the silks softer and more clinging, and the chiffons ever more diaphanous.

The films of the 1920s opened moviegoers' eyes to the mysteries of the East, the wonders of Polynesia, the wickedness of Paris, dream bedrooms and sumptuous bathrooms, the allure of silk lingerie, aristocratic lives of sex and sin, illicit love affairs, handsome and virile young male stars and sultry starlettes, three weeks of love and lust under continual moonlight, the pomp and passion of love in Medieval Europe, new forms of dance, instant success made possible by a chance meeting, and the humour of Charles Chaplin, Harold Lloyd, Buster Keaton and the Keystone Cops.

Actresses such as Norma Shearer were saved from fates worse than death. Joan Crawford allowed nude pictures of herself to be published in a popular magazine to help boost her career, and she also appeared very scantily clad in *Our Dancing Daughters* in 1928. Evelyn Brent was also scantily clad in many scenes in *Silk Stocking Sal* (1924), as was Hope Hampton in *Price of a Party* (1925), Fay Wray in *The First Kiss* (1928), Gloria Swanson in *Zaza* (1923), Greta Garbo in *The Temptress* (1926), Mae Murray in *The Circle* (1924), and a bevy of beautiful young starlettes in Erich von Stroheim's films *Foolish Wives* (1922) and *The Wedding March* (1928).

Actors such as Rudolph Valentino, Douglas Fairbanks, John Gilbert, and the very young Clark Gable and Gary Cooper helped to change the dress styles of many men of this period. The main influence for change, for both men's and women's wear, came from the American designers who were responsible for dressing the Hollywood stars — Walter Plunkett and André-Ani from California, Travis Banton from Texas, Adrian from Connecticut, David Cox from New York, Vera West from Philadelphia, Gwen Wakeling from Detroit, Edward Stevenson from Idaho, Charles LeMaire from Chicago and Howard Green from Nebraska were responsible for many of the popular fashions. Their designs were often copied by the French couturiers for the upper echelons of society.

Engraved illustration of fashionable menswear *La Cape noire* by Bernard Boutet de Monvel, highlighted in *pochoir* by Jean Saudé, for *La Gazette du bon ton*. 1913.

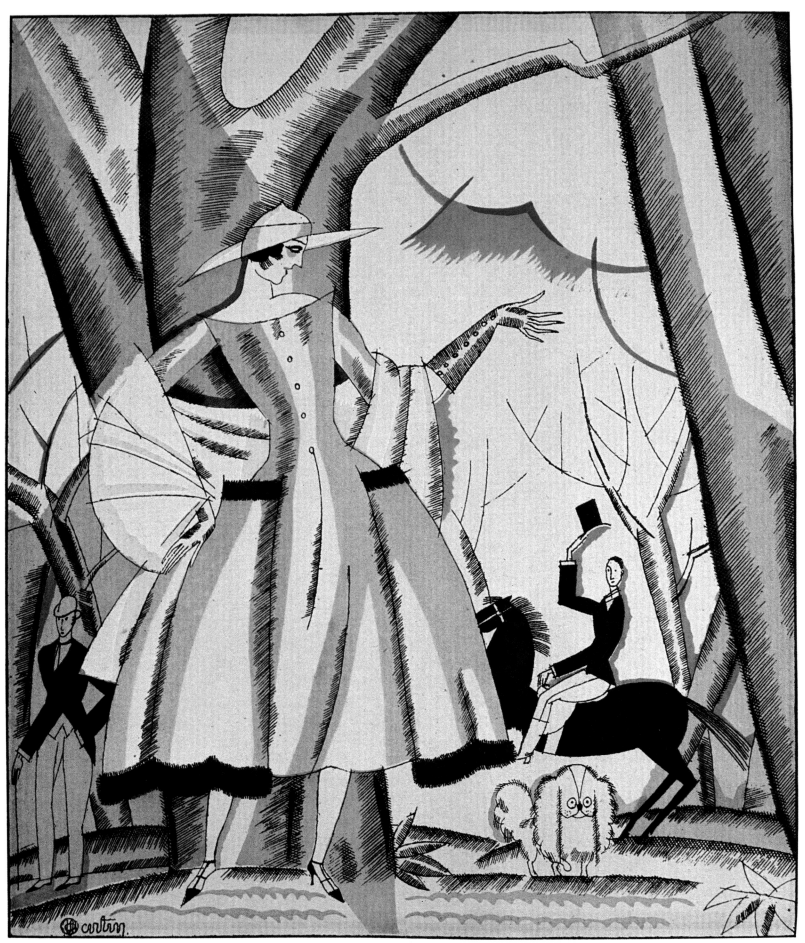

Engraved fashion illustration *La Promenade* by Charles Martin, highlighted in *pochoir* by Jean Saudé, for *Chaussures des Pinet*. 1922.

These couturiers had previously denied that film fashions influenced their styles, but by the early to mid-1930s the glamorous film star fashions worn by Greta Garbo, Marlene Dietrich, Tallulah Bankhead, Ginger Rogers, Joan Crawford and Jean Harlow were having a tremendous influence. Every woman clamoured to look as if she had been dressed in Hollywood.

Influential Paris couturier Elsa Schiaparelli is reported as saying,

The film fashions of today are your fashions of tomorrow. Gone are the days when advanced fashion ideas could be gleaned only by attending exclusive Paris dress parades. Nowadays it is possible for everybody to have access to the most up-to-date fashion news simply by going to the movies.

By 1933 the term 'glamour' had become synonymous with film fashions and women everywhere sought to be as glamorous as their favourite film stars. The fan magazines praised this new glamour and the new film star fashions: 'They make lovely women lovelier and plain women prettier', they simpered. 'Hollywood make-up will do wonderful things for you. It will discover beauty in your face that you didn't know was there. It will individualise that beauty, making you interestingly different.'

These fan magazines also moralised and sermonised, to help create controversy and maintain readers' interest, and they published numerous letters from readers complaining of the growing influence that Hollywood films were having on the Western way of life. 'The provocation of silken legs and half-naked thighs together with little or no concealment of the breasts was disgusting', wrote one outraged film-goer in 1934, after seeing one of Cecil B. DeMille's new productions. The magazine editors and film moguls knew that such 'shameless flaunting' added to the allure of these stars, as indeed did their risqué lifestyles. Many female stars of the silent screen and those of the early 1930s cultivated reputations as sexual athletes, with many of the male stars reputedly being their willing studs. This added to the acceptability and allure of the fashions they wore and the glamour they projected to fans who yearned for similar experiences.

As the 1930s progressed, film musicals became the centre of fashionable interest, especially those produced by Samuel Goldwyn and the Warner Brothers and directed by Busby Berkeley: *The Kid from Spain, 42nd Street, Footlight Parade, Roman Scandals* and *Dames*. Girls all over the Western world tried to model themselves on the scantily clad chorus girls, among them Paulette Goddard, Betty Grable and Lucille Ball. One publicity handout exclaimed, 'Fifteen pounds was the average weight of garments worn in the wicked days of the Music Halls of the 1890s but today our chorus girls wear only four ounces'.

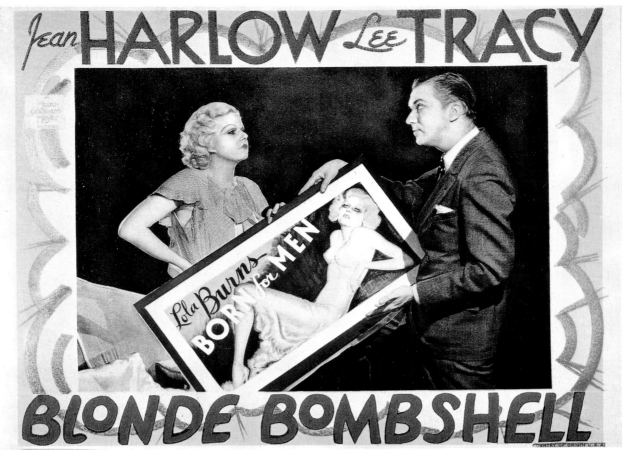

Offset litho foyer display card for *The Blonde Bombshell* starring Jean Harlow and Lee Tracy. 1933.

Offset litho foyer display card for *Roman Scandals* starring Eddie Cantor and The Goldwyn Girls. 1933.

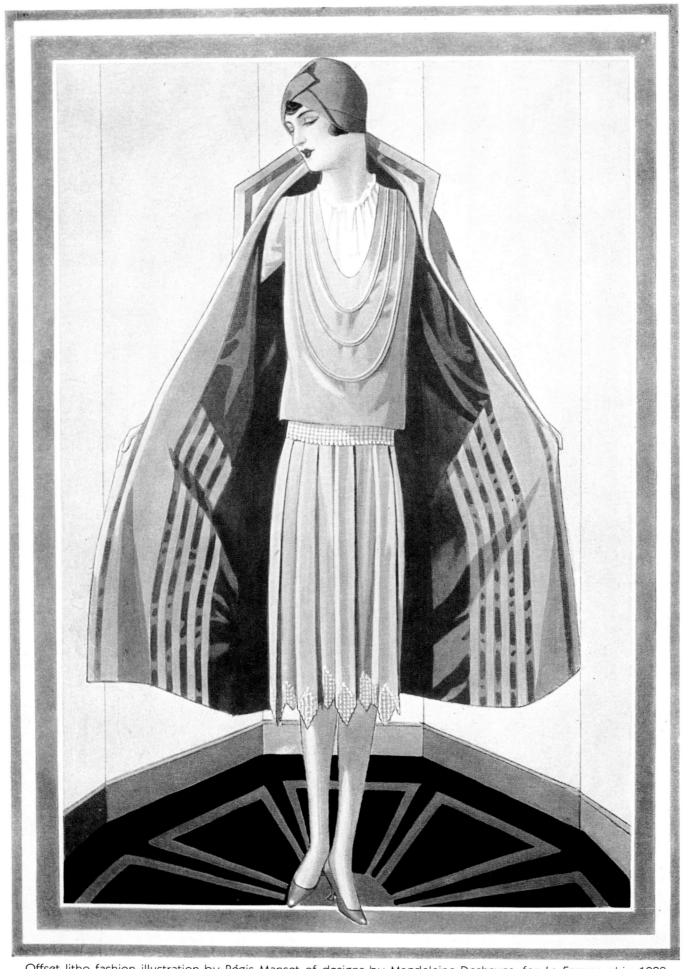

Offset litho fashion illustration by Régis Manset of designs by Magdeleine Deshayes, for *La Femme chic*. 1928

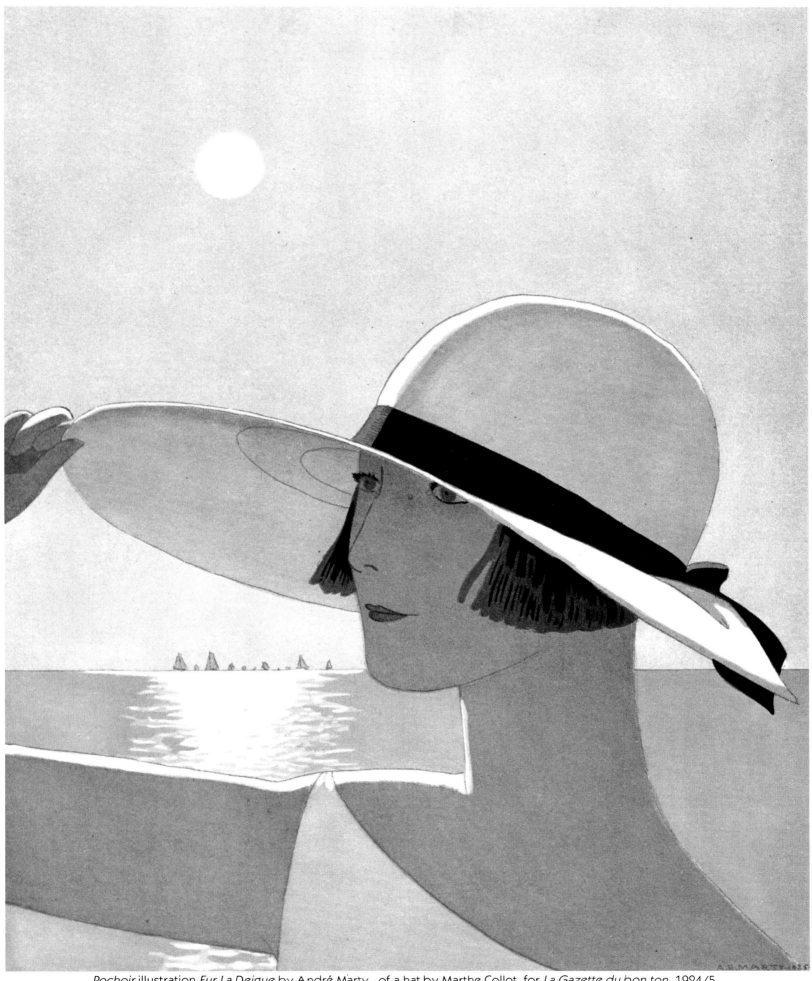

Pochoir illustration *Fur La Deigue* by André Marty , of a hat by Marthe Collot, for *La Gazette du bon ton*. 1924/5.

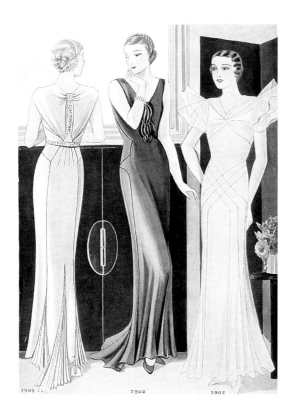

The critics attacked these skimpy young fashions and also the new dances, which they contended were 'intolerably suggestive — a mimetic representation of copulation'. It was not long before rigorous censorship was applied to all new films. Complaints about film star fashions, acts of embrace and what was described as 'simulated copulation' in many dance sequences were by no means new — similar complaints had been voiced ever since the late 1890s, when the first kinetoscope parlours had been introduced. But then these same critics had also attacked the invention of the motor car, the tango, jazz music, gramophone records and the wireless, the growing influence of air transport, dance halls, modern paintings, various books and theatrical productions, mixed bathing, and numerous other aspects of life that we now take for granted. And, of course, all of these changes were at least partially reflected in the clothing styles of the period; for example, the introduction of see-through dresses and topless bathing, and the wearing of seductive and provocative lingerie.

Another aspect of fashion that was under attack was sportswear, which had been made popular by three French couturiers, Coco Chanel, Jean Patou and Lucien Lelong. Critics claimed that it was unfeminine to wear what they described as 'masculine modes of attire' but the haut monde were not unduly perturbed: they willingly purchased these manly sporting styles from their favourite couturiers.

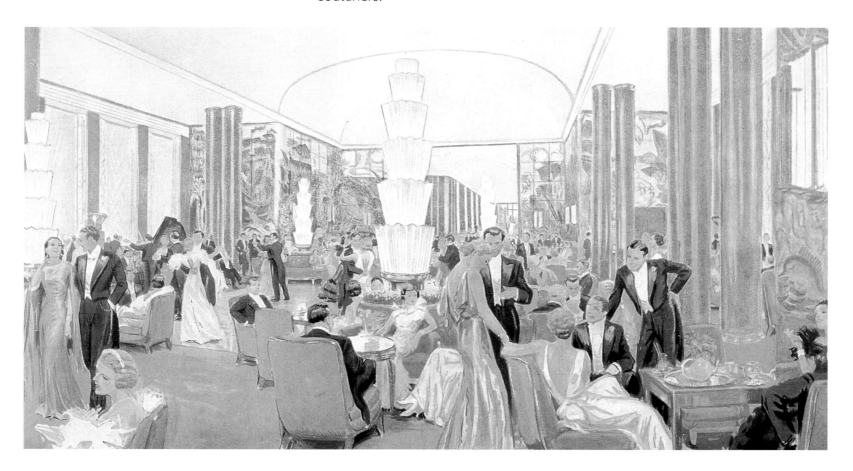

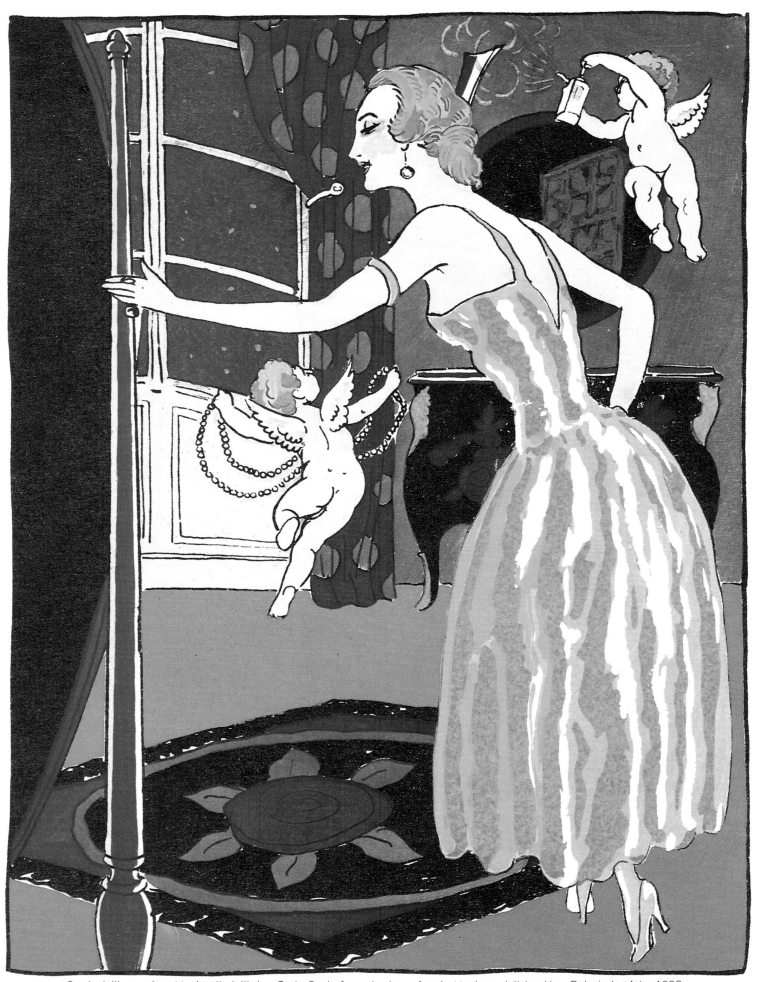

Pochoir illustration *Mado s'habille* by Carlo Bady from *La Journée de Mado*, published by Galerie Lutétia. 1932.

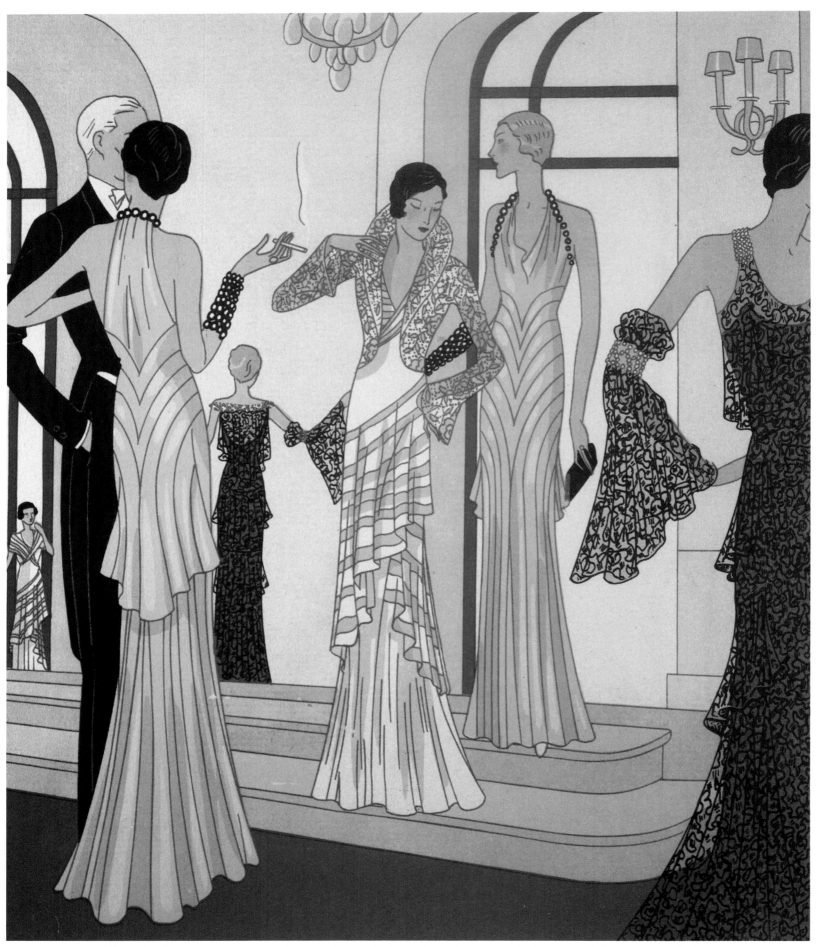

Offset litho fashion illustration by Maurice Renaud of French haute couture fashions, for *Art–Goût–Beauté*. 1932.

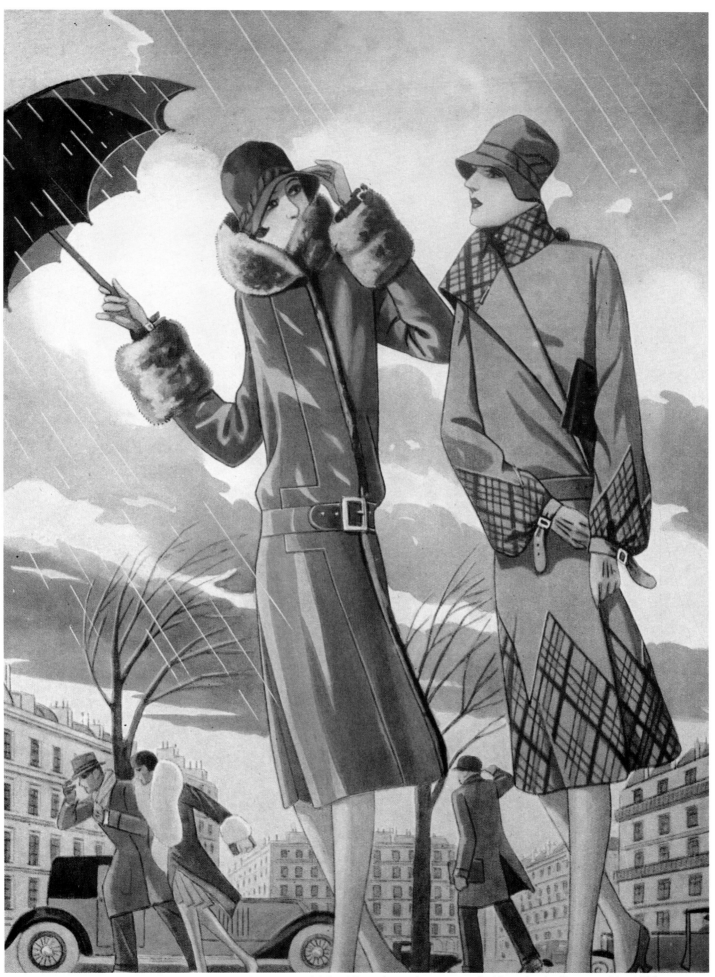

Offset litho fashion illustration by Charles Baldrich of French ready-to-wear fashion, for *La Femme chic*. 1929.

This form of sportswear was not particularly French in character since it was aimed more towards the English and American markets and was generally displayed on model girls from those countries, who had longer legs and broader shoulders than their French counterparts. In addition, these English and American models were from wealthy upper class backgrounds, which made what they wore and how they looked acceptable to most of the rich sporting fraternity who loved to play golf or tennis, to swim, ride horses, spend weeks yachting, skiing, climbing or hiking, or any one of a dozen other sports that were modish at that time. These couturiers also specialised in motoring garments and garments to be worn when flying between the major capitals of Europe or America.

The English and American girls also made suggestions about the line and fit of the garments they modelled. One couturier wrote in his autobiography that they 'helped to create the broader shouldered look of the late 1930s' and that they also insisted that their skirts be shortened 'to show their legs to advantage', thus helping to create the fashionable look of the late 1930s, when Elsa Schiaparelli, Jean Patou, Nina Ricci, Cristobal Balenciaga and Madeleine Vionnet were the most influential couturiers.

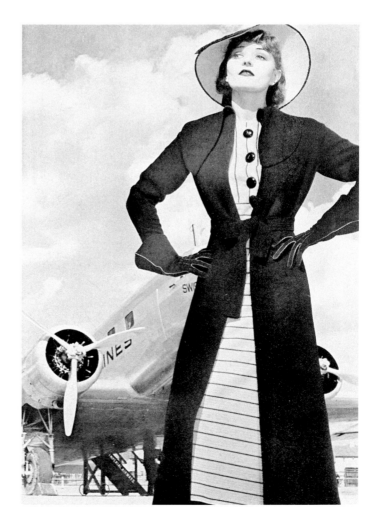

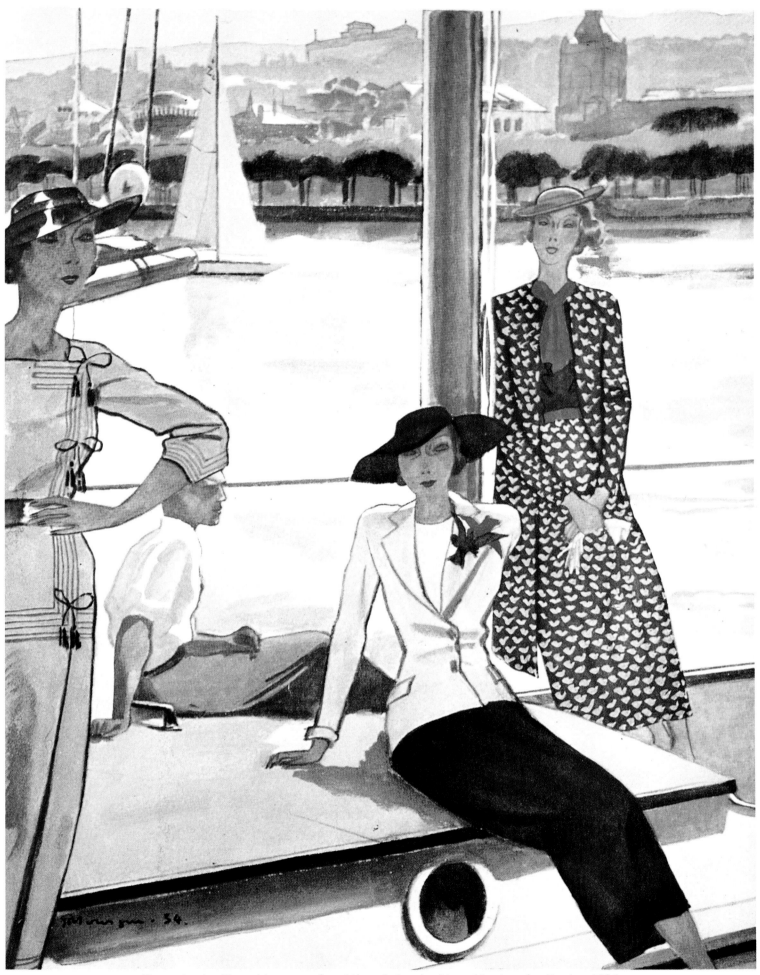

Illustration by Pierre Mourgue of yachting clothes by Marcel Rochas, for *Femina*. 1934.

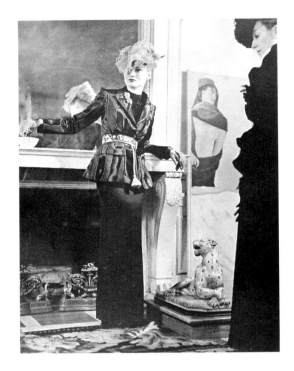

New developments in transportation during the 1930s gave rise to the streamlined mode of design and technological advance was reflected in the style known as New Modernism. In the world of painting and literature, Surrealism became fashionable. Television had also been introduced and there was much interest in interplanetary travel, magic rays and all kinds of scientific phenomena. Books on 'world travel' and 'the peoples of the world' abounded. All this affected not only the clothing styles people wore but also what they thought about these styles or about clothing in general.

As the 1930s drew to a close, women were being asked if they fancied having 'a long, smooth, stem-like torso', 'bosoms that were definitely bosom-shaped' and a 'ring-sized waist which could be achieved by modern magic'. But before most women of fashion could travel to Paris to purchase the new fashions the holocaust which had been threatening since Hitler's rise to power became a reality. War was declared on 3 September 1939.

For the next six years the clothing styles of the majority of people altered little. In Paris many couture houses continued to operate, even during the German occupation, but their styles were generally worn only by the German nouveau riche and wealthy members of neutral countries. Many women had donned uniforms, boiler suits or jumpers and shirts: they had decided that the time had come to work alongside the men in the armed forces and factories. It seemed as if the most feminine of their instincts had gone into hibernation. In their leisure time most women seemed content to just put on a little lipstick, to tuck their hair into a crocheted snood and to slip on a 'made over' blouse, a newly shortened skirt, thick stockings and sensible shoes. Fashion was never the same again.

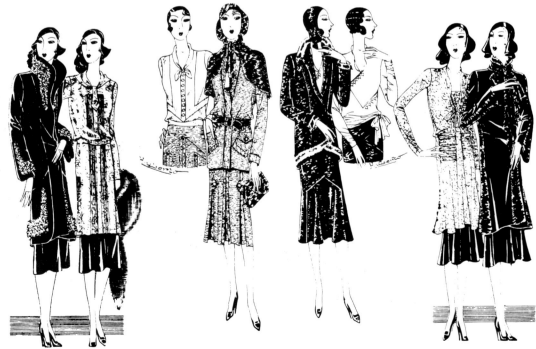

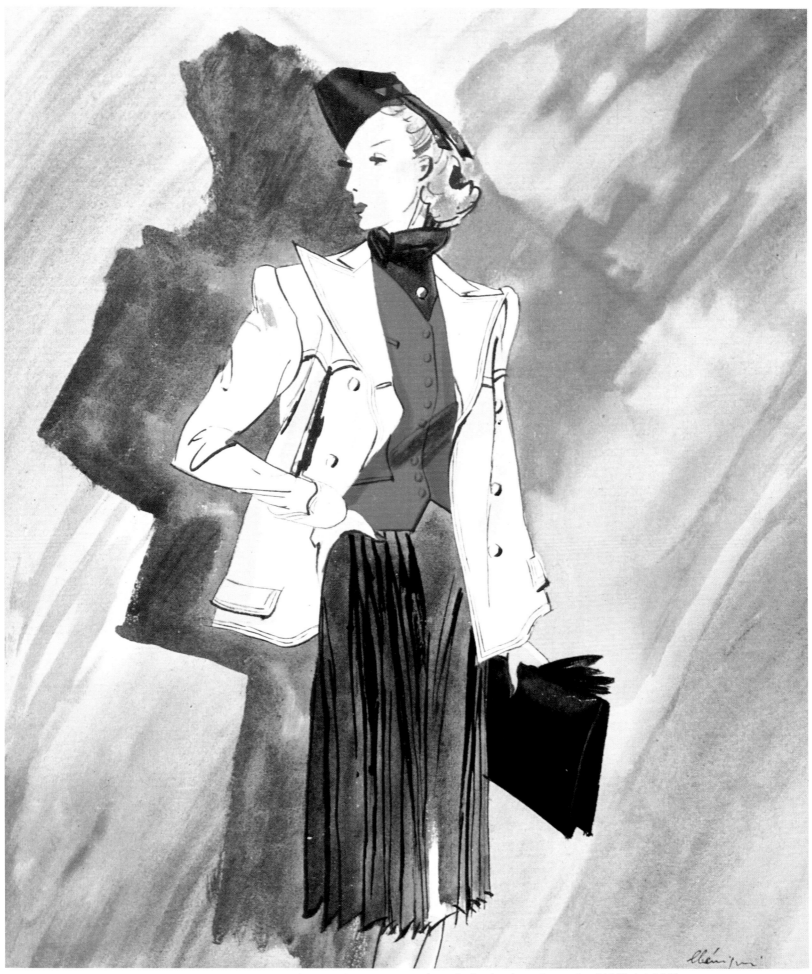

Illustration by Léon Benigni of a French couture wartime design by Jean Patou, for *L'Officiel*. 1941.

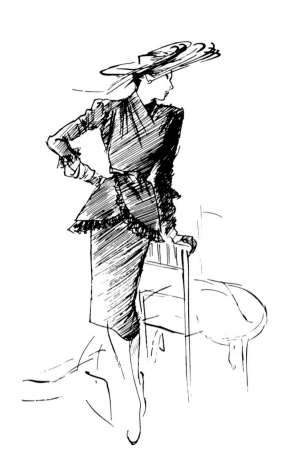

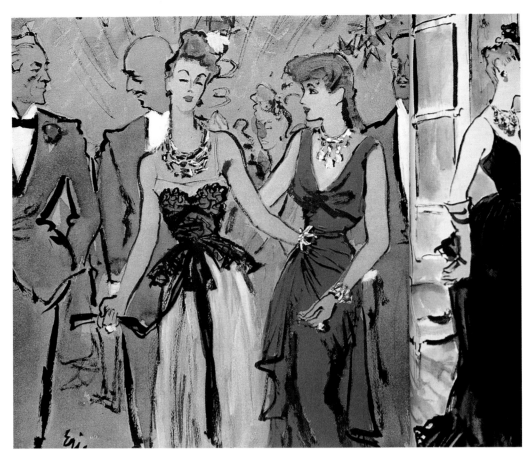

Illustration by Eric of American wartime fashions from Bergdorf Goodman, New York, for American *Vogue*. 1941.

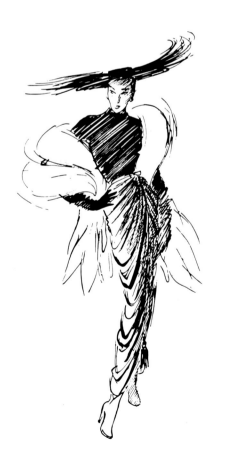

In 1946, released from the anguish, hardship and clothing regulations of the war, women began once again to take an interest in themselves. New clothing styles started to reach the headlines of local newspapers, and in the spring of 1947 Christian Dior launched his New Look, a style that was to totally revolutionise women's wardrobes throughout the entire Western world. Although these new styles were not as overtly sexual as those worn in the aftermath of World War I they nevertheless accentuated all of the wearer's most feminine character-istics, and with the contrivances of padding and tight lacing, women's breasts, waists and buttocks were once again the focus of fashion.

During the next ten years, until his death in October 1957, Christian Dior's designs dominated women's fashions, although the designs of Jacques Fath and Cristobal Balenciaga were also important. The young women in their new A-lines, H-lines, Y-lines, Tulip lines and Sack lines learnt that these fashionable styles, which simultaneously concealed and revealed their most alluring features, stimulated the interest of the males in their lives. It would seem from the cut and detail of these dresses that they were a deliberate invitation to imagine what lay beneath, just as those of the wearers' mothers had been in the 1930s. And, if one is to judge by the rapidity with which the new styles came and went, it would also seem that it was considered a crime for a woman to wear last year's styles.

In fact, most of the fashionable styles worn during this ten-year period admir-ably illustrate the conflicting desire that exists in the psyche of most women, between concealment and display. Each new fashion officially 'licensed' the dis-play of a previously hidden or neglected erogenous zone — the breast cleavage one season, the curve of the hips the next, a little more leg or a tighter waist the

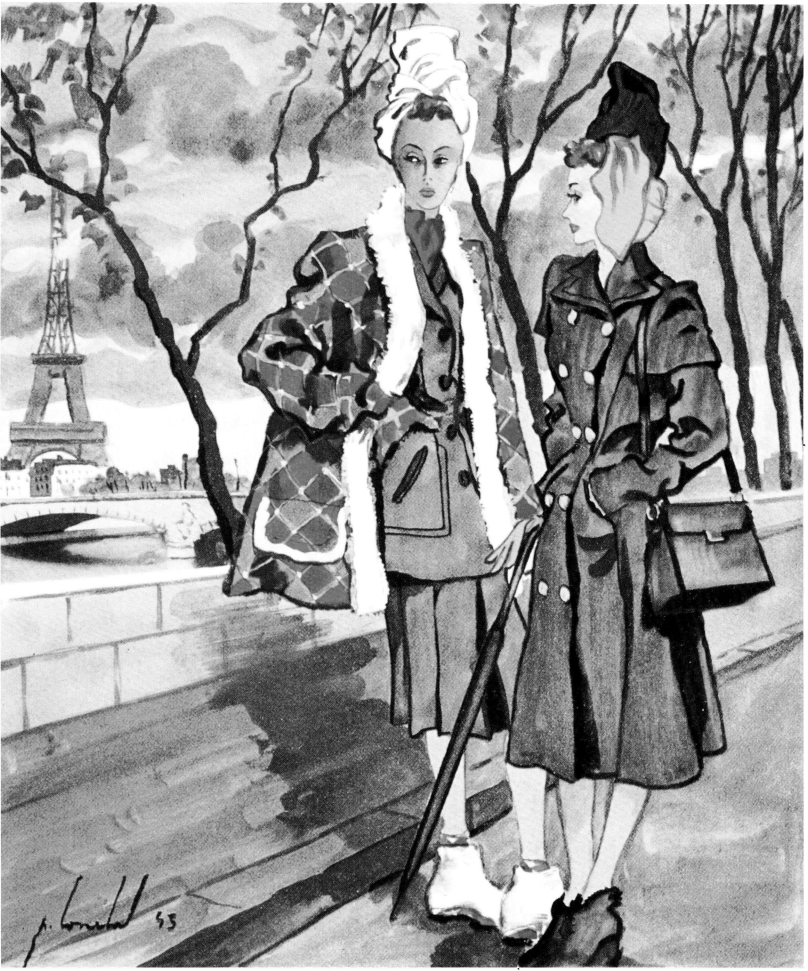

Magazine illustration by Pierre Louchel of French wartime fashions, for *La Femme chic*. 1943.

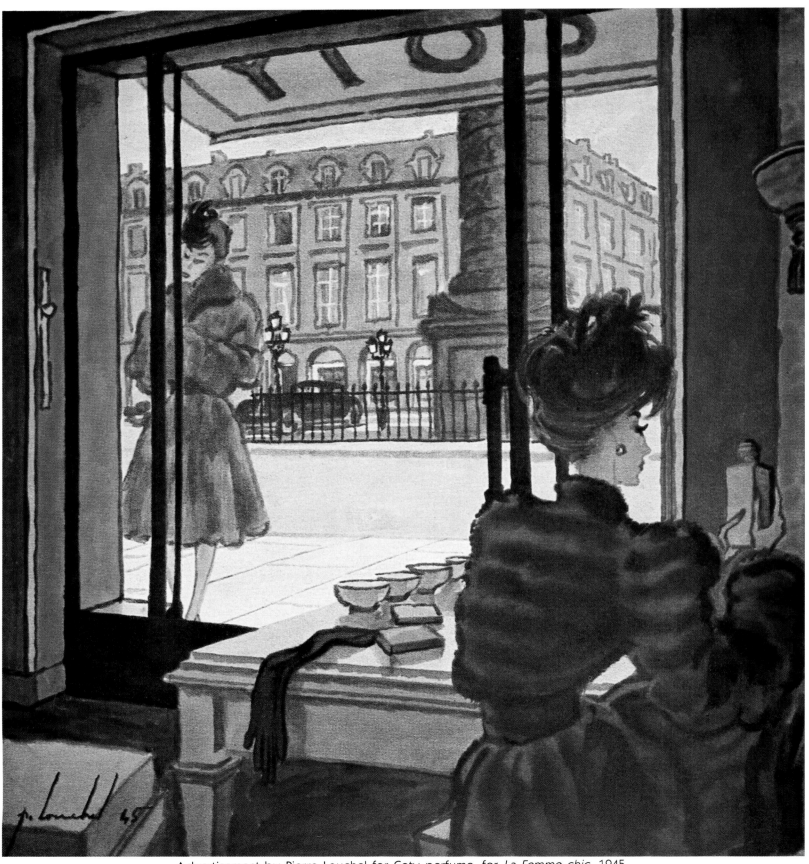

Advertisement by Pierre Louchel for Coty perfume, for *La Femme chic*. 1945.

next. Being adherents of a socially accepted fashion, women could openly display their female characteristics without any sense of shame. And, of course, these fashions were made more acceptable by the fear of being thought prudish or behind the times.

The fashionable styles worn by men were also beginning to change. Most still preferred to indicate through their clothing styles that they were reliable bread-winners and therefore tended to wear the plain, almost uniform-style suit that was perceived as in keeping with the prevailing commercial and industrial ideals. After 1955, however, Teddy Boys, Mods and Rockers, and Skinheads became headline news and the styles of dress worn by idols such as James Dean, Elvis Presley, the Beatles and Marlon Brando became widely worn. They preferred long, pointed 'winkle- pickers' or crepe-soled 'brothel creepers' to the traditional lace-up shoes of their conservative fathers. Their jackets were longer and more squarely cut than were the jackets their fathers wore, and they made a feature of contrasting velvet collars and cuffs. Their trousers were also much narrower and made without turned-up cuffs. They liked to wear their hair long. Others adopted James Dean-style jeans, the casual shirts and denim jackets favoured by Elvis Presley, or the T-shirt and leather motorcycle jacket made popular by Marlon Brando.

By the mid-1960s television was beginning to exert its powerful influence on fashion, as were the pop groups of the period and the young designers of Swinging London. International air travel was easier and cheaper than ever before. Censorship laws had been relaxed. The children born during the baby boom of 1945–46 were young adults with a plentiful supply of money to spend on their clothing styles. And they had decided to visibly and clearly select their own mode of dress based on a variation of the sexual attraction game for which they wrote the rules and which excluded all those who did not like or did not understand the new way of dressing. This attitude continues today, with each new generation inventing its own in-rules and variations with the object of excluding all others.

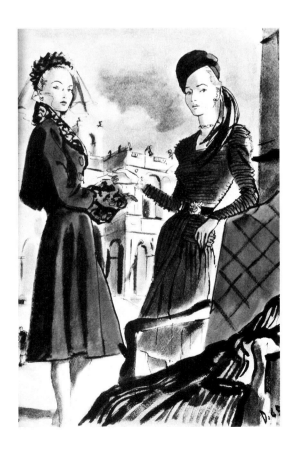

CREATING THE ILLUSTRATIONS

*E*ver since the first women's magazines were published in the mid-eighteenth century, the latest fashion ideas have been promoted throughout the Western world by means of pictorial images — simple woodcuts, hand-coloured copperplate engravings, aquatints, lithographs, elaborate *pochoir* prints, or monotone and coloured photographs. The first women's magazine to regularly include such illustrations was *The Lady's Magazine*, which commenced publication in London in the early 1760s, although prior to this there had been numerous trade-type publications that included the occasional fashion illustration for a particular promotion.

A number of books about various aspects of costume and dress had also been published, among them Abraham de Bruyn's *Omnium Poene Gentium* published in 1577, Dicesare Vecellio's *Habiti Antichi et Moderni di Tutto il Mondo* published in 1590, and Alexandro Fabri's *Diversarum Nationum Ornatus* published in 1593. These books and the various trade publications were, however, limited in their appeal and distribution, whilst those published after 1760, such as *The Lady's Magazine* and its many competitors, were specifically intended for a wider and more general readership among the newly rich who were avidly seeking guidance in the matter of fashionable dress.

The earliest of the fashion illustrations to appear in *The Lady's Magazine* were simple copperplate engravings accompanied by a brief description of the colour and fabric; by the early 1770s, however, these illustrations were regularly being hand-coloured and, although often rather crudely detailed, they must have done much to bring the provincial fashions of the British Isles into line with those of London. By the late 1770s France, Germany, Holland and other European countries were producing their own monthly fashion magazines and within a few years the illustrations featured in the German *Journal der Luxus und dei Moden* and the French *Cabinet des modes ou les modes nouvelles* and its successor the *Magasin des modes nouvelles françaises et anglaises* were far superior to those of *The Lady's Magazine*. Copies of these rival publications were regularly imported for sale in London and other large British cities.

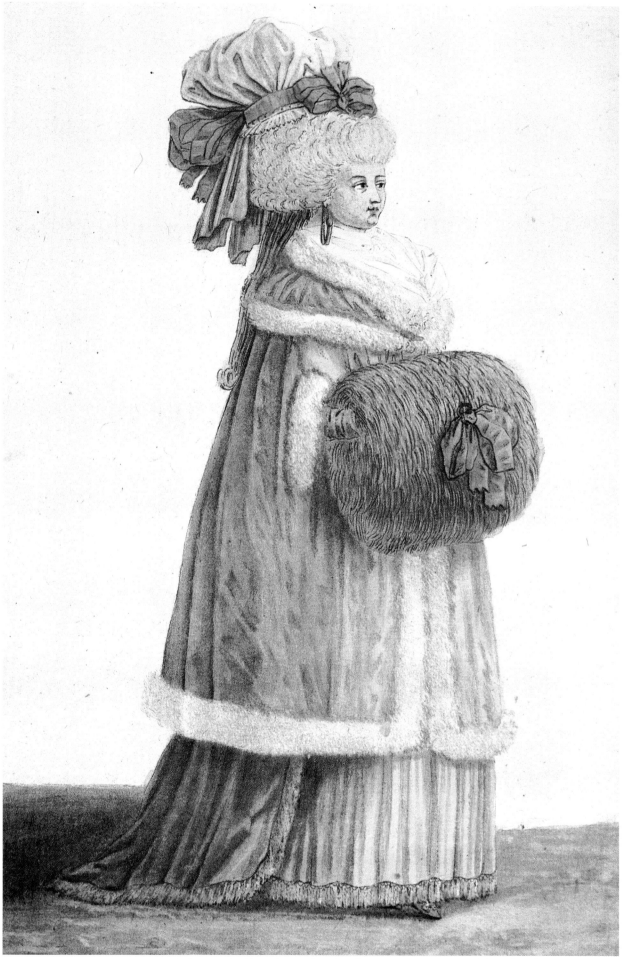

Hand-coloured engraving of French pre-revolutionary fashions by N. Dupin after Pierre-Thomas Le Clèrc, for *Costumes civils actuels de tous les peuples connus*. 1788.

Hand-coloured engraving of fashionable men's wigs by Jacques Esnaut after François-Louis-Joseph Watteau, for *Le Cabinet des modes ou les modes nouvelles*. 1785.

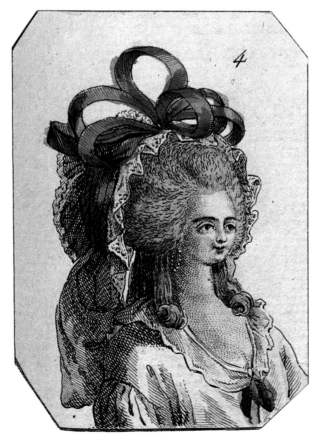

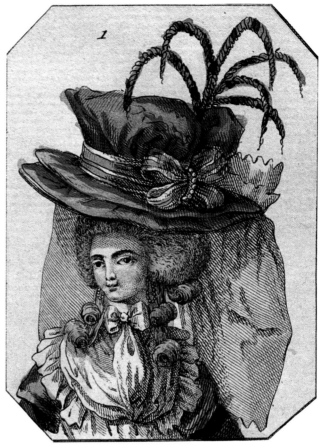

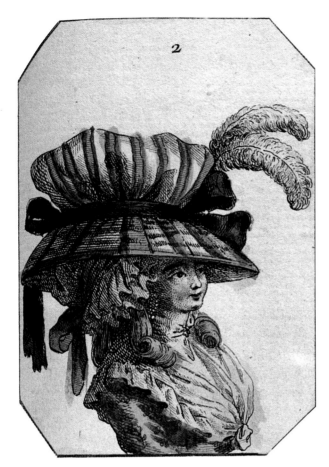

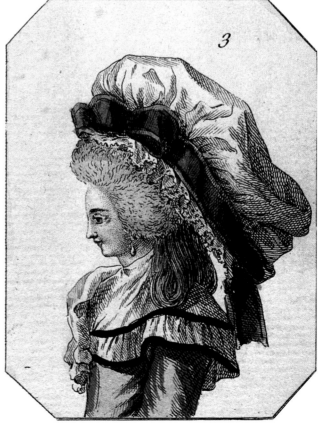

Hand-coloured engraving of French pre-revolutionary hats by Jacques Esnaut after François-Louis-Joseph Watteau from designs by Rose Bertin, for *Le Cabinet des modes ou les modes nouvelles.* 1786.

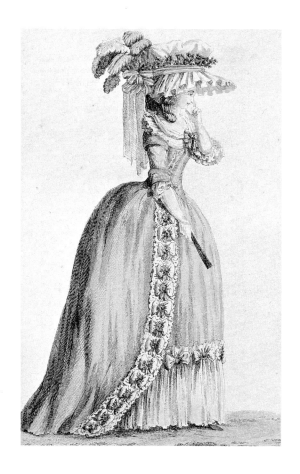

In addition to hand-coloured copperplate engravings of the latest women's fashions, the German and French publications included fashion plates of both men's and children's wear, new styles in furniture and interior schemes, new coaches and other items of fashionable interest. Many of these illustrations were specially commissioned from the leading artists of the period — Claude-Louis Desrais, Pierre-Thomas Le Clèrc, François-Louis-Joseph Watteau, Horace Vernet — in order to depict in an attractive manner the latest fashionable trends without necessarily giving the exact seam placement and design details. The seam placement and design detailing was, however, the stated aim of the growing number of British publications, which for reasons of cost tended to use only the depictive skills of an engraver rather than those of a pictorial artist. This provision of detail must have been a great advantage to the dressmakers of the period, but the haut monde preferred the European publications that captured 'the mood and ambience of each new style': they were not interested in how the style was made or the sewing method used for the decorative details. This philosophical difference was to bedevil many subsequent British fashion publications and it was the reason why many of them eventually began purchasing Paris-made fashion plates for inclusion in their monthly issues.

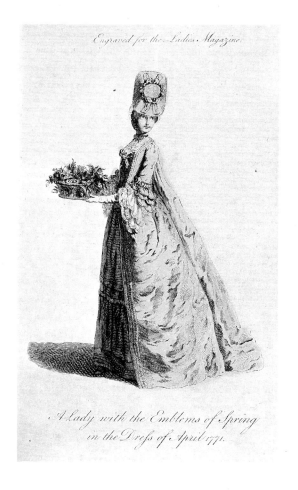

Engraved for the Ladies Magazine

A Lady with the Emblems of Spring in the Dress of April 1771.

This latter part of the eighteenth century was a time of great civil strife and dramatic social change. Changes in clothing styles come about not only because designers' ideas change but also, and more importantly, because society itself changes. Fashion changes are in fact the most conspicuous of the social mechanisms through which we hope to alter ourselves and our way of life. We think that by wearing a different style of dress we will become different people, closer to the ideal we have formulated in our dreams. Many social commentators note with surprise that our bodies actually seem to change in response to changing times and changing dreams.

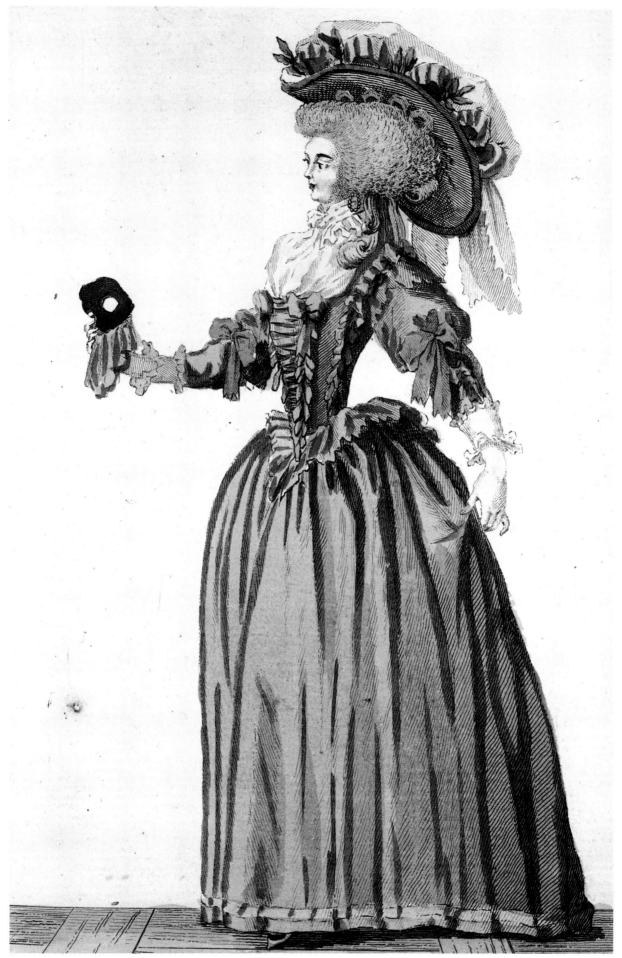

Hand-coloured engraving of a fashionable French dress and mask by Jacques Esnaut after Claude-Louis Desrais, for the *Magasin des modes nouvelles françaises et anglaises.* 1787.

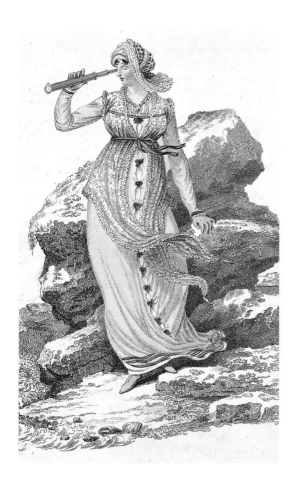

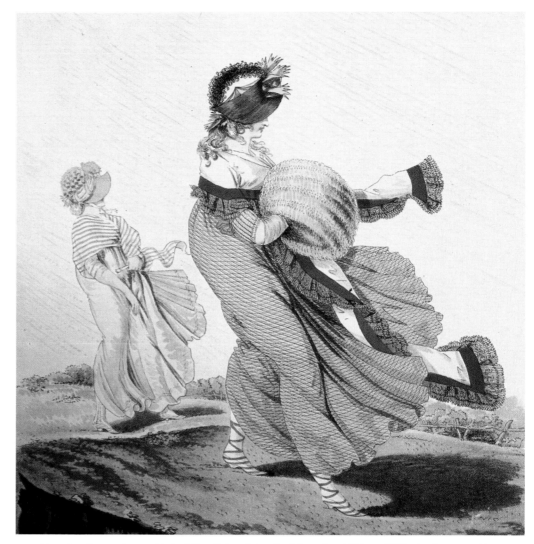

Hand-coloured aquatint of English winter fashions by Niklaus Wilhelm Innocentius von Heideloff, for his *Gallery of Fashion*. 1796.

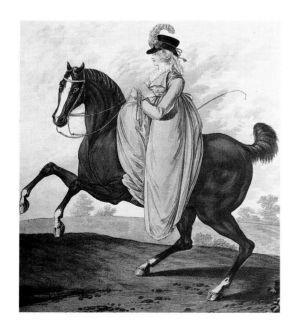

It is the elusive ability to change and to portray a glimpse of the future, and at the same time to make each design visually appealing, that marks out a talented illustrator: no matter how idiosyncratic an illustrator's style may be, he or she must capture the spirit of each new design, rather than its surface detail and seam placements. Although some of the resulting images may appear a little strange or even incongruous by today's standards, they are nevertheless an individual artist's attempt to capture the actual mood and ambience of each new style.

Artists such as Desrais, Le Clèrc and Watteau were responsible for many of the delightful illustrations featured in the *Cabinet des modes ou les modes nouvelles*; Niklaus Wilhelm Innocentius von Heideloff and several court dress-makers, among them Rose Bertin, were responsible for the illustrations in *Roman Gallery of Fashion*. Arthur William Devis, Thomas Stothard, Horace Vernet and several others worked under publishers such as Pierre La Mésangère, Rudolph Ackermann, John Bell, and Vernor & Hood to illustrate *Le Journal des dames et des modes*, *The Repository of Arts, Literature, Commerce, Fashion & Politics*, *La Belle Assemblée* and *The Lady's Monthly Museum*, all of which were published during the 1790s or early 1800s. Illustrators such as these acted as visual mediators in this intriguing and often turbulent period. George Barbier, Charles Martin, Paul Iribe, Marthe Romme and Georges Lepape, under the guiding hands of Lucien

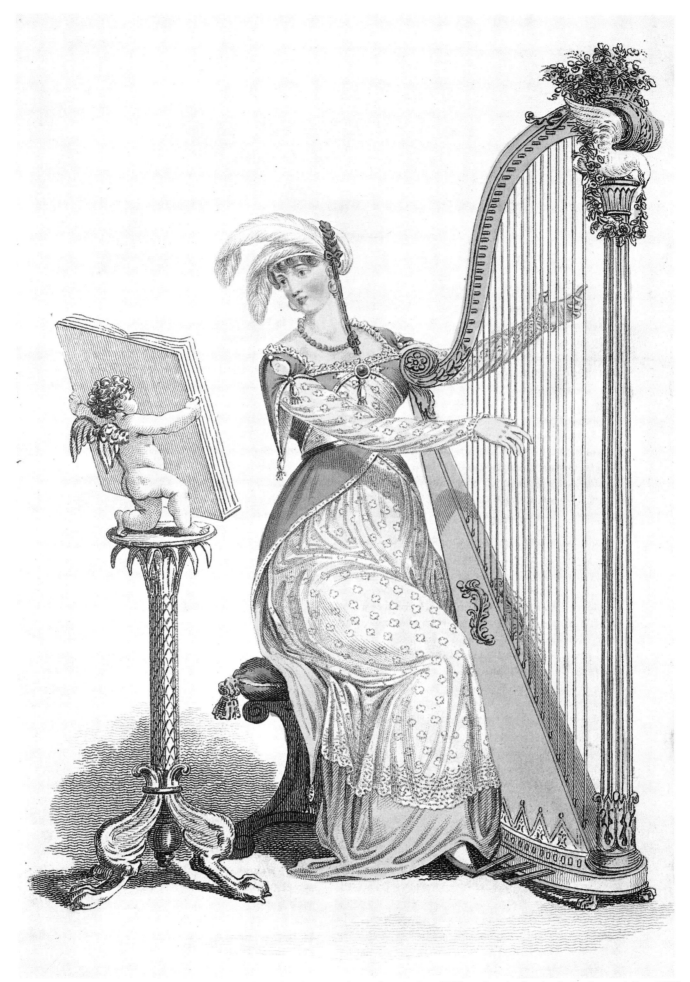

Hand-coloured etching of an English music dress by James Mitan after Arthur William Devis, for *La Belle Assemblée*. 1809.

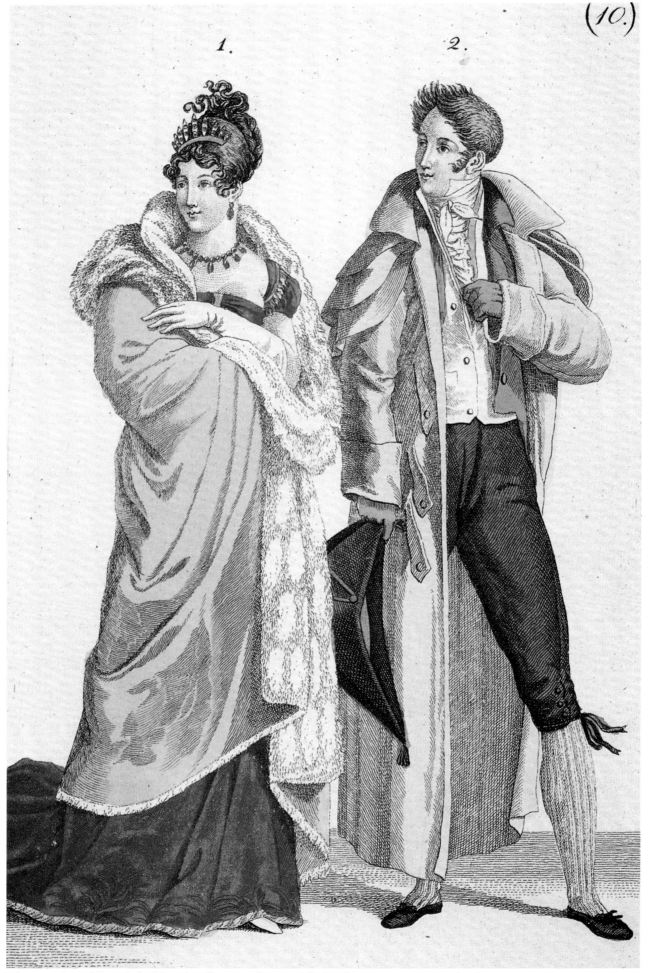

(10.)

1. 2.

Hand-coloured engraving of French fashions by Georges-Jacques Gatin after Horace Vernet, for *Le Journal des dames et des modes*. 1812.

Vogel and Umberto Brunelleschi, performed the same task early in the twentieth century, during another period of civil strife and dramatic social change.

It is the artistry and inventiveness of the images that make the fashions of these two periods unique: fashion and fashion illustration combined as art forms to reach their peak of creativity. The illustrations preserve the creative verve of these two distinctive eras, capture it for later generations to admire — and they help us to understand more fully the social and economic changes that were taking place.

The majority of the fashion illustrations of the late eighteenth and early nineteenth centuries were printed from skilfully made copperplate line engravings, the colours being individually added by a team of experienced workers who accurately copied the artist's original drawing. The craftsman who prepared the copperplate also followed the artist's original drawing, but in reverse, so that when printed each line and detail would be exactly as originally intended. To do this, the craftsman divided the original drawing into small squares and lightly marked a corresponding pattern onto the surface of a section of polished copper. The squares on the copperplate were drawn slightly smaller if the original drawing needed to be reduced for publication.

The outline and various details of the artist's original illustration were then accurately drawn in reverse using the grid of squares as a guide. These lines and details were engraved onto the surface of the copperplate by using a 'burin', a special engraving tool made from a short section of tempered steel, lozenge-shaped or square in section, with the actual cutting edge being at an angle. This cutting tool is set into a small wooden handle that is shaped to comfortably fit into the palm of the engraver's hand. When the engraving is in process the cutting edge of the burin is pushed along the surface of the copperplate at a slight angle, so that it bites into the metal but does not dig in too deeply. By lifting or depressing the angle of the cutting edge the engraver can make thick or fine lines, which greatly affect the finished look of the illustration.

During the process of cutting, burred edges often formed along the lines and details: these imperfections were usually removed with a small wooden scraper and then burnished with a curved steel burnishing tool. Occasionally, though, the burred edges were left in parts of the illustration, to give an added richness and depth and a slight three-dimensional effect to the final print.

Hand-coloured etching by Pierre Martinet of French indoor fashions, for *L'Observateur des modes*. 1823.

Hand-coloured aquatint of English archery dresses by an unknown artist, for George B. Whittaker's *La Belle Assemblée & Record of the Beau-Monde*. 1831.

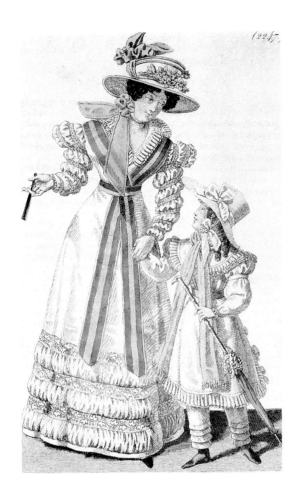

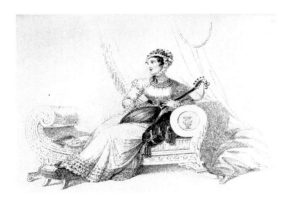

When the engraving was complete some printing ink was rubbed into the engraved lines of the printing plate to check for accuracy. Any necessary adjustments were made and the final shading added to the illustration by diagonal cross-hatching; that is, by cutting a series of fine parallel lines diagonally across the area or detail to be shaded and then cutting a similar series of fine lines diagonally or at right angles to these — the closer the lines the darker the eventual shading. Another method of shading used was to cover the surface of the printing plate with a series of very small dots, the greater the number of dots in a particular area the darker the eventual effect. Occasionally, when very fine lines were required, the line was cut with a series of dots; when the fold of a fabric was to be portrayed, a series of finely cut parallel lines or a mixture of parallel lines and dots was used. Finally, the finished plate was cleaned and boiled in caustic soda before a trial print was made.

Although the skill of the engraver was obviously of the utmost importance, that skill was not of itself capable of producing an aesthetically pleasing print. The engraver generally had little to say in an artistic sense, and it is the successful combination of his or her skill and the imagination of the original artist that is the hallmark of a good print. This is, of course, a most difficult achievement, and lesser artists and craftsmen were only too ready, as William Blake pointed out when discussing the art of the printmaker, to 'cover up [their] lack of talent with superfluous and often meaningless detail'. Ruskin commented on the same subject:

> To engrave well is to ornament a surface well, not to create a realistic impression . . . The object of the engraver is, or ought to be, to endow the surface of the engraved metal printing plate with lovely lines, forming an interesting pattern and including a variety of spaces delicious to the eye.

Fortunately, the very best fashion magazines of the period 1785 to 1810 — John Bell's *La Belle Assemblée*, Pierre La Mésangère's *Journal des dames*, Heideloff's *Gallery of Fashion* and Ackermann's *Repository of Arts* — employed not only many of the best pictorial artists but also many of the best engravers, among them Duhamel, Georges-Jacques Gatin, James Mitan and Philippe-Louis Debucourt. The initials or signature of these men on the bottom of an illustration, along with those of the original artist, add considerably to the illustration's value.

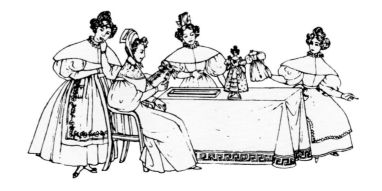

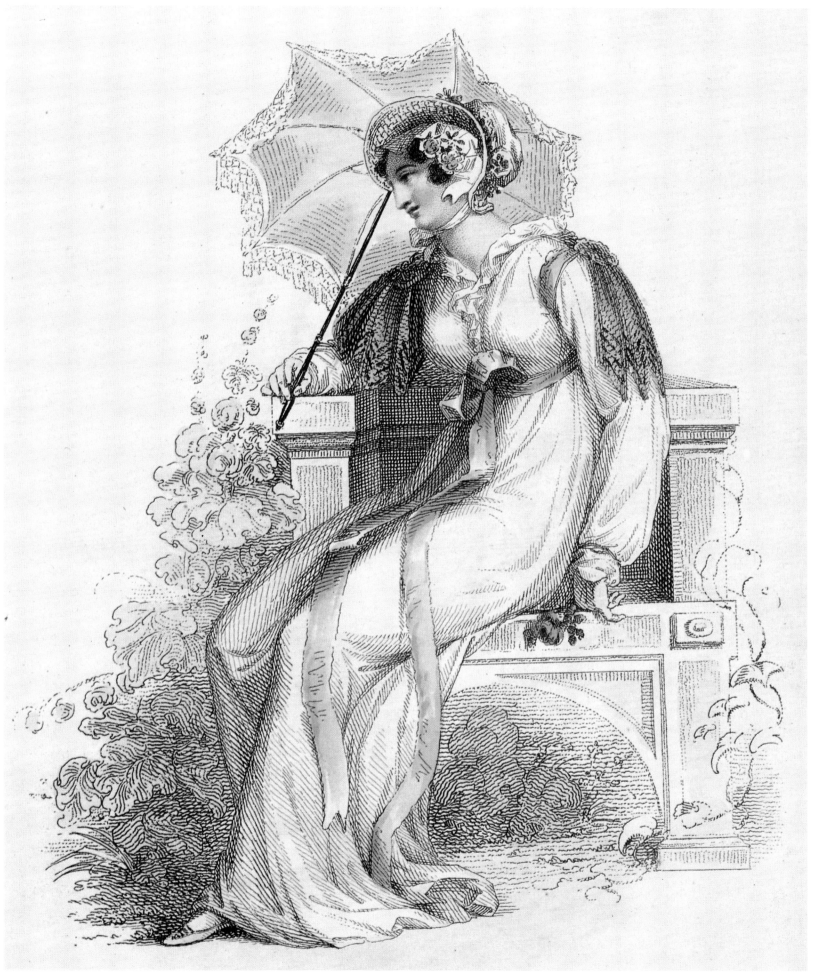

Hand-coloured etching of an English walking dress by an unknown artist, for Rudolph Ackermann's *Repository of Arts*. 1812.

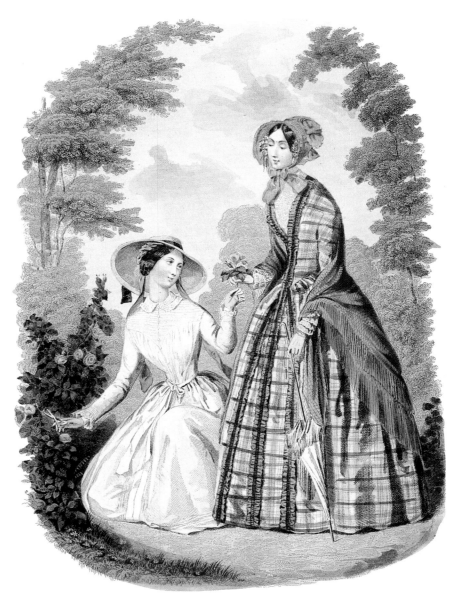

Hand-coloured steel engraving of French fashions by J. Desjardins after Adèle Anaïs
Toudouze, for *Le Magasin de demoiselles*. 1848.

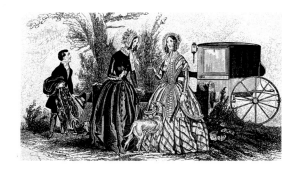

Occasionally magazine proprietors also commissioned etchings and aquatints to illustrate particular fashions, since these have a softer visual appeal than illustrations printed from an engraved plate and they also added variety to the publication. The technique of etching differs from that of engraving, although when completed the finished illustrations are printed and coloured in exactly the same way. For an etching, the copperplate is first coated with an acid-resistant substance. The illustration is drawn in reverse on this surface, but instead of the surface of the copperplate being engraved with a burin, the design lines and details are scratched through the acid-resistant surface so that when acid is applied to that surface it attacks the exposed metal and etches the lines and details required. The tool used to scratch through the acid-resistant surface of the copper printing plate is called an 'echoppe'; it is made from a short oval piece of highly tempered steel which is bevelled so as to give it a fine oval-shaped point that produces thin or thick lines when turned. The strength of the acid and the time for which it is used greatly affect the finished product: stronger acid and a longer etching time give a much darker effect than does weak acid and a short etching time; the best etchings combine these variations.

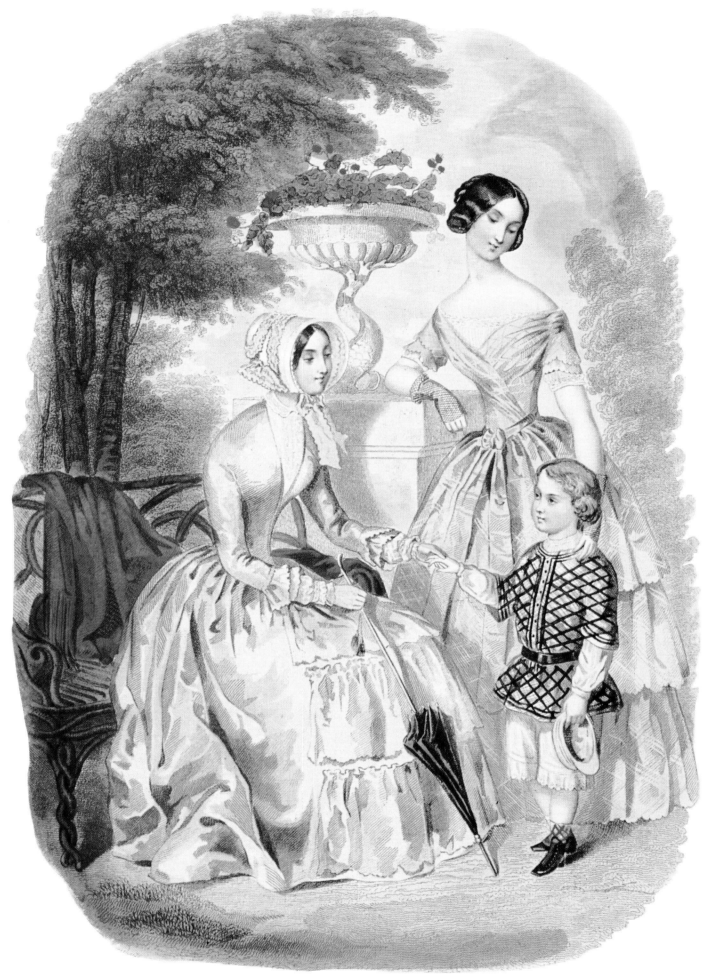

Hand-coloured steel engraving of French walking dresses by J. Desjardins after Adèle Anaïs Toudouze, for *Le Magasin des demoiselles*. 1848.

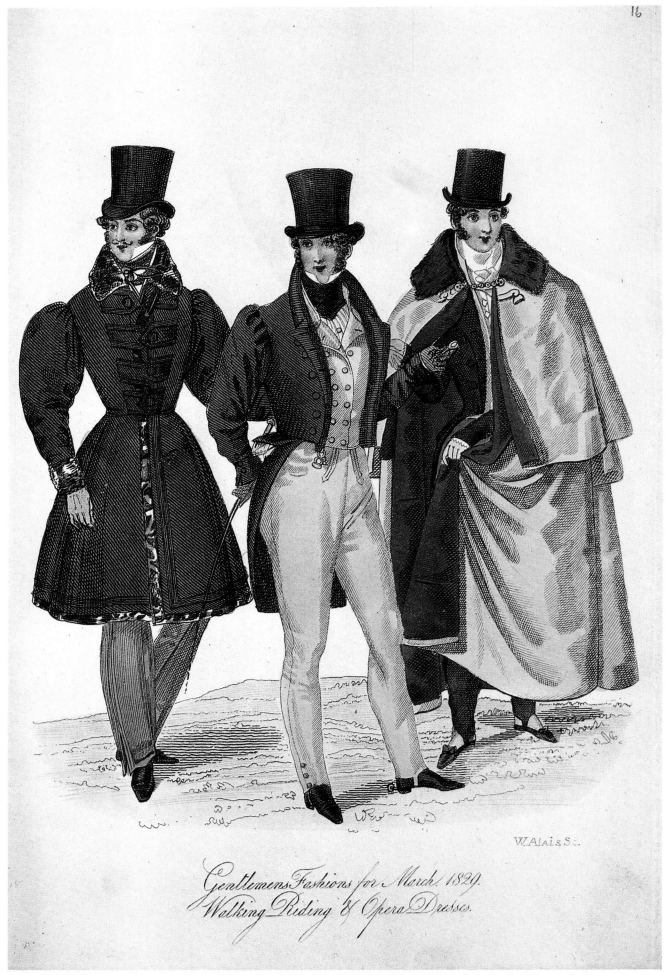

Gentlemens Fashions for March 1829.
Walking Riding & Opera Dresses.

W. Alais Sc.

Hand-coloured engraving of English men's fashions by William Wolfe Alais after Henry Ridley, for the *Gentleman's Magazine of Fashion*. 1829.

25 Juillet 1837.

1369.

Hand-coloured engraving of a satin corset by Barreau after Mlle Florensa de Closménil, for *Le Petit Courrier des dames*. 1837.

An aquatint, on the other hand, is a purely tonal process involving the use of aqua fortis (concentrated nitric acid) in varying strengths to eat into particular areas of an illustration, producing a range of tones but not generally specific lines or details. When making an aquatint, the copper printing plate is first covered with a porous substance of even texture, fine or coarse according to the effect required. The areas that are to remain white are blocked out with varnish and the plate is then etched for the first time by submerging it in acid until the lightest tonal effect is obtained. This process is repeated many times by using varnish to block out some of the previously etched areas and again submerging the printing plate in acid. The length of exposure to the acid at each stage determines the depth of each tone. These three basic methods — engraving, etching and aquatinting — were combined in some prints. Other prints were made from variations to the procedures; for example, the printing methods known as mezzo, stipple and intaglio.

The actual printing from the finished plate was the same for all methods. After the printing plate had been prepared, printing ink was applied to the surface of the plate. Then the plate was rubbed clean so that the only ink remaining was that held in the engraved or etched areas. The paper to be printed was placed on the surface of the plate and together these two were put in a hand-operated printing press, the pressure forcing the paper into the etched, engraved or tonal areas to absorb the ink. A clear and precise image was the result. Each copy of each illustration was individually printed in this way before being coloured by hand. Fashion illustrations printed in this way can be easily recognised by the indentation of the printing plate around the outside edge of each print.

As the nineteenth century progressed demand grew for larger and more ornate fashion illustrations, with some eventually involving over twenty grouped figures plus architectural features and furniture. Larger print runs than were possible by the hand-printing method, which usually kept below 5000 copies, were also required. Print runs of up to 100 000 became quite common. These large runs were usually printed in Paris and exported to many parts of the world for use in locally published magazines, which by 1860 were making a feature of including 'the very latest Parisian fashions'.

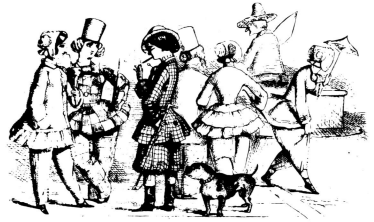

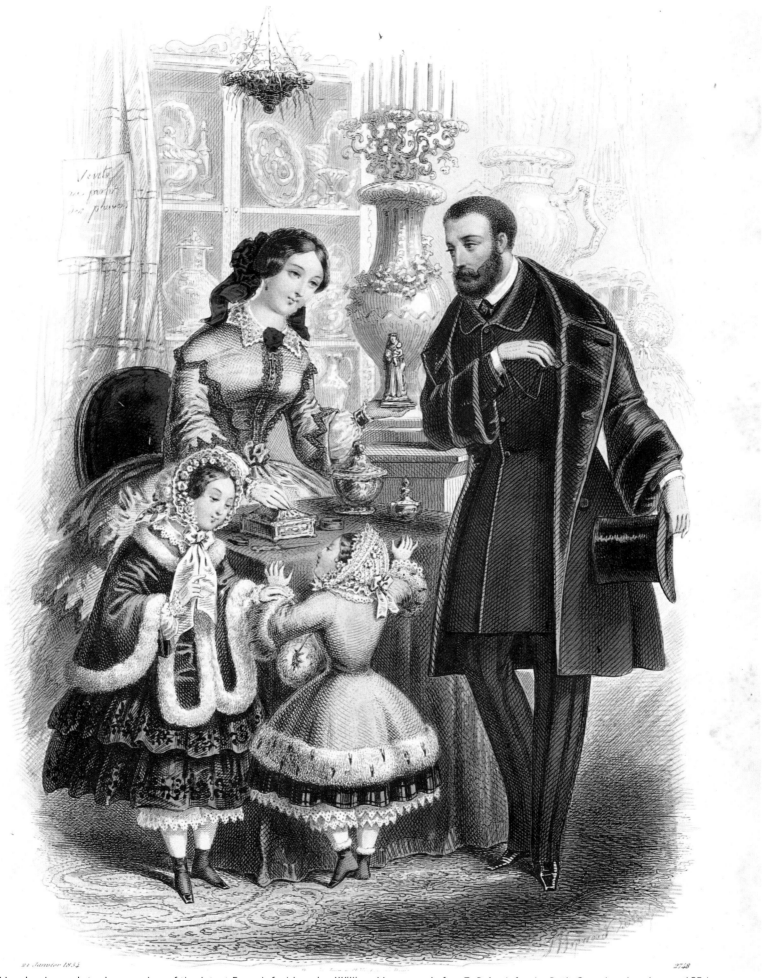

Hand-coloured steel engraving of the latest French fashions by William Hopwood after E. Préval, for *Le Petit Courrier des dames*. 1854.

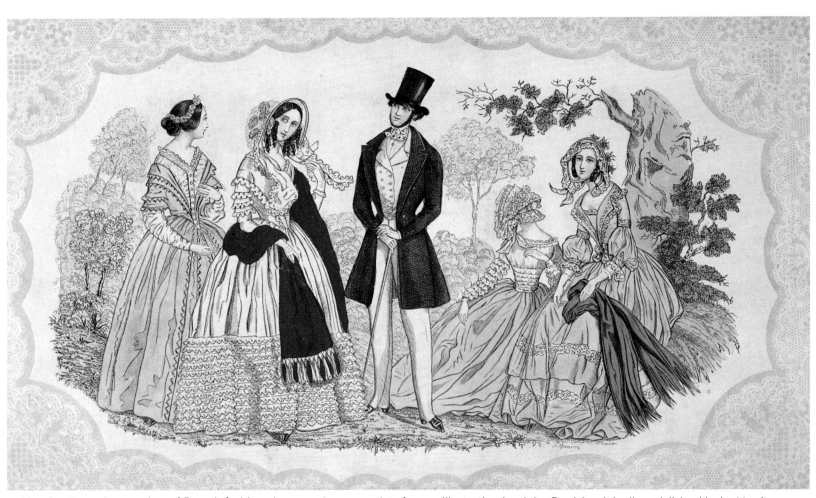

Hand-coloured engraving of French fashions by an unknown artist after an illustration by Jules David, originally published in *Le Moniteur de la mode. Graham's Magazine* (Philadelphia). 1843.

For such large runs mechanised printing presses were used, the engraving being made on cylindrical revolving steel plates. This brought about a decline in the quality of most illustrations, although those designed by Jules David, A. de Taverne, Adèle Anaïs Toudouze and A.M. Adams are better than most. The quality of the hand-colouring of these prints also deteriorated. Those of 1840 to 1890 were coloured by a team of up to sixteen young children aged between five and ten years. The children were seated at a long trestle table, with the 50 000 or more copies of each fashion plate placed at one end. A printed fashion plate was passed down the table, each child applying one colour to one area only before handing it on for the next colour to be added. By the time it reached the end of the table the fashion plate was fully coloured. A crude form of stamped-on lino-cut or stencil colouring was also used for more complicated areas and sometimes the final colour was added by the *pochoir* method, an illustrative technique that reached its height of excellence during the Art Deco period.

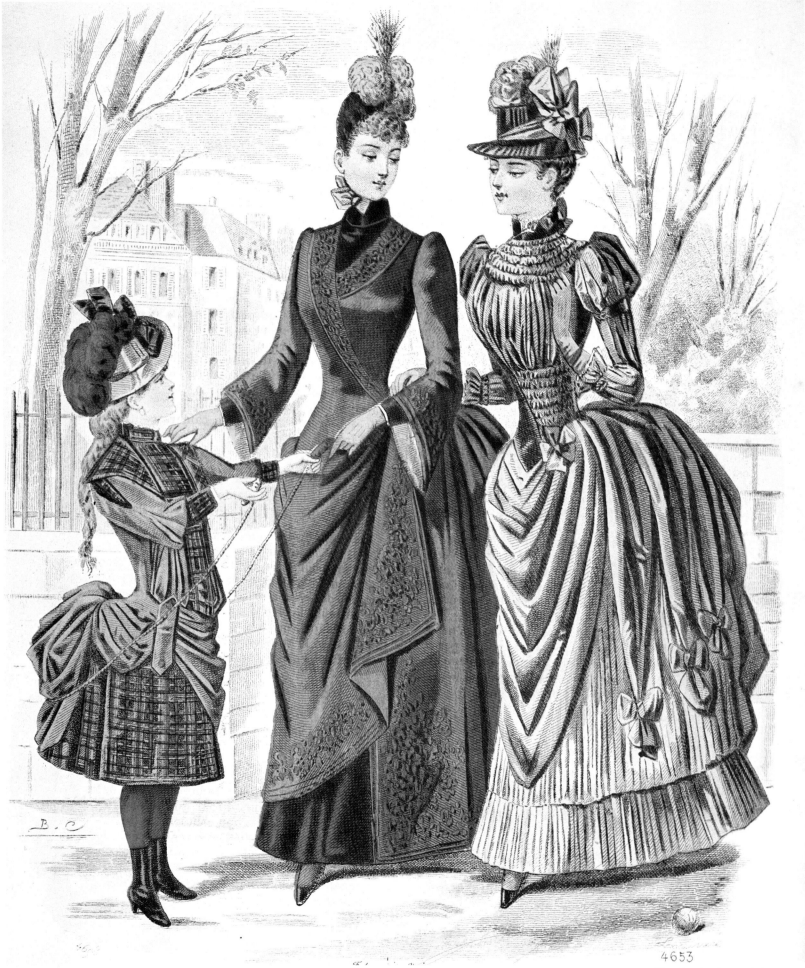

Hand-coloured steel engraving of the re-emerging bustle dresses of the mid-1880s by Bodin et Carrache after A. Chaillot, for *Le Journal des demoiselles*. 1885.

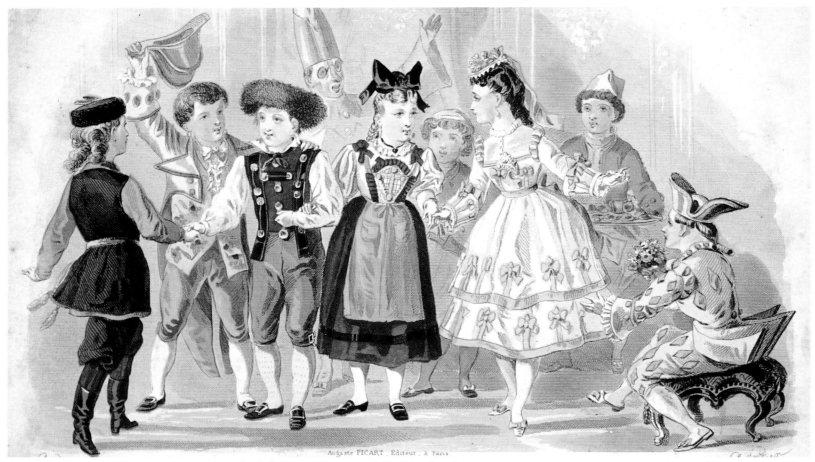

Hand-coloured engraving of children's party clothes by A. Portier after A. M. Adams, for *Les Modes de l'enfance*. 1873.

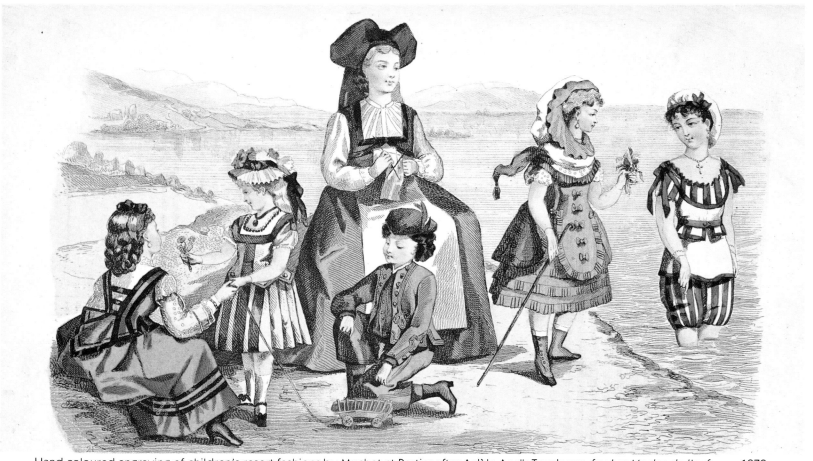

Hand-coloured engraving of children's resort fashions by Muchot et Portier after Adèle Anaïs Toudouze, for *Les Modes de l'enfance*. 1872.

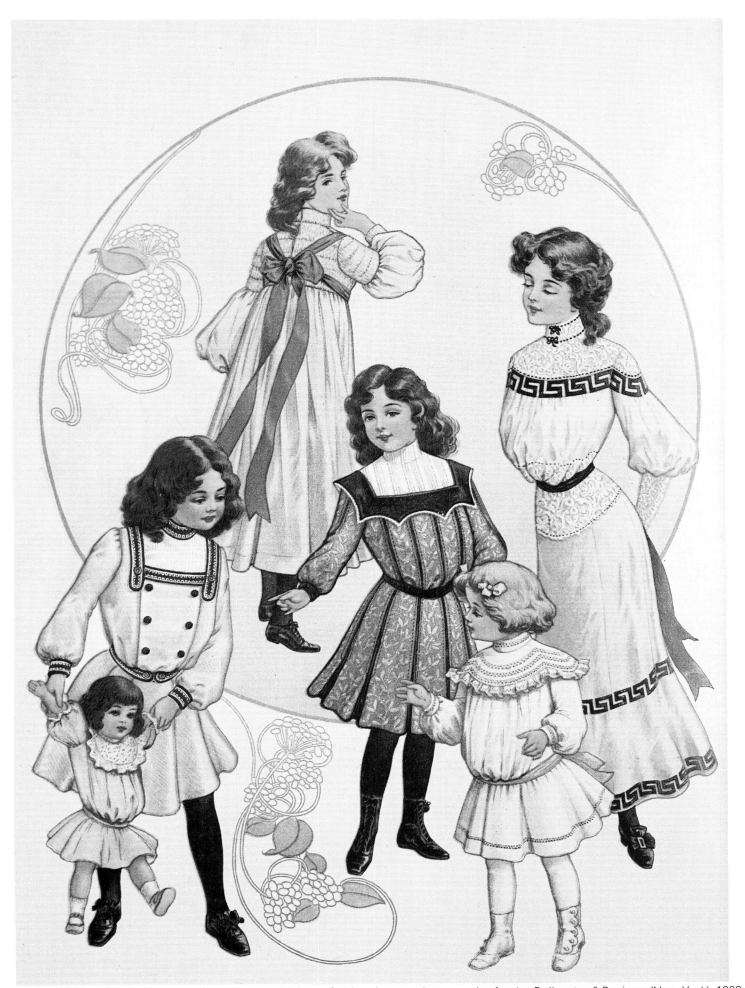

Chromo-litho illustration of American ready-to-wear children's fashions by an unknown artist, for the *Delineator & Designer* (New York). 1902.

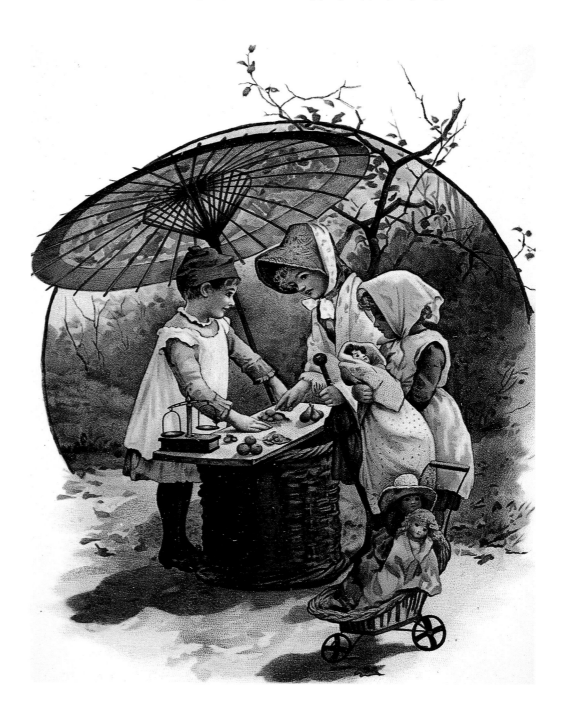

As the nineteenth century progressed the demand for these illustrated magazines continued to increase. More and more titles were produced, there was keen competition among publishers for the new trade, and the price of each issue began to fall. When it was first published in April 1794 von Heideloff's *Gallery of Fashion* cost seven shillings and sixpence per copy, or four guineas for twelve issues by subscription; the print run was between 250 and 500 monthly copies. At the back of each twelfth issue a list of new subscribers was published. The publication obviously had wide appeal: important personnages in Venice, Madrid, St Petersburg, Dresden, Moscow, New York, Philadelphia, and Stockholm regularly purchased copies during the magazine's nine years of publication.

In 1860, however, fashion magazines such as the *Englishwoman's Domestic Magazine* were selling for only one shilling per copy, or ten shillings and sixpence for a yearly subscription, and it has been estimated that over 50 000 copies of this magazine were sold each month. There were at least twenty rival fashion magazines on sale at the time, some costing as little as sixpence an issue.

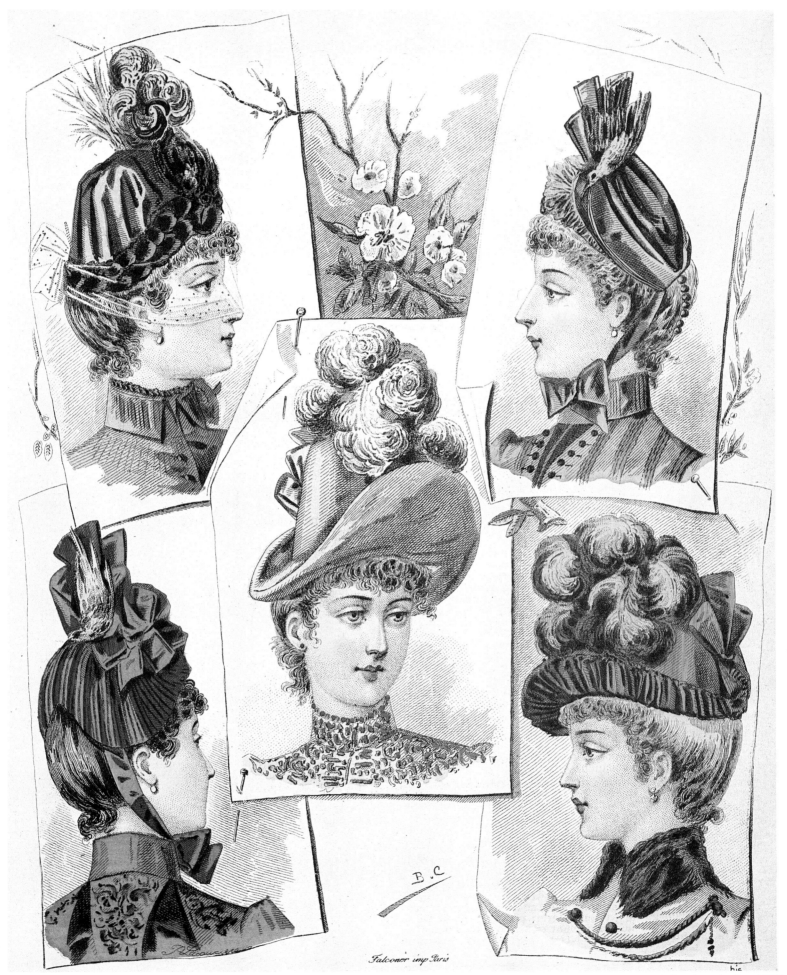

Hand-coloured steel engraving by Bodin et Carrache of fashionable hats designed by Mlle Boucherie et Guelle, for *Le Journal des demoiselles*. 1887.

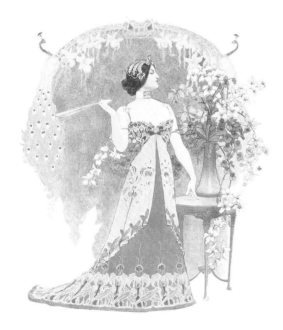

Accompanying this dramatic increase in sales and decrease in prices were short-cuts in the printing and colouring of the fashion illustrations. This and the demand for greater novelty of design led to a marked decrease in the overall quality of the illustrations. At first glance, though, the demand for novelty and decorative detailing seems to have added an amusing quality to the illustrations, particularly those published between 1825 and 1850. However, even then the illustrators were beginning to run out of ideas — one must remember that between 1797 and 1827 La Mésangère's *Journal des Dames* alone issued over 2350 different fashion plate illustrations.

By 1827 none of the fashion magazines were actually illustrating the current fashions, as had been the practice of the earlier publications: the sheer force of demand for newer and more decorative illustrations led the illustrators to 'invent' designs continuously, and this ultimately had a significant effect on the way people dressed. If one multiplies the total of 3624 separate fashion engravings that were published in the *Journal des Dames* by the similar output of at least twenty competitors it becomes apparent why the fashions of this period became so ornate and cumbersome, and why between 1840 and 1880 women's dress became extraordinarily extravagant, rivalling the fashions of the fallen court of Versailles.

This is not to say that all of the fashions and fashion illustrations produced during this period should be disregarded: they were an accurate reflection of the changes then taking place in society. Many of the illustrations do have charm, although like much of the painting, sculpture and furniture of the time, they have little aesthetic merit.

During the latter part of the nineteenth century, in an attempt to cope with the increasing demand for fashion illustrations, teams of illustrators and engravers were being employed, each specialising in just one aspect or one part of an illustration. Some did nothing but design or engrave the background, the faces and hands, the ornate details of the dress, or the hats and accessories; others specialised in drawing and engraving children, dogs, embroidery or lacework. The result was that very few of the engraved fashion plates published during this time are worthy of note.

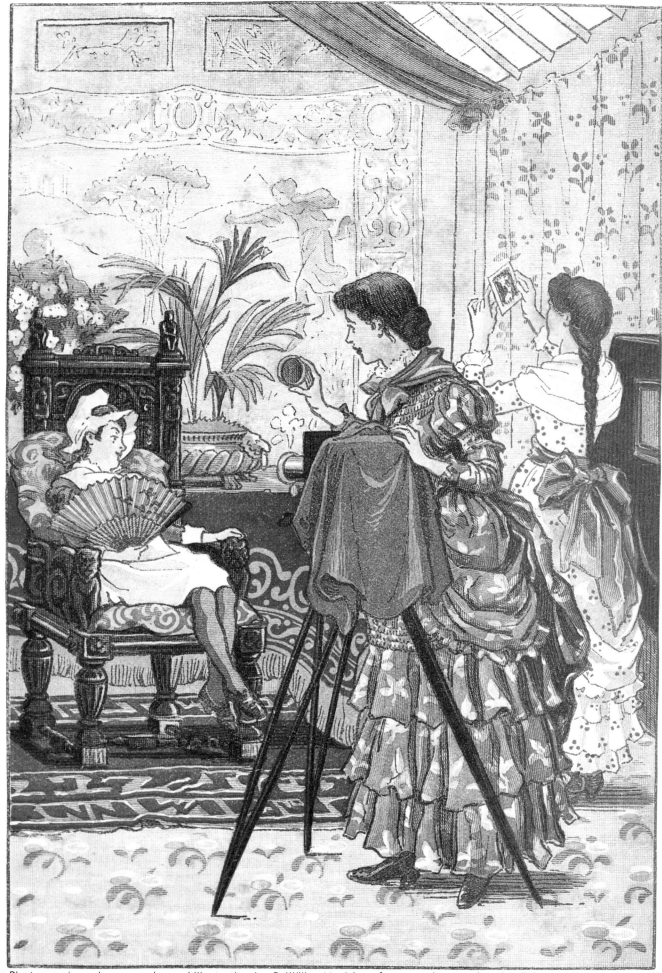

The Young Photographer, chromo-coloured illustration by R. Willes-Maddox after wood engravings by Edmund Evans, *Every Girl's Annual*.
1883/84.

By the 1880s some publishers had begun experimenting with colour-printing techniques which had been developed in answer to the growing demand for illustrated children's books. Hence we find in fashion illustration the emerging influence of illustrators such as Walter Crane, Kate Greenaway, Richard Doyle and Constance Haslewood and of printers such as Edmund Evans, Marcus Ward and Ernest Nister. The influence of Japanese *ukiyo-e* colour woodcut prints was also beginning to show itself in some illustrations, as was the work of illustrators such as Aubrey Beardsley and Eugène Grasset. Fashion photography had begun its long career, too, and several new-style magazines such as *Vogue* had commenced publication. The fashion emphasis had begun to change, the crinoline and bustle styles that typified the years between 1850 and 1880 giving way to oriental influences.

The oriental influence on fashion and the closely associated decorative arts had in fact been growing in importance since the opening up of trade with Japan in the mid-1850s and the subsequent introduction of steel-hulled merchant ships, but most women still preferred the more expensive ornate styles. The Japanese influence received a boost in 1878 and again in 1889, when unique collections of traditional Japanese kimonos, hand-printed silk textiles, samurai armour, ancient ceramics, *ukiyo-e* prints, lacquer work, netsuke carvings and many other items became the centre of attraction at exhibitions such as those held in Paris at that time. Many works from China, Russia, Persia and Turkey were also admired during the 1889 exhibition, which finally brought to the notice of the haut monde the interest in oriental works that for some time had been influencing designers such as Gallé, van de Velde, Guimard and William Morris, painters such as Monet, Degas, Whistler, Manet and van Gogh, and illustrators such as Grasset, Mucha and Toulouse-Lautrec. The end result was the Art Nouveau style.

Pochoir illustration by Paul Iribe of designs by Paul Poiret, printed by Jean Saudé, for *Les Robes de Paul Poiret*. 1908.

More liberal forms of education for both boys and girls were beginning to change the traditional Western way of life and many girls were encouraged to actively participate in sport. These developments were to have a profound effect on twentieth century fashion. Egalitarian ideas had also begun to triumph over many of the out-dated aristocratic habits and privileges, and by the end of the century inventions such as the telephone, electric light, photography, moving pictures and the automobile had been introduced and were soon to change the morals and aspirations of a great many people.

As Western society began to respond to the changing times, a new generation of potential customers was taking an interest in the latest fashionable styles. The opulence and clutter of the latter part of the nineteenth century was slowly discarded and new styles of fashion promoted by magazines such as *Les Modes*, which featured coloured photographs, superseded fashion styles promoted by those magazines that continued to feature the traditional ornate hand-coloured fashion plates.

The new generation of the world's fashionable elite could now see the latest Paris styles whilst sitting in the comfort of their own homes, instead of relying on the depictive skills and creative imagination of the fashion illustrators and engravers whose inventions and interpretations had dominated the world of fashion for close on 150 years. The photographs of the latest fashionable styles, captured by the Paris studios of Reutlinger, Boyer and Paul Nadar, became the centre of interest for the growing number of nouveau riche aspirants and for a time the work of the fashion illustrators entirely disappeared from the pages of the most fashionable magazines.

With this new method of illustration came a new style of fashion journalese. It was most noticeable in American magazines such as *Vogue* and *Harpers Bazaar*, which used evocative 'word pictures' to convey the latest fashion news: they had not yet mastered the technique of coloured photographic reproduction although they regularly featured black and white photographs reproduced by the newly developed half-tone process. In their turn, these new-style magazines had an impact on the fashionable styles being featured because the camera's lens did not always compliment the free-flowing Art Nouveau styles the couturiers wished to feature. A desire arose for a new mode of design that was more suited to the new century.

The young Paris couturier Paul Poiret sensed this change of mood and in 1908 he commissioned little known Paul Iribe to illustrate a publicity album of designs to be known as *Les Robes de Paul Poiret*. Iribe produced a masterly set of line drawings, which were then highlighted with watercolour pigments applied by hand through finely cut stencils. This was the technique known as *pochoir*. It was developed for the Iribe album by the colourist Jean Saudé, who had learnt its basis whilst working as an apprentice on several albums of Art Nouveau textile and furniture designs. Today the Iribe album and a subequent one, *Les Choses de Paul Poiret*, illustrated by Poiret protégé Georges Lepape and published in

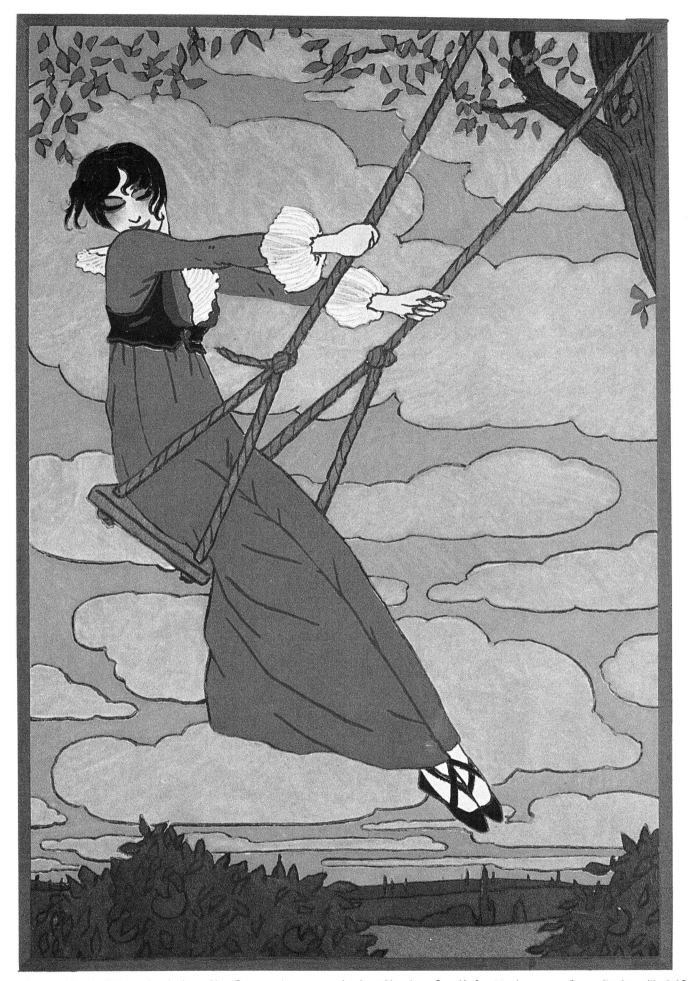

Pochoir illustration *La Balançoire* designed by Georges Lepape and printed by Jean Saudé, for *Modes et manières d'aujourd'hui*. 1912.

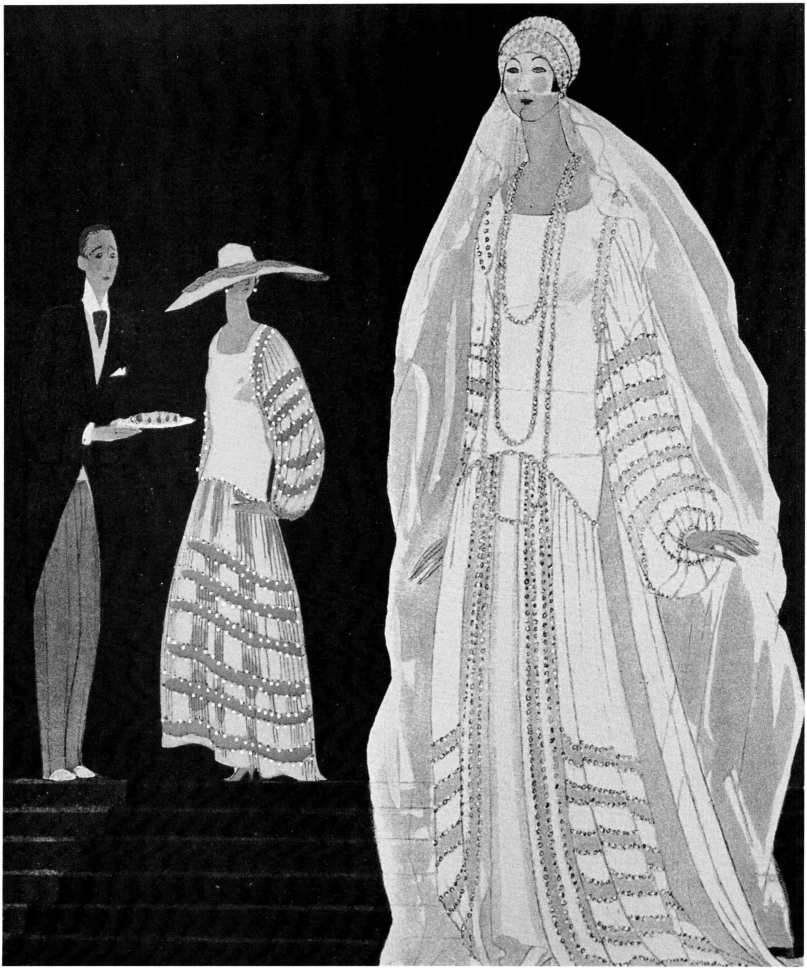

Pochoir fashion illustration *Hyménée* of a Jeanne Lanvin wedding dress, by Georges Lepape, for *La Gazette du bon ton*. 1924.

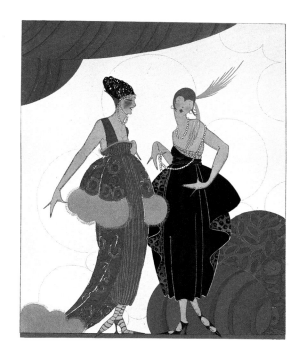

1911, are recognised as landmarks in the development of twentieth century illustration and Art Deco design.

The *pochoir* method of hand-colouring through finely cut stencils was based upon the ancient Japanese technique of stencil printing, which was often used for printing kimono fabrics and had been combined with the Medieval European method of stencil printing used on some illuminated manuscripts. It had been used for a number of Art Nouveau albums, notably *La Plante et ses applications ornementales*, which featured designs by M.P. Verneuil and Eugène Grasset, and *Le Meuble au XXme siècle*, with designs by Gustave Raynal.

Jean Saudé is known to have closely studied the intricately cut Japanese stencils, some of which involved as many as 750 cuts within a 4 centimetre square to achieve the desired pattern. He also took an interest in Japanese *ukiyo-e* prints and Russian paintings and theatrical design. In his *Traité d'enluminure d'art au pochoir*, published in 1925, Saudé wrote,

> The art of *pochoir* resides as much in the method used to interpret the original illustration as it does in the method used for printing the colours, so the first step in making a *pochoir* print is to accurately analyse the original illustration and to break it down into its component parts.

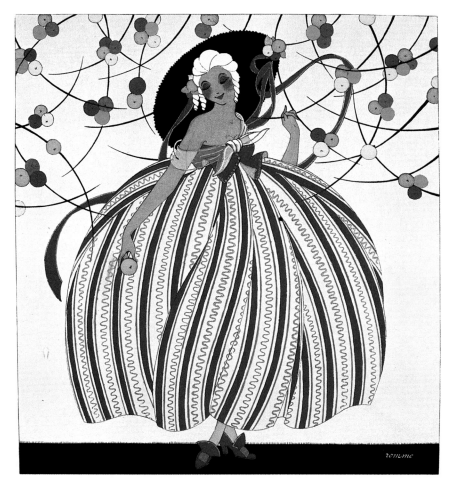

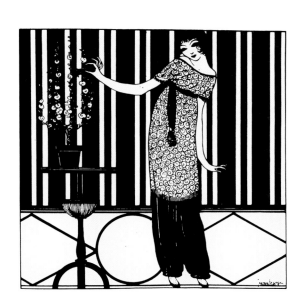

Pochoir illustration by Martha Romme and printed by Jean Saudé, for the deluxe album *Les Douze Mois de l'année*. 1919.

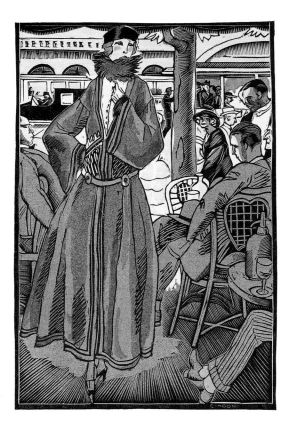

The underlying drawing was then translated into a litho-print, wood engraving or etching — some artists such as Bonfils and Martin preferred to do this themselves. The next step was for each colour to be analysed so that an accurately cut stencil could be made from a sheet of very fine zinc or copper or from thin oiled card, depending on the result required, the size of the stencil and the expected print run. Next, a stencil was cut, following the exact outline and the subtle detailing for each area of the original drawing. If there was a slight variation in the colouring or if a stippling effect had been used, four separate stencils were sometimes necessary; they were cut so as to graduate or stipple the colour during the printing process. Finally, when all the stencils were cut — and there could be over thirty for an elaborate print — the colours were matched to the pochoirist's selection and a base was added to achieve the correct printing viscosity.

In his treatise Saudé explained that the order of printing and the method used for applying the colours were important. A trial print was made in order to test the accuracy of each stencil, the strong colours generally being printed first and the lighter or more translucent ones overlapping slightly. Creamy white hand-made papers were used and the colour was applied with a soft, medium, medium-hard or stiff brush. A sponge could also be used, the paint then being partly removed with blotting paper to obtain a variegated effect.

After the trial print had been approved and signed by the artist the required number of *pochoir* prints was made — generally between 150 and 350 for a deluxe album such as *Les Robes de Paul Poiret*, up to 1250 for a deluxe magazine such as *Le Journal des dames et des modes,* or 2000 for *La Gazette du bon ton.* Thus if a deluxe portfolio or album contained sixteen *pochoir* prints that each required between twenty to twenty-five stencils, as was the case with George Barbier's *Le Bonheur du jour ou les grâces à la mode,* published in 1924, then between 320 and 350 stencils had to be cut. Each of these was then printed for each of the 300 prints required, and so nearly 100 000 separate hand processes were required to exactly reproduce the limited edition of three hundred published copies.

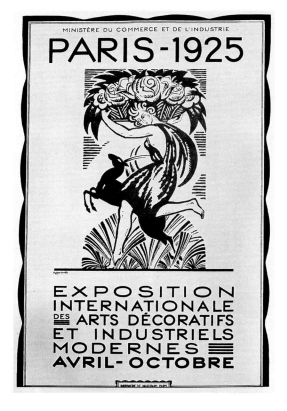

MINISTÈRE DU COMMERCE ET DE L'INDUSTRIE

PARIS-1925

EXPOSITION INTERNATIONALE DES ARTS DÉCORATIFS ET INDUSTRIELS MODERNES AVRIL-OCTOBRE

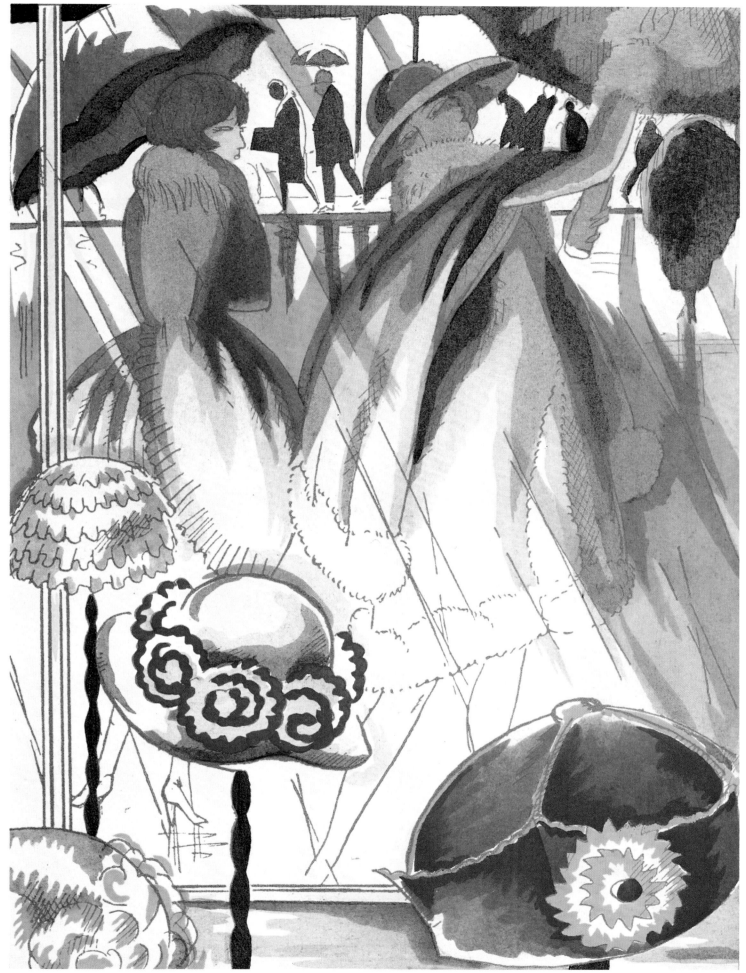

Pochoir illustration *Chapeaux de printemps* by Robert Bonfils and printed by Jean Saudé, for *Modes et manières d'aujourd'hui.* 1920.

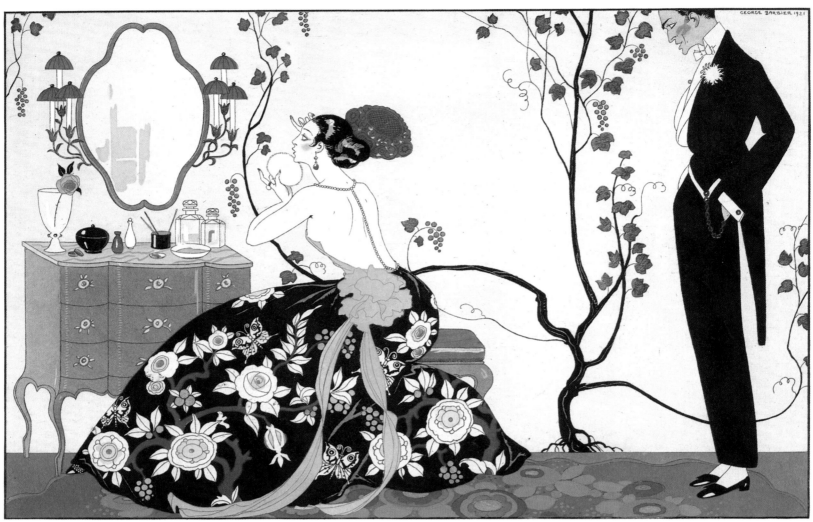

Engraved fashion illustration *Le Grand Décolletage* by George Barbier with *pochoir* colouring by Jean Saudé, for *Le Bonheur du jour on les grâces à la mode.* 1924.

The most noteworthy artists who began to adapt their illustrative styles for reproduction by the *pochoir* technique were George Barbier, Charles Martin, Bernard Boutet de Monvel, Pierre Brissaud, André Marty, Georges Lepape and Paul Iribe; they were later joined by Maurice Taquoy, Robert Dammy, Umberto Brunelleschi, Robert Bonfils, Eduardo Bénito, Sonia Delaunay, Erté, Raoul Dufy and Francesco Javier Gosé. George Barbier was the most prolific and arguably the most creative member of this very talented group.

Barbier was born in Nantes in 1882 and spent two years (1908–10) studying painting at the Ecole des Beaux Arts in Paris. He developed a love for ancient Greek art, which he combined with the sophistication of Japanese *ukiyo-e* prints and the oriental colours and details he had so admired in the Ballets Russes productions of *Cléopâtre* and *Schéhérazade.* His illustrative career spanned twenty years, from 1912 to 1932, and he worked for many famous publications: *La Gazette du bon ton, Le Journal des dames et des modes, Les Feuillets d'art,*

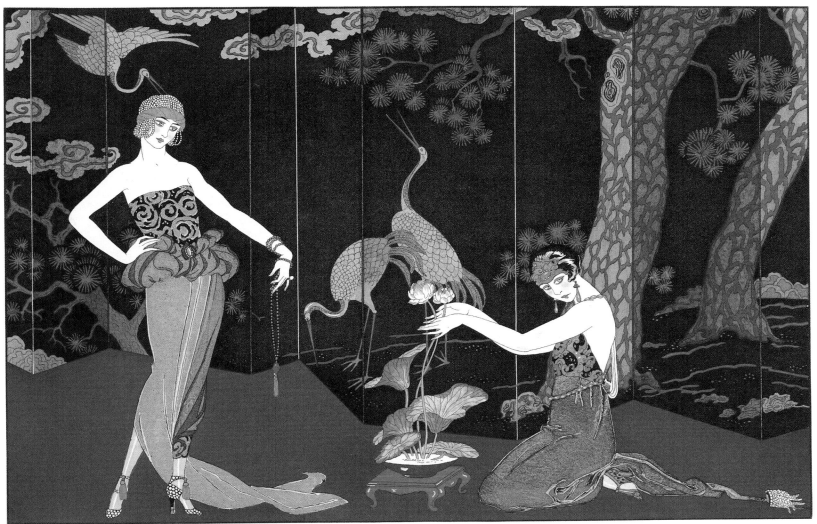

Engraved fashion illustration *Le Goût des laques* by George Barbier with *pochoir* colouring by Jean Saudé, for *Le Bonheur du jour ou les grâces à la mode*. 1924.

La Guirlande d'art et de la littérature, *La Guirlande des mois*, *Falbalas et Fanfreluches*, *Le Bonheur du jour ou les grâces à la mode*, and *Modes et manières d'aujourd'hui*.

Another important illustrator of the Art Deco period was Paul Iribe, born Paul Iribarnegary in Angoulême in 1883. Iribe began his illustrative career in 1905 by supplying cartoons to a variety of fashionable publications, among them *L'Assiette au Beurre* and *La Vie parisienne*. In 1908 he established his own magazine, *Le Témoin*, to which Raoul Dufy, Jean Cocteau, Sam and André Lhote contributed as well as undertaking the illustrations for *Les Robes de Paul Poiret*. In 1910 he opened an interior design atelier in which he designed furniture, fabrics, wallpapers and objets d'art. His best known patron was Jacques Doucet, whose apartment he refurbished in the Art Deco style, the centrepiece being Picasso's painting *Les Demoiselles d'Avignon*.

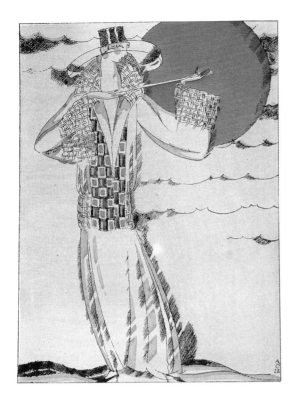

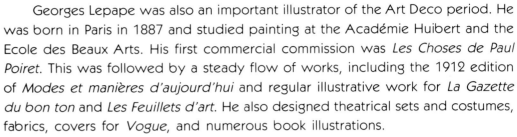

Georges Lepape was also an important illustrator of the Art Deco period. He was born in Paris in 1887 and studied painting at the Académie Huibert and the Ecole des Beaux Arts. His first commercial commission was *Les Choses de Paul Poiret*. This was followed by a steady flow of works, including the 1912 edition of *Modes et manières d'aujourd'hui* and regular illustrative work for *La Gazette du bon ton* and *Les Feuillets d'art*. He also designed theatrical sets and costumes, fabrics, covers for *Vogue*, and numerous book illustrations.

Many illustrators came from all over Europe to work in Paris during this exciting and creative period. Umberto Brunelleschi, for instance, was born in Montemurlo in Tuscany, Francesco Javier Gosé was born in the small Spanish town of Lerida, Sonia Delaunay, Erté and Léon Bakst were born in Russia; others came from Poland, Denmark, Hungary, Switzerland, England, Austria and Germany. But possibly the greatest influence on the illustrative style used throughout the Art Deco period came not from an illustrator but from a magazine proprietor — Lucien Vogel.

Born in Paris in 1886, the eldest child of a painter and illustrator, Lucien Vogel was raised among artists and spent much of his childhood visiting art galleries and museums. At the age of sixteen he commenced a two-year course in design at the Ecole des Beaux Arts and in 1906 he began his professional career as art director of the fashion magazine *Femina*. In 1909 he was appointed editor of the influential magazine *Art et décoration* and in 1911 he commissioned Edward Steichen to photograph Paul Poiret's controversial dresses. These pictures of professional model girls casually posed in Poiret's salon represent the first true collaboration between designer, magazine editor and photographer.

It was in 1911 that Lucien Vogel and his wife Cosette first formulated their plan to publish the revolutionary fashion magazine *La Gazette du bon ton*. The story goes that during the summer of 1911 the couple were staying in the country with one of Cosette's cousins, and the walls of the room they slept in were covered with colourful and elegant paintings by Pierre Brissaud and Bernard Boutet de Monvel. Waking early and looking at these paintings in the bright morning light, Lucien turned to his wife and asked her if she had ever seen more beautiful fashion drawings. They decided there and then to produce a magazine that would make use of such creative talent.

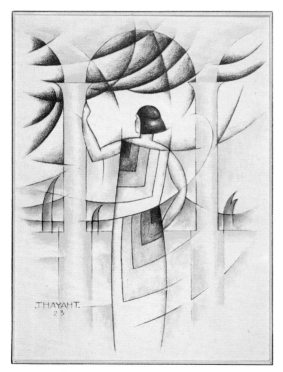

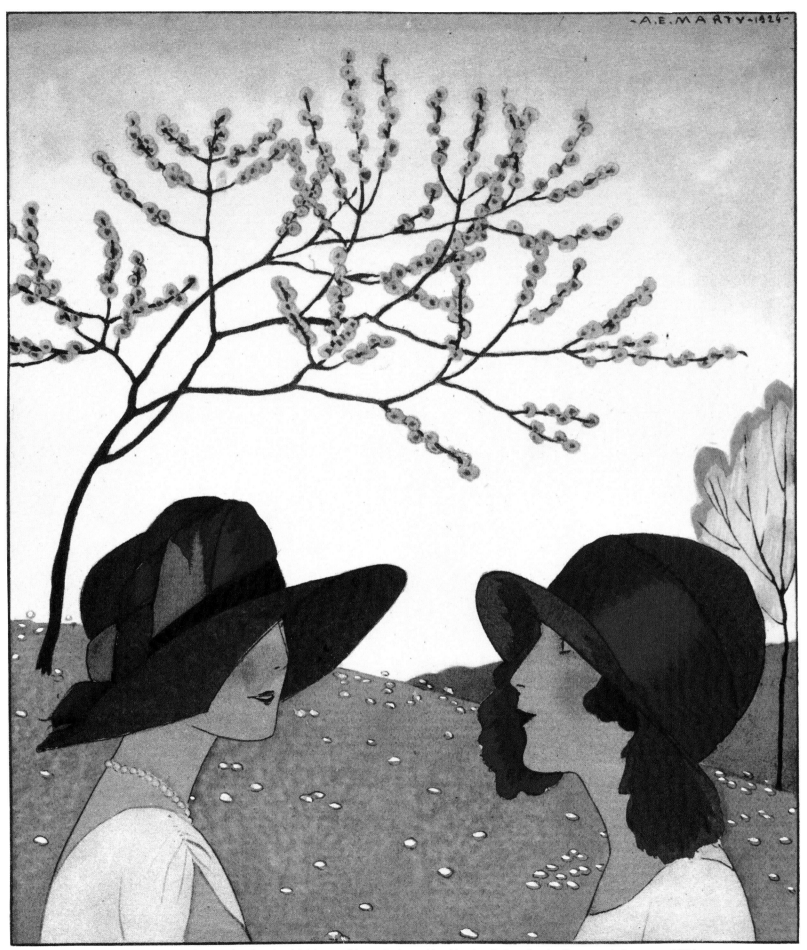

Pochoir fashion illustration by André Marty of hats designed by Marthe Collot, for *La Gazette du bon ton*. 1924.

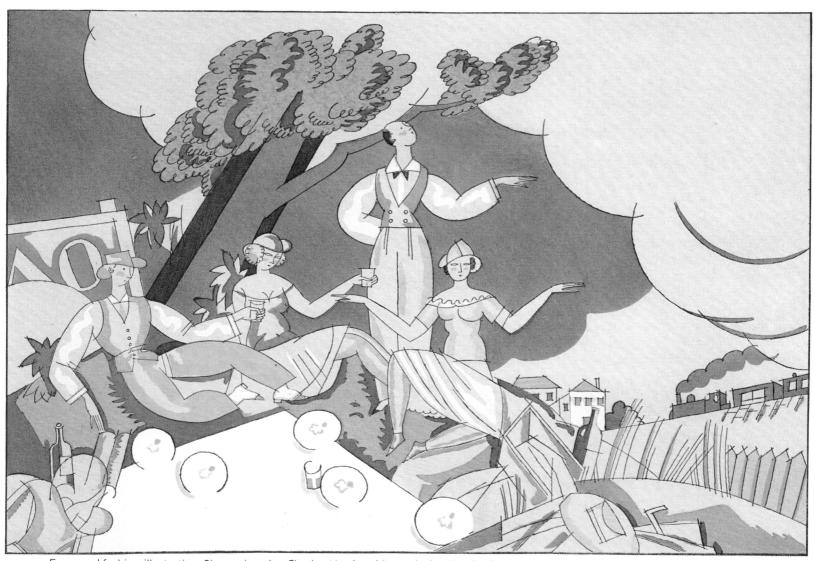

Engraved fashion illustration *Pique-nique* by Charles Martin with *pochoir* colouring by Jean Saudé, for *Sports et divertissements*. 1920.

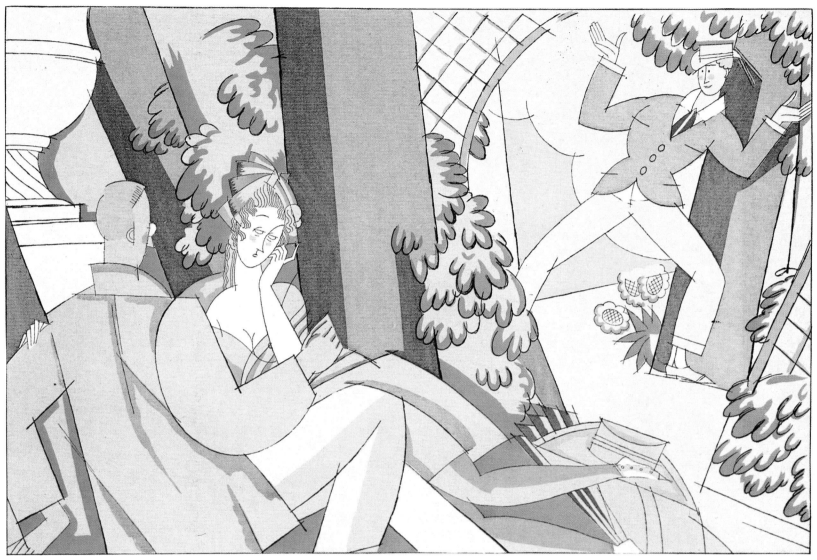

Engraved fashion illustration *Flirt* by Charles Martin with *pochoir* colouring by Jean Saudé, for *Sports et divertissements*. 1920.

During the following months the Vogels devoted themselves to finding more artists of the calibre of Brissaud and Boutet de Monvel and the group they formed had all attended the Ecole des Beaux Arts together — Pierre Brissaud, Bernard Boutet de Monvel, George Barbier, André Marty, Charles Martin, Georges Lepape, Paul Méras, Jacques Drésa and Francesco Javier Gosé. Edna Woolman Chase knew these artists well and described them in her autobiography *Always in Vogue*, published in 1954:

> *Talent they had in plenty; their business instincts were nil. Their good fortune was to meet with Lucien Vogel, publisher, press agent, wet nurse and catalyst, who formed them into a cohesive unit and created for them a show window in his proposed* Gazette du bon ton *... Vogel's idea of displaying their art and splitting the magazine's profits had appealed to the gifted spirits until he one day advanced a little proposition which evoked a furore.*

It had been proposed that this new magazine was to be sponsored by the seven leading couturiers of the period — Chéruit, Doeuillet, Doucet, Lauvin, Poiret, Redfern and Worth — and Vogel's suggestion was that each of the artists should draw one of these backers' designs for publication in the magazine. Woolman Chase wrote,

> *This first sniff of trade outraged the geniuses, yet it was a sound idea, for it would flatter the sponsors and give a certain journalistic and serviceable quality to a project that, if it remained in the realm of pure art, might wither before its flowering.*

She continued that, although this group of artists 'cried out that they were creators and originators, Papa Lucien talked to them like a French uncle, enunciating little phrases about francs and sous, and in no time all the boys came round'. In fact, they reached a compromise whereby each artist could design and publish one picture of his own choosing for every one he produced for a couturier.

Under Vogel's direction the artists set to work to develop the 'story-telling pictures' for which the *Gazette* was to become famous. He also persuaded Jean Saudé to undertake the *pochoir* printing of the illustrations. The magazine was designed to appeal to the haut monde and the art connoisseurs of the period, to be 'a truly modern review of art and fashion, and an exact record of the fashionable life of our time'. A special type face was designed that was compatible with the *pochoir* prints and irregular layout. Special hand-made paper was selected and many of the leading writers and poets were commissioned to contribute to the first few issues.

Le Jardin des Modes

LA BELLE PRISE
Une robe et un manteau de NICOLL et Cie

But Lucien Vogel's *La Gazette du bon ton* was not the only *pochoir* publication being planned at that time: Jacques de Nouvion was planning to reintroduce an up-dated version of Pierre La Mésangère's famous *Le Journal des dames et des modes*, with copperplate engravings highlighted in *pochoir*. And Pierre Corrard's plans for the deluxe fashion annual *Modes et manières d'aujourd'hui* were also well advanced. Several other *pochoir* fashion magazines such as *Luxe de Paris* were also in the planning stage and numerous design albums with *pochoir* plates were already in production.

Pochoir illustration *L'Hiver* designed by Paul Allier, for *Les Quartre Saisons*, published by Galerie Lutétia. 1928.

The first copy of *Le Journal des dames et des modes* was published in June 1912. It was the first regularly published fashion magazine to contain *pochoir* prints of the latest fashionable ideas of the Paris couturiers as well as those designed by the artists themselves. The first copy of *La Gazette du bon ton* was also published in 1912, as was *Modes et manières d'aujourd'hui*. The publishers of these revolutionary Art-Deco-style magazines with their beautiful *pochoir* prints had all realised that the 'new age' and the 'newly developed production methods' demanded 'a new style of publication that was truly reflective of its time', and they promised that there would be

> ... no confusion of fashion details inevitable in photographic reproductions. Each illustration will be hand-coloured by the pochoir *process in imitation of the artist's original — a true picture of fashionable life, not a mere reflection of a lifeless model girl ... Each illustration will be a complete picture of contemporary life, with the latest fashions by the great couturiers being featured in their own appropriate settings.*

These deluxe magazines gathered together in their pages the true spirit of the era. They acted as the mirror of all that was smart and most elegant in the social life of the wealthy Parisians and elite members of world society between 1912 and 1925. Even today, through the marvellous *pochoir* illustrations that were one of the main features of these publications we can admire and enjoy this golden age of artistic achievement.

Between 1912 and 1914 these superb publications flourished. *Le Journal des dames et des modes* published a total of seventy-nine editions containing 186 *pochoir* prints by such artists as George Barbier, Léon Bakst, Charles Martin, Armand Vallée, J. van Brock and Etienne Drian. Plate number 1 was an exact copy of a 1812 illustration by Horace Vernet, originally published in the magazine's namesake.

Coloured litho illustration *Aux Courses* by M. Rojan, for *La Grande Maison de blanc*, published by La Belle Editions. 1929.

The deluxe fashion annual *Modes et manières d'aujourd'hui* also published a further three albums between 1912 and 1914. The 1912 edition contained twelve superb illustrations by Georges Lepape, the 1913 edition was illustrated by Charles Martin, and the 1914 edition contained twelve illustrations by George Barbier. These three illustrators were also regular contributors to *La Gazette du bon ton* which, between its first edition in November 1912 and the outbreak of World War I, published a total of nineteen editions, each with ten *pochoir* illustrations. The first ten subscribed copies were personally signed by the publisher Lucien Vogel.

The practice of signing certain copies and not others was used to encourage the fashionable elite to be among the first to purchase these publications. *Le Journal des dames et des modes*, for instance, was strictly limited to 1250 subscribers, with the first twelve copies of each edition being printed on Imperial Japon paper, numbered and signed by the publisher. *Modes et manières d'aujourd'hui* was also available only by subscription. It too was printed on Imperial Japon paper and each copy was individually numbered and signed by the artist. The first twelve copies were larger in format and contained the bonus of one of the artist's original drawings.

The purchasers of these and the many other *pochoir* publications that were published between 1912 and 1914 and then from 1918 until the end of the 1920s had grown up with illustrations by Walter Crane, Maxfield Parrish, Kate Greenaway, Ivan Bilibin and Aubrey Beardsley, and with children's magazines that often contained exotic-looking illustrations printed by the richly coloured chromo-litho process developed by Kronheim and the Dalziel Brothers or unique wood-coloured prints developed by Edmund Evans. Their visual senses were highly developed and they loved to be excited by the array of visual images then being printed by Jean Saudé and his competitors.

Magazine illustration by Kees van Dongen of Elsa Schiaparelli evening dress and cape, for *Harpers Bazaar* (London). 1935.

Magazine illustration by Jacques Demachy of the latest Paris fashions, for *Femina*. 1932.

They also liked to think that they were on the threshold of a Renaissance and gloried in the fact that designers such as Lalique, Picasso, Delaunay, Ruhlmann, and Eileen Gray were designing their fabrics, furniture, glass objects and lacquer work; that couturiers such as Chéruit, Doucet, Lanvin, Poiret and Paquin were designing their clothes; that artists such as Kay Nielsen, W. Heath Robinson, Léon Carré, Thomas Mackenzie, Harry Clarke, François-Louis Schmied, Jessie M. King, Ronald Balfour, and Edmund Dulac were designing their deluxe edition books; and that George Barbier, Charles Martin, Erté, Georges Lepape, Edouard Bénito, Martha Romme and Janine Aghion were designing the *pochoir* prints for a new array of fashion publications. Among these new publications were *Les Feuillets d'art*, *Le Goût du jour*, *La Guirlande d'art et de la littérature*, *Falbalas et Fanfreluches*, and the one-off volumes *Les Douze Mois de l'année*, *The Essence of the Mode of the Day*, *Sports et divertissements* and *La Dernière Lettre persane*.

During the 1920s the glossy magazines of the period — *Vogue*, *Harpers Bazaar*, *L'Officiel*, *La Femme chic*, *Les Elégances parisiennes*, *Excelsior Modes* and *Femina* — were also beginning to develop their own unique style, with many of the leading photographers of the period — Steichen, de Meyer, O'Doÿé, Moisson — and a number of the *pochoir* illustrators adorning their pages. The influence of these publications was growing, and as their circulation increased so did the number of advertisers anxious to reach this growing affluent market. Lucien Vogel noted this change of fashion emphasis and in 1921 he decided to sell the *Gazette* to the American publisher Condé Nast to help finance his new project, *L'Illustration des modes*. Two years later Condé Nast also bought *L'Illustration des modes* and renamed it *Le Jardin des modes*. Part of the agreement, however, was that Vogel stayed on to run the new magazine as editor-in-chief, with his wife Cosette being employed as fashion editor and his brother-in-law Michel de Brunhoff as artistic director. Vogel employed the photographic skills of the Seeberger brothers and he also employed many of his favourite illustrators on the new project — Martin, Barbier, Lepape and Marty — and he introduced a number of new artists to the realms of fashion illustration, notably Marie Simon, Eric, Jacques Demachy, Pierre Mourgue and Helen Smith, several of whom later became famous working for Condé Nast's flagship, *Vogue*.

After the 1925 Exposition Internationale des Arts Décoratifs et Industriels Modernes (the Art Deco exhibition) fashion and fashion illustration once again began to change. The deluxe *pochoir* publications that had come to epitomise the Art Deco era became fewer and a sudden drop in subscriptions forced the *Gazette* to close. The pochoirists began to concentrate on other projects and during the next few years they produced numerous books and design folders: *Nous deux*, with illustrations by Jean Dulac; *Fêtes galantes*, with illustrations by George Barbier; *Répertoire du goût moderne*, with furniture, interior design and ceramics by Ruhlmann, Elise Djo-Bourgeois, and Pierre Chareau; *Décors et couleurs*, with design ideas by Georges Valmier; *Relais*, with textile designs by

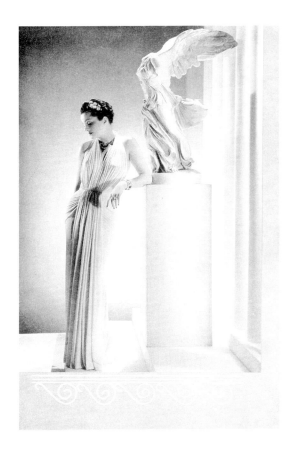

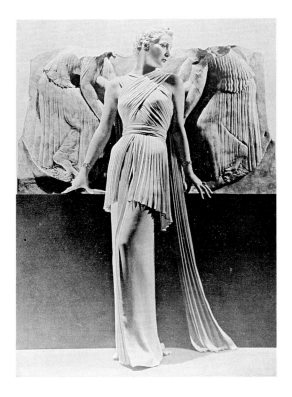

Edouard Bénédictus; *Kaleidoscope*, with design ideas by M.P. Verneuil; *Compositions*, with textile designs by Sonia Delaunay; *Les Tapis modernes*, with carpets designed by Jean Lurçat, Eileen Gray, Pablo Picasso and Jean Arp. By the beginning of 1930, however, the majority of the *pochoir* studios, like so many of the expensive and exclusive ateliers that served the needs of the wealthy, began to close down.

The influence of the pochoirists did not end with the demise of the *pochoir* studios: many of these artists went on to work for the growing number of glossy magazines. Georges Lepape and Charles Martin worked for *Vogue*; Bernard Boutet de Monvel and Erté worked for *Harpers Bazaar*; Pierre Brissaud and André Marty worked for *Le Jardin des modes*; whilst new illustrators such as Jacques Demachy, Pierre Mourgue, Eric, Mario Simon and Helen Smith seem to have worked for numerous magazines throughout the 1930s and into the 1940s. They were joined by many others, all of whom developed their own idiosyncratic style.

A new group of fashion photographers was also beginning to make its presence felt in the early 1930s, led by Baron George Hoyningen-Heune, Horst P. Horst, Cecil Beaton, Harry Meerson, and Georges Saad. Baron Gayne de Meyer, Edward Steichen, Jules, Louis and Henri Seeberger and the Reutlinger Studio were still active and as the 1930s progressed the fashions seemed to change in synchrony with the changing photographic styles. But fashion photography had not yet taken over completely from fashion illustration. In his book *Fashion Drawing* (1932) Eliot Hodgkin noted that at the time there remained a slight bias in favour of illustration because fashion magazines were about the newest fashion ideas and 'You cannot very well photograph a dress of which there so far only exists the paper pattern'. Fashion photographers had to wait until a new fashion was in production and then it was often too late to photograph it for inclusion in a magazine: the two to three month lead-time needed for preparation and printing of the magazines made the styles appear dated.

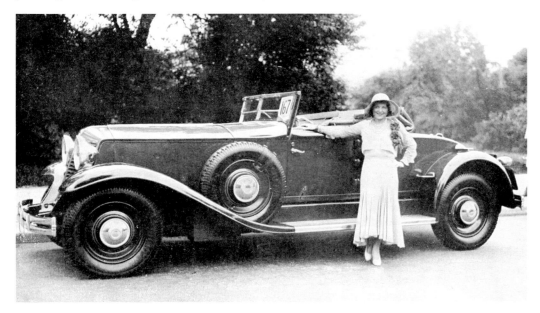

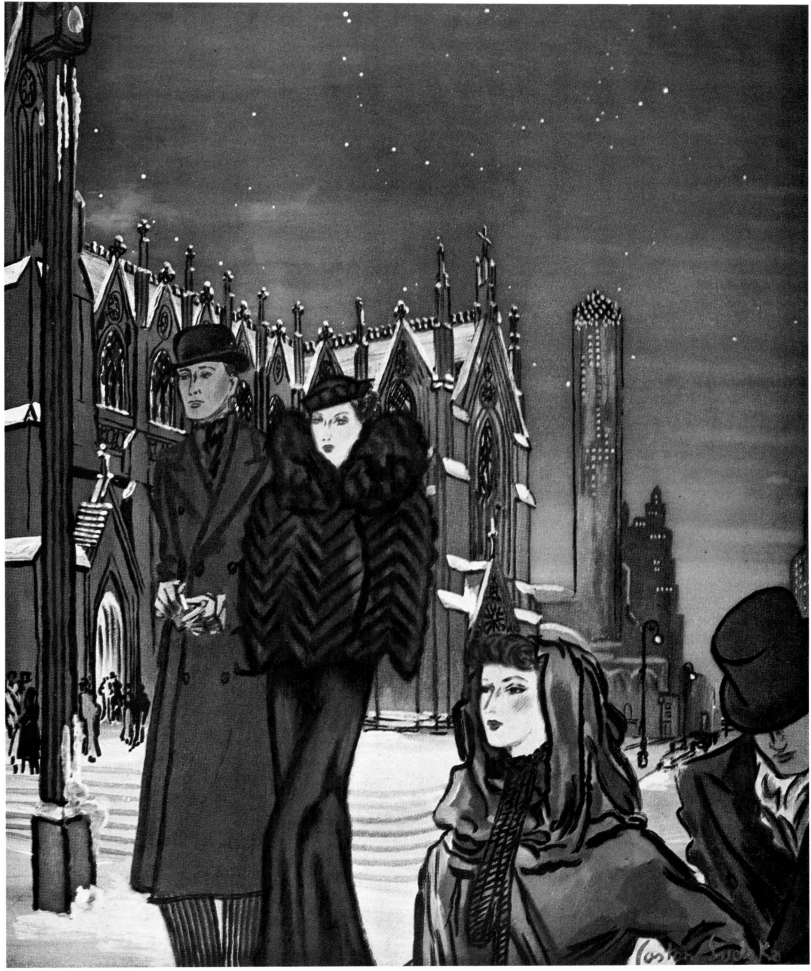

Magazine illustration by Gaston Sudakes of American fashions by Hattie Carnegie, for *Harpers Bazaar* (London). 1934.

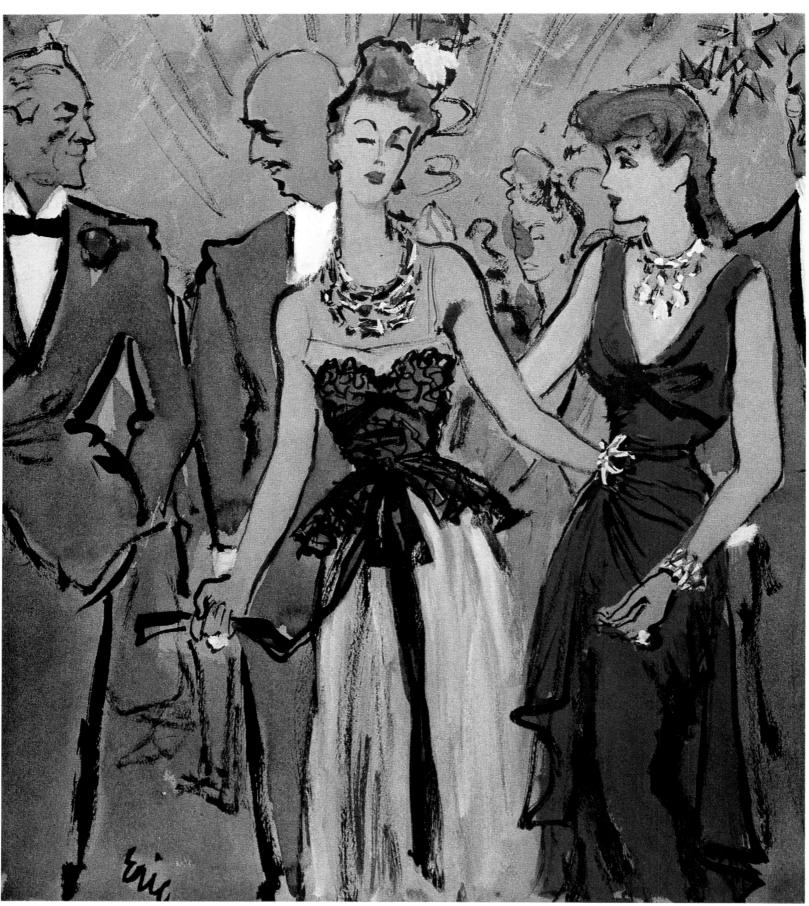

Magazine illustration by Eric of American wartime fashions, for American *Vogue*. 1941.

But the fashion illustrators of the early 1930s were not having it all their own way. Most of the income earned by the magazines came from advertisements and as a result much of the illustrative work was done for manufacturers and department stores. This called for 'grafting bizarre details and a modern face onto an already out-dated advertisement' according to Eliot Hodgkin. He went on to say that in the advertiser's mind 'every woman is supposed to be chronically dissatisfied with her figure and incapable of altering it' so an illustrator 'must show Mrs Everyman as she would appear after putting on a magic dress that makes her look delightfully slender'. There was very little room for idiosyncrasy or creativity and most illustrations were mundane affairs.

The illustrators were also running into problems with their art directors, who were beginning to specify exactly what they wanted and refusing to accept illustrations that did not meet their requirements. Prior to this most illustrators had been encouraged to undertake a commission as they saw fit and the best of them were asked to create an image that reflected their own views of the latest fashion, using the technique they thought most suitable. But the art directors of the early 1930s were responsible for designing their magazine as a complete ensemble, with as much regard being given to the layout, the balancing of text and the placement of advertisements as to the content of each illustration or photograph.

This was in complete contrast to the ideals of the editors of such magazines as *La Gazette du bon ton*, *Les Feuillets d'art* and *Le Journal des dames et des modes*, who expected their artists to design the layout of the pages they had been commissioned to illustrate and often to design the fashionable garment to be used in their illustration. The artists also created the mood for the magazine rather than having to follow the art director's concept, which by 1934 was beginning to become stereotyped and boring. Only the French magazine *Le Jardin des modes*, under the direction of Lucien Vogel and Michel de Brunhoff, seems to have been free from this heavy-handedness. Its circulation began to increase and its competitors were forced to once again give their illustrators more freedom to draw the sorts of images for which they had become famous.

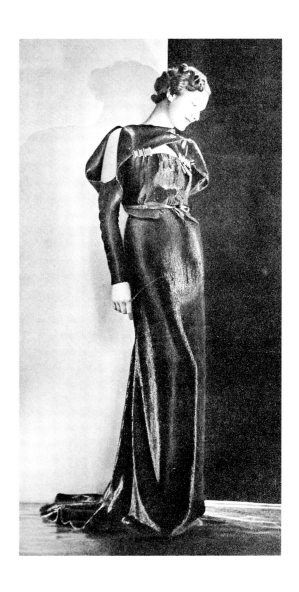

The art directors of most other magazines turned their attention to photography. Cecil Beaton, Harry Meerson and the three Seeberger brothers were joined by Man Ray, Martin Munkasci, Erwin Blumenfeld and Toni Frissell to offer a great variety of visual skills to the magazines they worked for.

The reproduction of the photographic images using a refinement of the halftone process was beginning to improve and the photographers were demanding that they have dresses specially made in advance of their general release for sale. By the late 1930s if one were to visit Rome in the first few weeks after Christmas one may well have seen models shivering on the Spanish Steps, being photographed in what a magazine's editor and designer thought would be next spring's clothes. This meant that these supposedly new fashions had to be invented especially for the photographic sessions although they were often quite unlike the new designs that did become fashionable that spring. This had the effect of

PIERRE BALMAIN

Magazine illustration by René Gruau of casual evening designs by Pierre Balmain, for the *Album de la mode du Figaro*. 1945–46.

forcing designers to 'fly a kite' (to use a design created especially for publicity purposes) or of forcing the photographers to use less stylish clothing and place more emphasis on novelty accessories, unusual locations and the photogenic qualities of the model. Although this tended to slow down and to distort the fashions of the period, there were nevertheless some fine images published in the mid- to late 1930s. As had happened with the inventive fashion plate illustrations of the mid-nineteenth century, these photographs eventually began to influence the actual fashions being worn.

The fashion magazines of the early 1940s, however, were conceived and published under the depressing cloud of World War II. Even though Paris was occupied by the German armed forces, many of the couture houses continued to launch their new collections each spring and autumn. By 1942 the American fashion industry had also begun to produce new ranges of fashionable clothing; hitherto the huge American fashion industry relied upon France for its inspiration. The isolation that resulted from the war gave rise to a new breed of American designers who were producing clothing styles more suited to the American lifestyles. Illustrators and photographers promoted these new American fashions and so began the breakdown of the pre-eminence of French fashion, which had ruled the sartorial world for more than 250 years. In Britain, Australia and numerous other countries however, new fashions were strictly controlled by law and new materials were in very short supply, so the fashion industry did not develop in the same way as in America.

In October 1944 the war-induced break with Paris fashion came to an end and images of the styles that had developed in that city during its occupation were launched upon an unsuspecting world. Photographs of young girls riding bicycles whilst wearing floating gathered skirts that emphasised their tiny waists were circulated around the world. They were also wearing tightly fitting sweaters and their hair was built up in elaborate pompadour styles. After the liberation these fashions began to change: they had developed during the occupation as a means of popular defiance and the materials used had in the main been pre-war stock.

As the Paris fashions changed so did the fashions of the rest of the world. They were recorded and promoted throughout the world by photographers and illustrators, who also continued to promote the new fashions of their own countries. The magazines of the late 1940s were embellished with a wider and more interesting range of images than ever before.

\mathscr{D} ESIGNING THE \mathscr{F} ASHIONS

\mathscr{T}he great and original fashion designers of the past followed many different paths to success but the fact that they nearly all worked in Paris at some stage in their careers gives them at least one common thread. Working in Paris should not be confused with being French, though: Worth and Redfern were English; Molyneux was Irish; Elsa Schiaparelli and Nina Ricci were Italian; Dessès was born in Egypt of Greek parents; Yves Saint-Laurent was born in Algeria; Karl Largerfeld is German; Cristobal Balenciaga was a Spaniard; Mainbocher was American; Hanae Mori and Kenzo are Japanese; Sonia Delaunay was Russian; and Robert Piquet was Swiss.

Many great designers also came to the world of high fashion by a circuitous route: Zandra Rhodes, the current doyenne of British fashion, began her career as a fabric designer and did not start designing the kinds of fashions for which she is famous until she was in her early thirties; Paul Poiret started out as an apprentice umbrella maker; Jeanne Lanvin began her professional career as a milliner, as did Coco Chanel and Rose Bertin; Leroy, the official designer to the Empress Josephine and creator of the Empire fashion, was originally a painter; Adrian designed film fashions for the major MGM stars of the 1930s before opening his own fashion business in Beverly Hills; Kensai Yamamoto and André Courrèges trained to be civil engineers; Madame Grès wanted to be a sculptor; Claude Montana commenced his career designing costume jewellery; Jacques Fath wanted to be an actor; Jean Muir started work in a solicitor's office; and the innovative ready-to-wear designer Emmanuelle Khanh was originally a model at Balenciaga.

However, some designers knew precisely what they wanted and went to college to study or went straight into the industry. The present designer at the House of Dior, Marc Bohan, started as an assistant to Molyneux; Givenchy was a protégé of Balenciaga; Doeuillet trained with Callot Soeurs; Christian Dior worked as a *modeliste* for Lucien Lelong. Of those who turned to study, American Calvin Klein graduated from the Fashion Institute of Technology, New York; the English designers Ossie Clark, Bill Gibb, Tuffin and Foale, Anthony Price and the Emanuels all graduated from the Fashion School of the Royal College of Art in London; Japanese designer Issey Miyake studied at L'Ecole de la Chambre Syndicale de la Couture in Paris as did Italian designer Valentino.

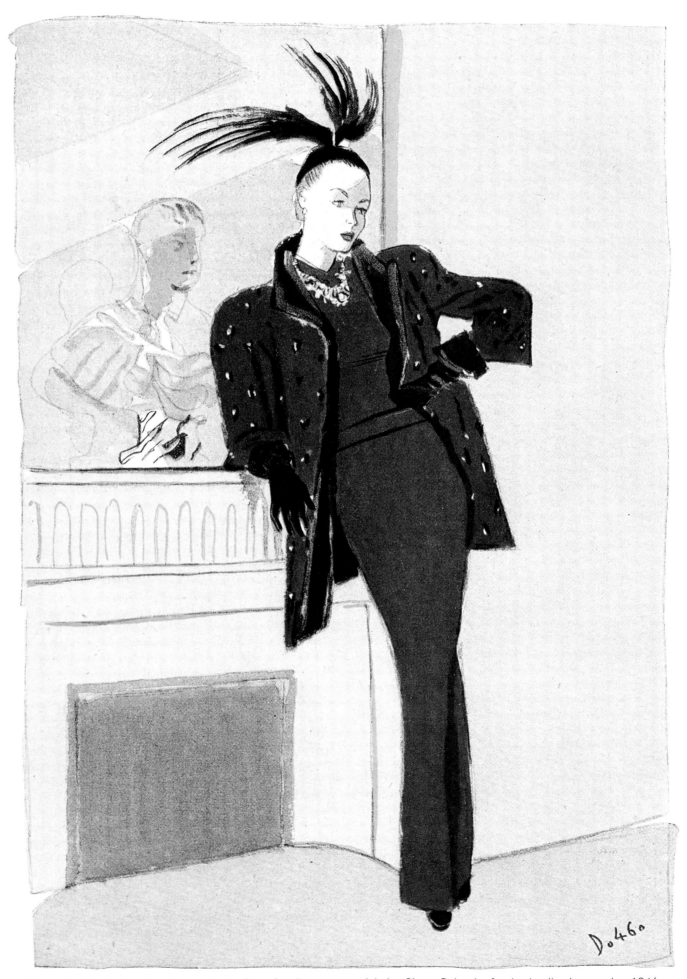

Magazine illustration by Alexandre Delfau of a dinner ensemble by Pierre Balmain, for *Le Jardin des modes*. 1946.

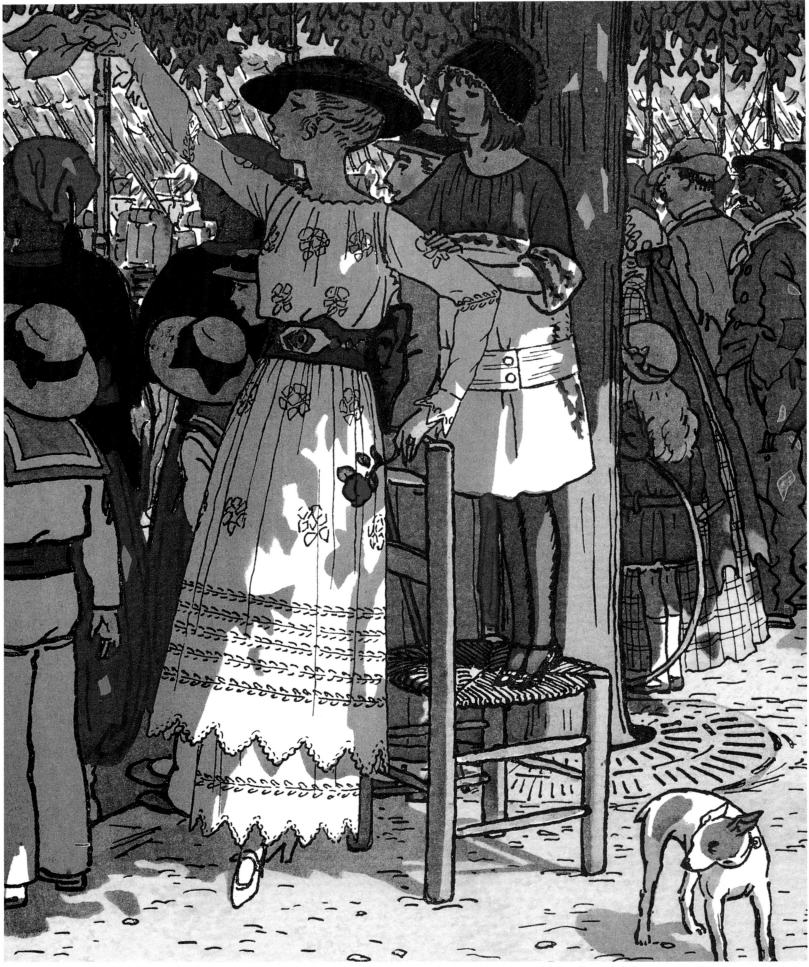

Pochoir illustration by Pierre Brissaud of a Jeanne Lanvin morning walking dress, for *La Gazette du bon ton*. 1914.

The training of fashion and design students in art schools or institutes of technology is a relatively recent innovation. Prior to the 1930s, when the ready-to-wear fashion industry as we know it really began, training was confined to haute couture, with the couturiers of the day invariably dictating the latest fashionable styles and employing design assistants and *modelistes* to carry them out. France was also the centre of Western culture during most of the nineteenth century and the printing ateliers of Paris supplied the majority of hand-coloured fashion plates, thus establishing Paris as the fashion capital of the world.

Between 1905 and 1930 French haute couture boomed, a luxurious and exotic world frequented by rich society ladies, the few remaining demi-mondaines, theatrical personalities, an increasing number of nouveau riche, and numerous others who could afford modes of dress in which no amount of labour or material was too expensive and no designer's ideas too extravagant. The salons of the *grands couturiers* were extraordinarily luxurious: every comfort and ease that worldly taste could devise was to be found there, for one could hardly expect one's clients to judge the effect of a toilette in an inappropriate setting.

The fashionable woman of the period devoted many hours a day to the care of her person and her wardrobe. 'Everything down to her chiffon handkerchief was made to order,' wrote Diana Vreeland in the introduction to the catalogue of an exhibition entitled 'Inventive Paris Clothes 1909 to 1939', held at the Metropolitan Museum of Art in New York in the mid-1970s. She continued,

> The household was maintained by a plentiful number of excellent servants, and with splendid houses to visit and lavish fêtes to attend, her main preoccupations were being beautiful and being noticed — at parties, balls, theatres and restaurants. For relaxing at home she wore a special *robe déshabillé, cut to fit the body in the most comfortable and luxurious way. Her feet rested on the most beautiful carpets on the most highly polished parquet floors; she was surrounded by fresh flowers, gleaming lustres, rare and expensive books, paintings of former periods and selected pieces of contemporary art, and many mirrors and candles reflecting this delightful way of life.*

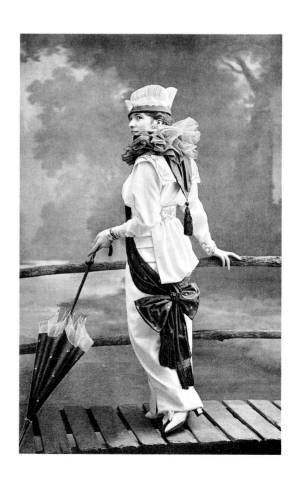

The couturiers and designers who served the woman of fashion understood the need to employ the best of traditional dressmaking skills while developing extraordinary techniques of their own, combining both old and new methods in unexpected experimental ways — 'experimentation merging with perfection, which prevented perfection from becoming dull and cloying', as Madeleine Ginsburg put it in the catalogue of the Victoria and Albert Museum's exhibition 'Fashion 1900 to 1939', held in the late 1970s.

In the years between 1905 and 1914 the elegant women of New York, London, St Petersburg, Berlin and Buenos Aires would converge on Paris in February or March to choose their spring and summer clothes, and again in August or September for their autumn and winter wardrobes. Even the most worldly eyes must have been dazzled by the parade of each new season's fashions.

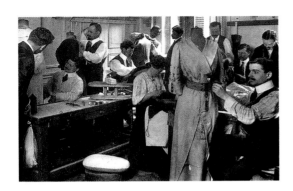

Each of the garments shown at the seasonal parades was the result of many hours of work and many hours of fittings, the practice being for the original design to be cut directly into the desired fabric and then fitted onto the model girl. There was no system of pattern cutting as there is today, and no sorting out of the main features and details until the principal *modeliste* of the couture house had seen the effect of the cut and material on the model girl, to see how it 'fell' and 'moved'. If the effect was not to the *modeliste's* liking the garment would be recut and refitted until the desired look was achieved. At least twice as many new designs were made each season as could possibly be shown in the fashion parade.

The fashion parade was the start of a long process. Every dress ordered from a *maison de couture* was made to the individual measurements of the client, this involving at least four fittings, sometimes more. Back in the workroom between fittings, the garment was *mis à plat* (laid flat on a table), taken to pieces and put together again according to the 'language of the pins' with which the alterations had been noted at the previous fitting. The making of a couture gown entailed hours of specialised work: seventy to a hundred for a morning dress, up to five hundred for an embroidered ball gown.

Each workroom was ruled with a rod of iron by one of the great fitters, those stalwarts of the *maisons de couture*. Unequalled anywhere outside the centre of Paris, each fitter had her own particular group of clients whom she 'dressed'; she knew and understood them, their bodies, their foibles, their weaknesses, their tastes and their idiosyncrasies. In her workroom she was second only to God.

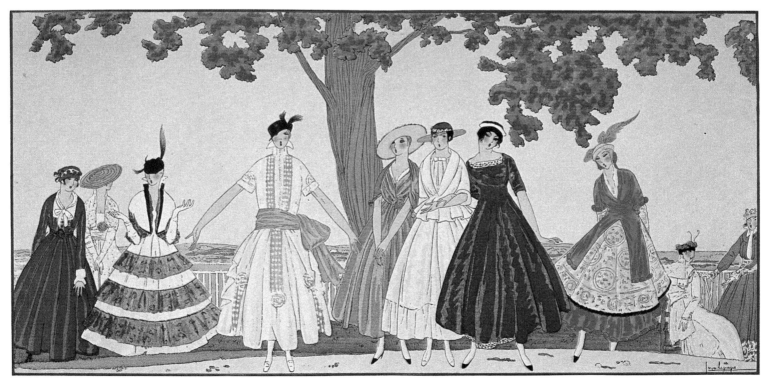

World War I fashions shown at the Panama Pacific International Exhibition, San Francisco, 1915. From an illustration by Georges Lepape for *La Gazette du bon ton*.

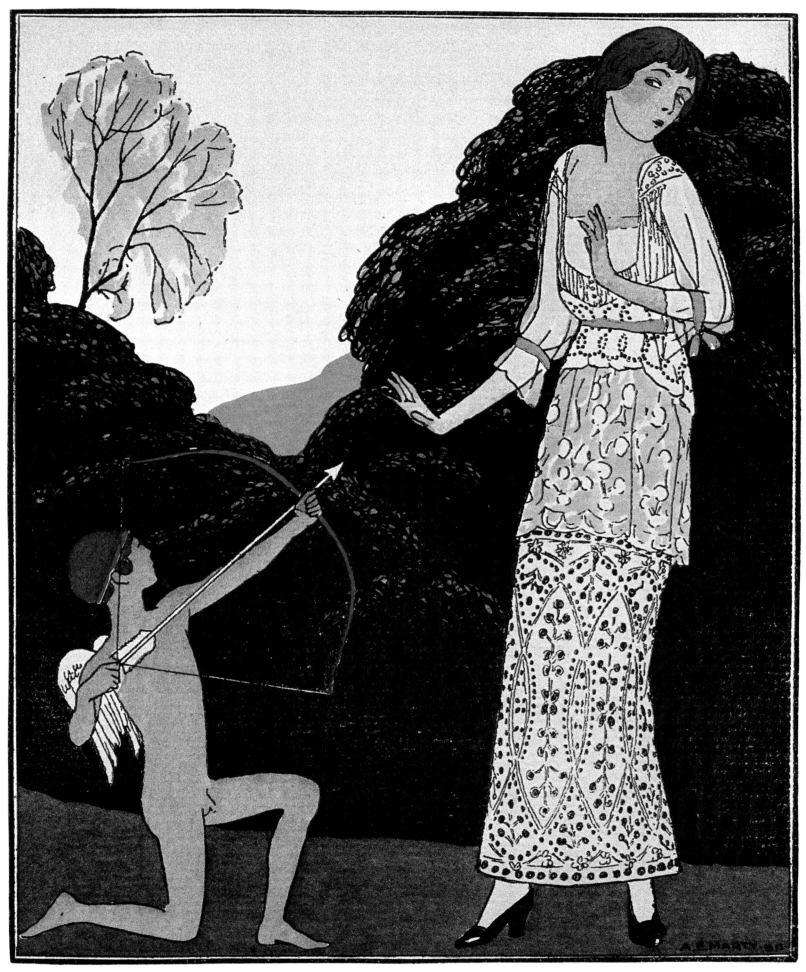

Pochoir illustration by André Marty of a broderie-anglaise boudoir dress by the House of Doeuillet, for *La Gazette du bon ton*. 1913.

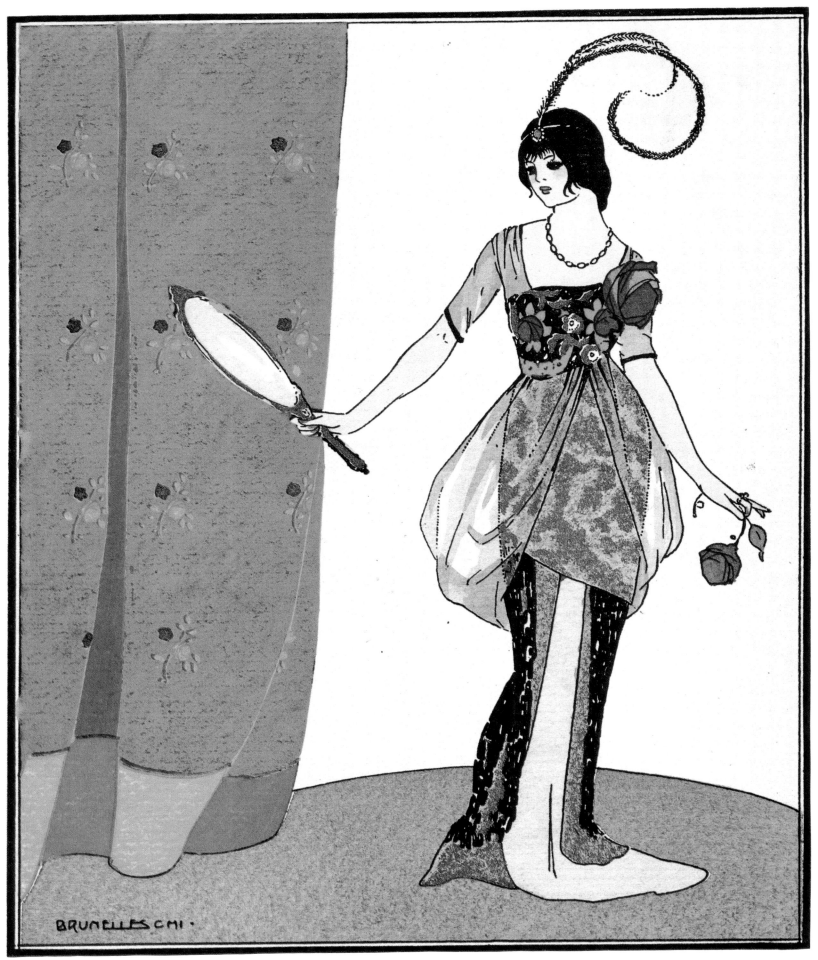

Pochoir illustration by Umberto Brunelleschi of a silk evening dress by Chéruit, for *La Gazette du bon ton*. 1912

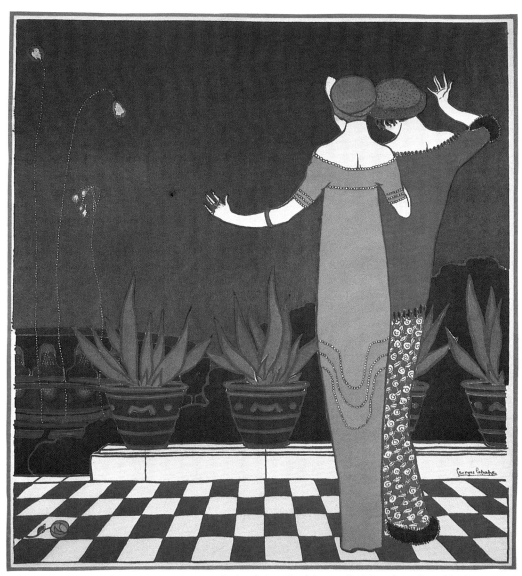

Illustration by Georges Lepape and highlighted with *pochoir* by Jean Saudé of two evening dresses by Paul Poiret, for *Les Choses de Paul Poiret*. 1911.

For every client there was also a particular *vendeuse* (saleswoman), who was responsible for the overall conduct of the order. The *vendeuse* looked after her client from the moment she walked into the salon until the moment the order was delivered. She reserved a seat for her to see the collection, kept a fitting room for her in which to choose her dresses after the parade, helped her with choosing a model, material and trimmings, and humoured her through the trauma of the fittings and the sudden disasters that sometimes occurred. It was also the responsibility of the *vendeuse* to arrange details with the stockroom, the embroiderer, the furrier and the milliner, to carefully inspect each item as it came down finished from the workrooms, and finally to see that delivery was effected on time.

This, then, was the luxurious world ruled over by Paul Poiret, Chéruit, Doucet, Doeuillet, Paquin, Redfern, Worth, Jeanne Lanvin, Madeleine Vionnet and Callot Soeurs.

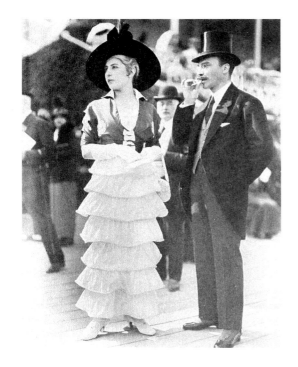

Paul Poiret was arguably the most flamboyant of the fashion innovators of twentieth century fashion. For over a hundred years the female body had been trussed in tight bodices and corsets, or distorted by bustles, crinolines and leg-of-mutton sleeves. Poiret threw away all this nineteenth century artifice and helped to create the supple, slender look that still dominates fashion today. But although he released the waist and freed the bust, he did not believe in the complete emancipation of the female form. Sometimes he imposed restrictions of his own, one example being the hobble skirt of 1912, so narrow at the hem that the wearer could scarcely walk: Yet smart women were delighted to follow his dictates and happily minced along the streets of Paris and the other capitals of the Western world during his reign.

Poiret was born in April 1879 in the very heart of Paris, near Les Halles. He spent most of his early years in an apartment above his parents' fabric shop. After finishing elementary school, he studied for a short time in a college run by Jesuit priests. He was apparently only an average student, spending most of his time sketching in the margins of his text books. After school, however, he exercised his talents and ingenuity by playing the violin in a small serenading group that wandered through the local neighbourhood. He also performed conjuring tricks at parties and studied the paintings and sculptures at the Louvre, which was very close to his home.

At the age of sixteen Poiret began work as an apprentice umbrella maker in a small factory owned by a friend of his father. He wrote in his diary in 1897, 'I'm dying of boredom. My eyes are starved. It's a lousy life. Umbrellas! The same infuriating routine over and over again! It's ridiculous, I'll go mad!' Later he wrote in his autobiography, 'The very dreariness of the circumstances forced me to dream ...' and in the evenings he designed and created dresses from the remnants he collected from his employer's floor and from his parents' shop.

For Christmas his sisters bought him a small designer's model on which to pin his fabrics, and the following spring they persuaded him to send some sketches of his designs to Madame Chéruit, head of the well-known fashion house. To his amazement she bought twelve and asked him for more. His work for Chéruit soon came to the attention of Jacques Doucet, at that time the most famous of the *grands couturiers*, and in mid-1898 Doucet invited him to work permanently for him as his junior assistant, to help rejuvenate his famous couture house at 21 Rue de la Paix.

Poiret was put in charge of tailored suits, and soon tasted his first triumph when over three hundred customers ordered a short red wool cape he had designed. Flushed with this success, he set about designing a range of tightly fitted jackets to be worn with flaring skirts, which reduced the fashionable, billowing mono-bosom and the exaggerated curved derrière then so much in vogue. These designs upset many of Doucet's established customers but were a big hit with the younger clients, as were many other innovative designs that followed until Poiret left for his military service at Rouen in 1900.

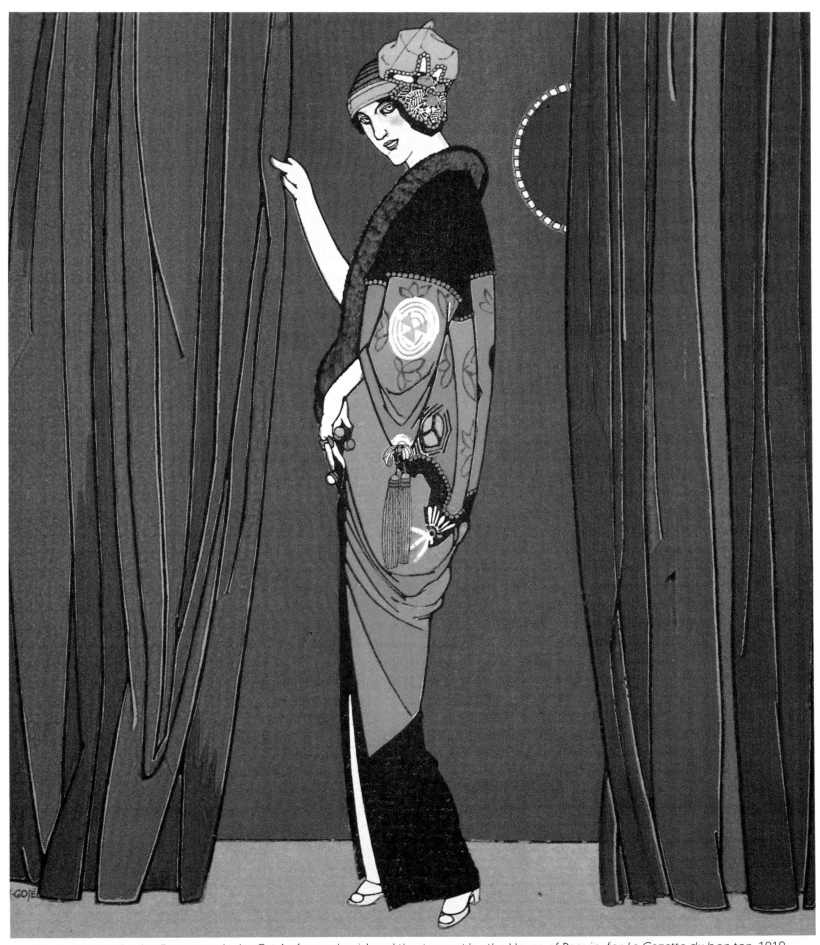

Pochoir illustration by Francesco Javier Gosé of an embroidered theatre coat by the House of Paquin, for *La Gazette du bon ton.* 1912.

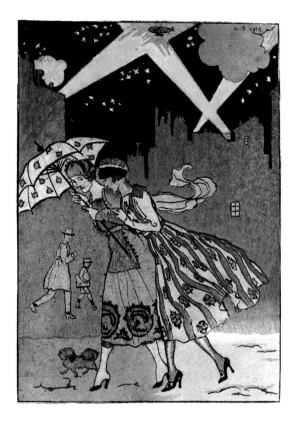

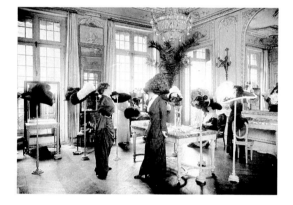

After a year Poiret left the army and joined the House of Worth as a designer of simple day clothes to complement the elaborate evening gowns of velvet and brocade for which the house had been famous since the days of the Empress Eugénie in the 1860s and early 1870s. He stayed at the House of Worth for two-and-a-half years, leaving in mid-1903 to strike out on his own.

On 1 September 1903 Poiret opened his small fashion house at 5 Rue Auber, behind the Opera. He later wrote,

At that time, lilacs, sky-blue hortensia, straw, anything that was pale, washed out and cloying to the eye, was held in the highest regard. I hurled some hell-bent wolves into that sheepfold. The bright reds, the royal blues, and the oranges and sharp citrus lemons made all the rest sit up and take notice.

Inspired by his friends Matisse and Braque and other members of the Fauves he soon introduced the full spectrum of colour into the everyday lives of the Parisians.

Early in 1906 Poiret moved to larger premises — a three-story mansion at 37 Rue Pasquier, near the Gare Saint-Lazare. In the same year he married Denise, the 19-year-old daughter of a textile manufacturer from Elbeuf in Normandy. She had a fine bone structure and a lithe figure, in contrast to the ample female shape still admired at that time. Soon Poiret was designing special clothes for her, including several with raised waists in the Empire style, which made the pregnant Denise look taller, slimmer and more graceful than any other woman in Paris.

The Poiret revolution began in earnest soon after the birth of his first child. He based his autumn 1907 and spring 1908 collections around the high-waisted styles originally designed for his pregnant wife. He transformed Denise into his ideal model, accentuating her graceful, willowy figure, and she became the prototype for the feminine silhouette so beautifully captured by Paul Iribe in the 1908 album *Les Robes de Paul Poiret*. Poiret later told a magazine reporter, 'My wife is the inspiration of my creations. She is the expression of all my ideals.'

The Empire style was an immediate success. In May 1908 the Paris correspondent of the American magazine *Vogue* wrote,

The fashionable figure is growing straighter and straighter, less bust, less hips, more waist, and a wonderful long, slender suppleness about the limbs. Here even the cab drivers and the butcher boys have already become accustomed to seeing ladies stepping along sidewalks holding closely in one hand the long skirt, which reveals plainly every line and curve of the leg from hip to ankle. The petticoat is obsolete, pre-historic. How slim, how graceful, how elegant women look!

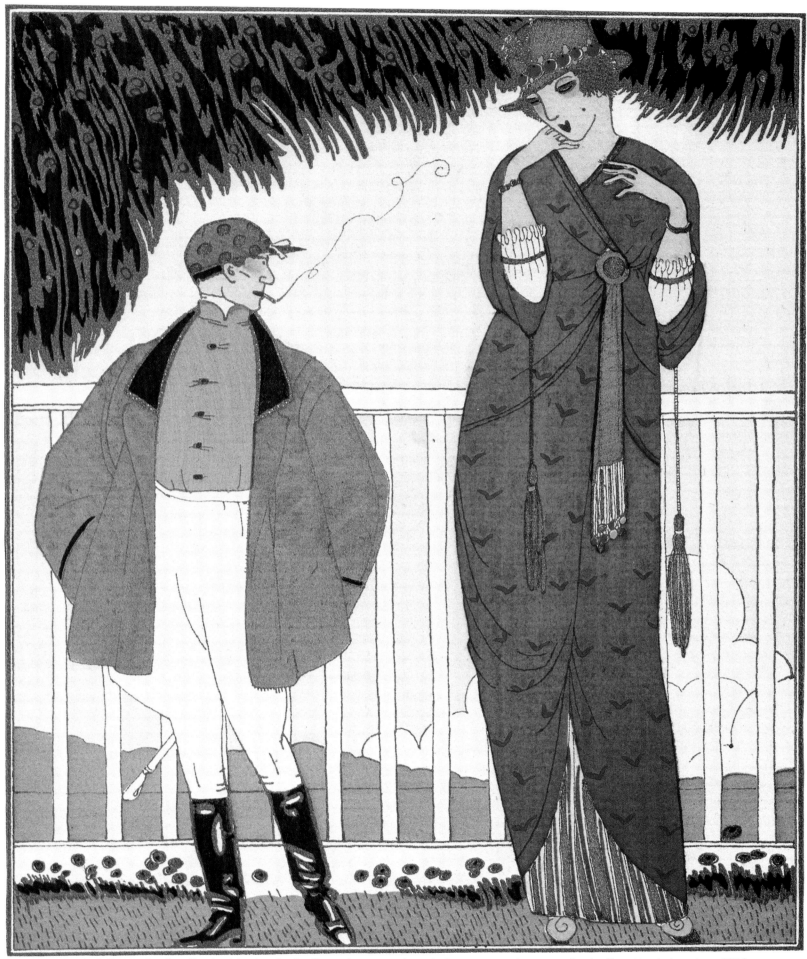

Pochoir illustration by Charles Martin of a Redfern afternoon dress to be worn at the races, for *La Gazette du bon ton*. 1913.

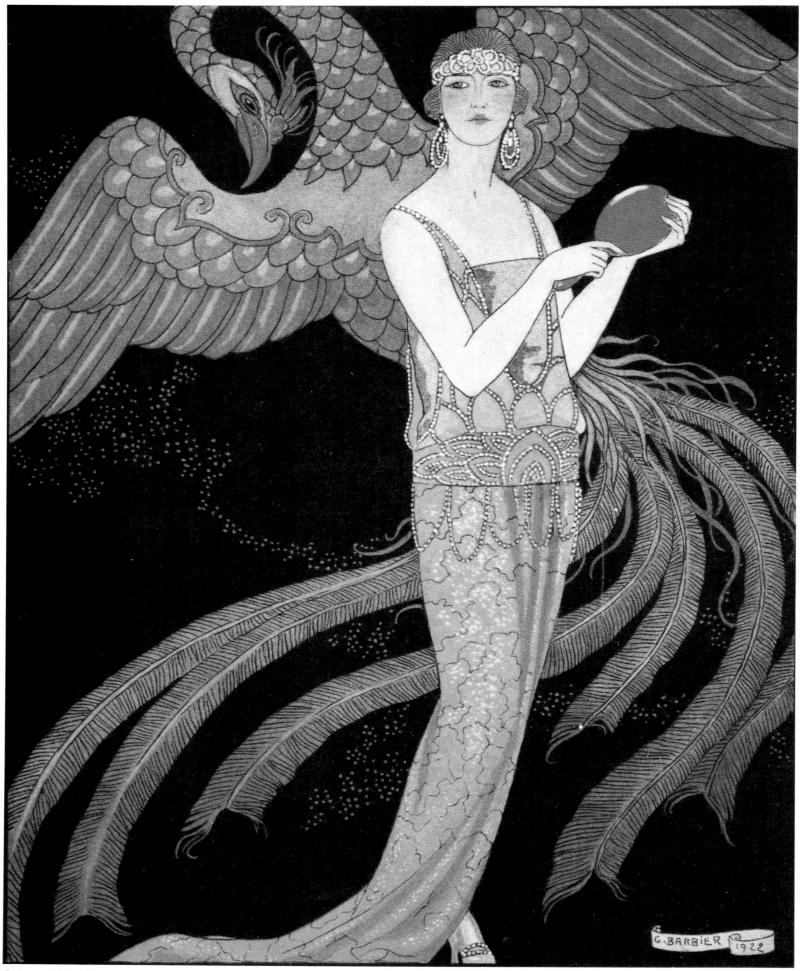

Coloured litho illustration of a beaded evening dress by the House of Beer, highlighted in silver and colours by George Barbier, for *La Gazette du bon ton*. 1922.

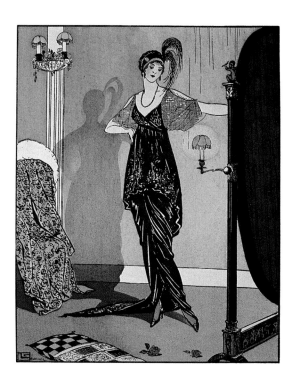

In mid-1909 Paris was electrified by the arrival of Diaghilev and the Ballets Russes, whose exotic costumes, designed in vibrant colours by Bakst, Bilibin and Benois, were worn over corsetless slim and supple bodies. Poiret responded in equally extravagant fashion, turning his salon into an evocation of the Arabian Nights, strewing it with large colourful oriental floor cushions and dressing his assistants in rich brocades trimmed with fur.

Poiret's parties and costume balls during this period were legendary. For one spectacular masquerade called 'The One Thousand and One Nights', held in June 1911, he transformed his house into an oriental palace. Pink ibis, white peacocks and flamingoes wandered in the garden, and parrots, macaws and monkeys were chained to trees scattered with hundreds of coloured lights. Eastern cooks prepared exotic dishes that were served with strangely spiced drinks. Flutes and zithers played as the guests reclined on the large, colourful cushions and soft rugs to watch exotic entertainments, whilst a slim nude 'slave' danced under a cloud of gauze. At the height of the evening's entertainment, Paul Poiret stepped forward in a sultan's costume, complete with quilted silk caftan and bejewelled turban, to open the royal cage of beautiful favourites. Out stepped Madame Poiret, wearing her husband's latest creation of loosely cut harem pantaloons in chiffon, fitting tightly at the waist and ankle, under a short hooped tunic of gauzy gold lamé which swayed in the evening breeze like an exotic flower. A gold lamé turban with a tall aigrette fastened with a jewelled clip completed the astounding outfit.

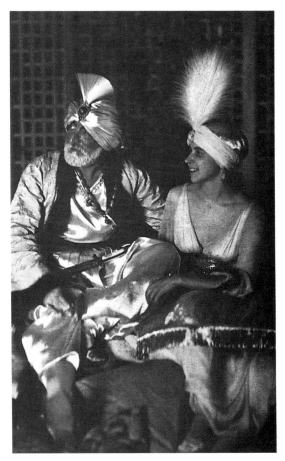

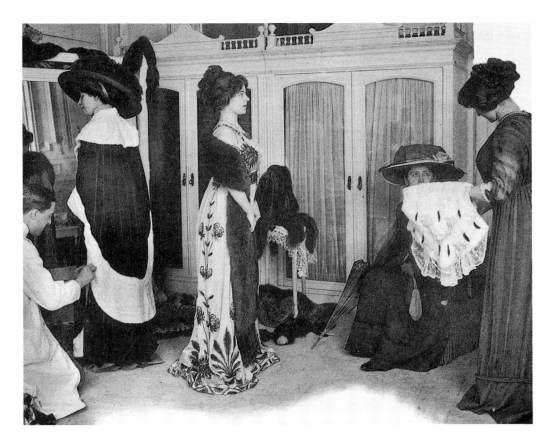

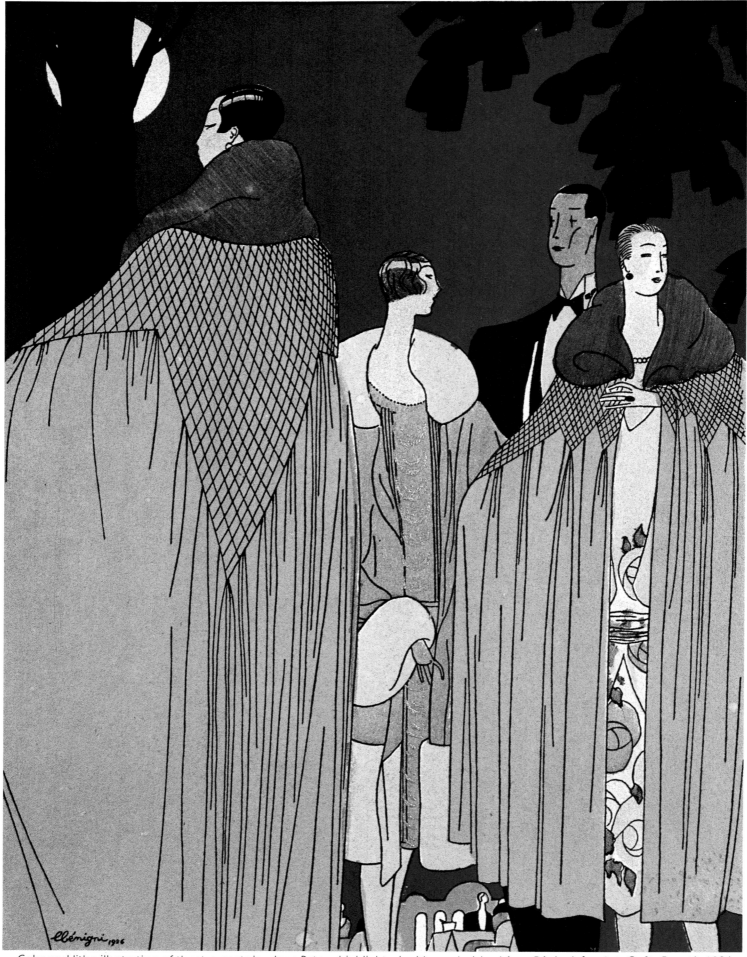

Coloured litho illustration of theatre coats by Jean Patou, highlighted with *pochoir* by Léon Bénigni, for *Art–Goût–Beauté*. 1926.

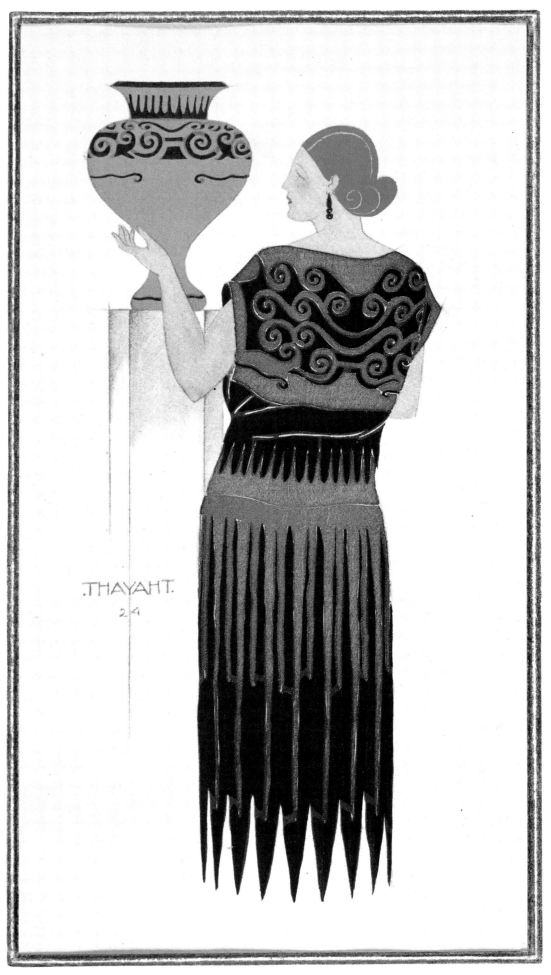

Offset litho illustration of an evening dress by Madeleine Vionnet, highlighted with gold and colours by Thayaht, for *La Gazette du bon ton.* 1924.

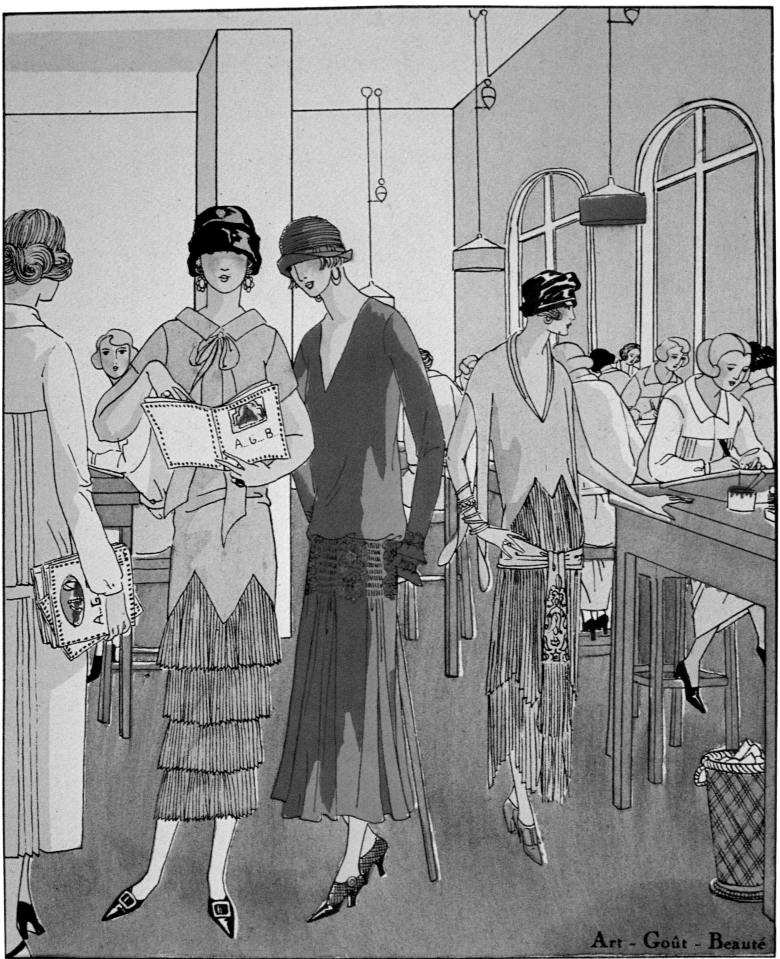

Offset litho illustration of afternoon dresses by Premet and Callot Soeurs, highlighted in *pochoir* by Robert Polack, for *Art–Goût–Beauté*.
1924.

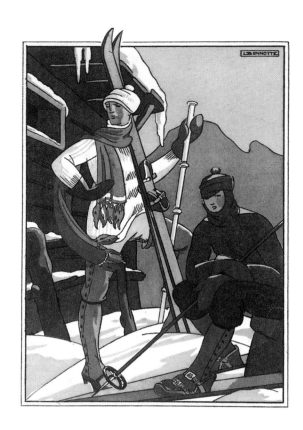

This sensational evening received enormous publicity, and the fashionable women of Paris flocked to Poiret's salon to order from his new Persian collection. He is reputed to have taken over two million francs' worth of orders in the first few days. His previous employer Jean Worth was horrified, describing the new fashions as 'hideous' and 'barbaric', 'really only suitable for the women of uncivilised tribes'. Jacques Doucet was more helpful and sent Poiret many of his own customers, among them the famous actress Gabrielle Rejan and Margot Asquith, the brilliantly witty wife of the English Liberal Prime Minister. She created a scandal and provided Poiret with enormous publicity when she wore a Poiret dress to an official reception at 10 Downing Street.

In 1911 the second Poiret album *Les Choses de Paul Poiret* was published, illustrated by Georges Lepape; it proved to be yet another marvel of Parisian elegance. The following year Poiret extended his influence further into the world of fashion illustration when he joined the syndicate of couturiers who were to finance *La Gazette du bon ton*. His business was flourishing.

Soon it was time to move to even larger premises at 26 Rue d'Antin, where he employed 350 workers. He also started the Martine School of Decorative Arts. With Raoul Dufy he infused new life into textile design, and he gave new significance to perfume by linking it for the first time to the name of an already famous fashion house. He opened his first boutique to sell his own ready-made merchandise, and he designed many costumes for the theatre. Georges Lepape, Paul Iribe and Erté all worked in Poiret's design atelier, and Raoul Dufy, Matisse and Charles Martin were there, too, devising new and unusual fabric prints.

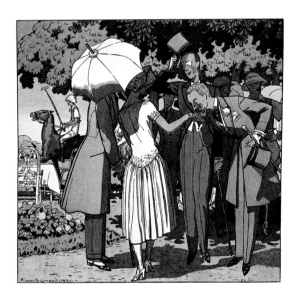

Both in his sense of clothes and in his own lifestyle, Poiret caught the essence of Parisian taste during that heady period between the end of the Belle Epoque and World War I. For his clientele he made the world of Persian princes and oriental princesses seem real. With the outbreak of war in August 1914, however, the oriental dream began to fade. The emancipation of women's dress, started by Poiret in 1908 when he first liberated the lady of fashion from the trussed and fusty image of the previous hundred years, was soon to be completed by the sheer, practical necessities of war work.

Whilst war was actually being waged the trousers and overalls of the munitions workers, the uniforms of the nurses and the jodhpurs of the 'farmerettes' were not considered to be 'normal' dress and were rarely featured in the pages of the glossy fashion magazines. Immediately after the war, though, there appeared a young girl who caught the essence of this change in the clothes she made from muted tweeds and jersey. Her name was Gabrielle Chanel.

Gabrielle 'Coco' Chanel was born in Saumur in the Loire Valley on 19 August 1883, the second illegitimate daughter of Jeanne Devolle and Albert Chanel (they married on the arrival of their third child in 1885). She grew up in the Périgord countryside around Brive, travelling from town to town with her parents, who were vendors of haberdashery, yard goods and dress trimmings.

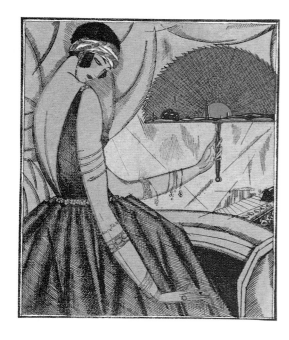

When she was twelve her mother died and Gabrielle Chanel was placed in an orphanage run by the Sisters of the Sacred Heart of Mary at Moulins. At the age of fifteen she left the convent to work locally in a small dressmaker's shop and two years later she moved to Paris. By 1910 she had become a successful milliner, known for her unusual hats. In 1913 she opened her first dress shop in Deauville, then a small seaside town with a large sporting community, where she specialised in designing and making simple forms of sportswear.

When war broke out many of the Paris couture houses closed down and many fashionable women moved away from the city, some going to Deauville. Chanel's shop flourished, and by 1916 she had saved enough money to move to the fashionable resort of Biarritz, where she opened her first couture house. By the end of the year her enterprise had grown into a full-scale *maison de couture* with 300 workers. Edmonde Charles Roux, in her biography of Chanel, writes of this period,

> For anyone who was still able to think about elegance, that acute dilemma 'Chanel or Poiret?' did not exist. Gabrielle's formidable rival was devoting all his talents to the armed forces, where as a military tailor he had the responsibility of redesigning the army uniform — a task he achieved by reducing the fabric costs by 1 meter and the making costs by three hours, resulting in the saving of many hundreds of thousands of francs.

In 1919 Chanel established her couture house in Paris, at 21 Rue Cambon, and from there launched her functional sporty fashions in the autumn of that year. The clothes she designed were simple, comfortable, muted in colour, and more notable for their casual chic than for innovation of cut. It was the very simplicity of her designs that made them a success with the American and British haut monde, who had wearied of ornate and fussy dressing. Gone were the days when fashionable women sought to be swathed in orgies of fabric and loaded down with gold and sequins, *à la Poiret*.

Gabrielle Chanel's impoverished background was a great advantage to her in this post-war period. Other designers were accustomed to a clientele for whom sumptuousness equalled elegance and now found it difficult to give up ornamentation, but she had never yielded to its temptations. The elimination of inessentials dominated her work, her only concessions being to costume jewellery, which she promoted as her hallmark, and to perfume.

The couturier Madeleine Vionnet was born in the Jura Mountains region in 1876. Like Chanel, she had little schooling, leaving school after failing her *prix d'excellence* at the age of eleven. For the next five years she worked twelve hours a day as an apprentice dressmaker, eventually joining the house of Vincent in the Rue de la Paix at the age of sixteen as a qualified seamstress. In her early twenties she moved to London, where she worked for four years with the court dress-maker Kate Reilly, who dressed her Victorian society ladies in costumes of voluminous richness.

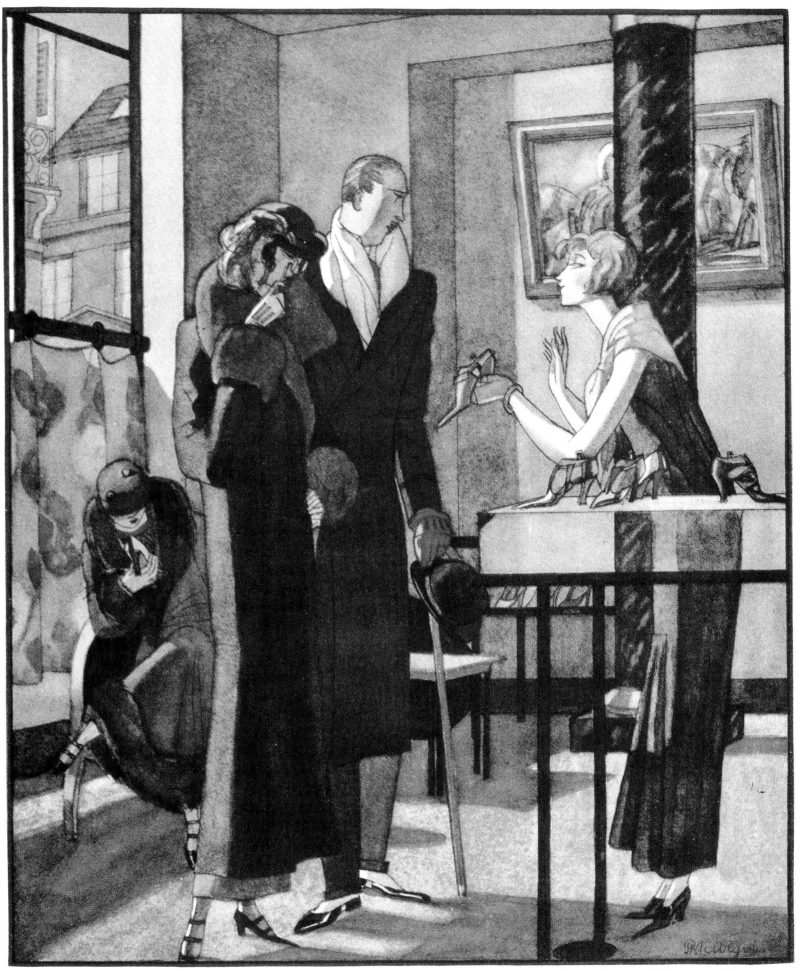

Coloured litho illustration of shoes by Perugia, highlighted in *pochoir* by Pierre Mourgue, for *La Gazette du bon ton*. 1924.

Back in Paris at the turn of the century, Madeleine Vionnet was befriended by Madame Gerber, one of the three sisters who ran the couture house of Callot Soeurs, which, with those of Worth and Jacques Doucet, led Paris at that time. Fashionable women were still encased in a heavy armature, with half an aviary balanced on their heads, high-boned collars that nearly strangled them, tight pointed shoes that almost crippled them, and corsets that squeezed their waists, snarled up their intestines and endangered their health. But Isadora Duncan was already dancing with bare feet, bouncing breasts and trailing draperies, and painters had liberated colour from the gloom of the nineteenth century.

Vionnet responded to these changes by designing avant-garde peignoirs, tea gowns and *robes déshabillé*, first for Callot Soeurs and then, from 1907, for Jacques Doucet. At the same time as Paul Poiret she discarded the corset. She thought it 'a monstrous contraption'. Until her retirement in 1939 Vionnet would not allow her model girls to show her dresses in what she described as 'those hideous and painful medieval contrivances'; from 1907 onwards they wore her seductive peignoirs and *robes déshabillé* not only corsetless but with bare feet. She plainly intended the more adventurous of her customers to wear her revolutionary styles in public.

In 1912 Vionnet opened her own house at 212 Rue de Rivoli and there she achieved considerable success. During World War I lack of materials forced her to close down but she re-opened at the end of 1921 at 5 Avenue Montaigne. Between 1922 and 1930 she developed her famous simple, superbly elegant clothes, which exploited to the full the relationship between the dress and the structure of the body. This she did by what is best described as the invention of the 'bias cut'. With her scissors she changed the course of fashion and dressmaking techniques and the manner in which she manipulated fabric has never been equalled. Everything she created had to hang and cling and she used special fabrics to this end — slippery satins, fluid velvets, heavy silk crepes and the finest crepe de Chine, all woven to an unprecedented width of 150 centimetres. 'You must dress a body in a fabric, not construct a dress into which the body is expected to fit,' she said.

Never before had well-shaped bodies had a more beautiful showcase, and no other designer has ever surpassed Vionnet's understanding of proportion, balance, and the harmony between a dress and the rhythm of the body underneath. Her invention of the bias cut also allowed dresses to be made without any tricky fastenings: they could be slipped over the head and allowed to fall with a new naturalness. This is all the more surprising when one remembers that Madeleine Vionnet was born early in the last quarter of the nineteenth century and that her first important jobs were at the height of the Belle Epoque, working for Kate Reilly and Callot Soeurs. Vionnet said that she owed her eye for perfection — and thus her success — to this period of her life, particularly the years spent with Callot Soeurs. Until her death in 1975 she kept a photograph of Madame Gerber constantly by her.

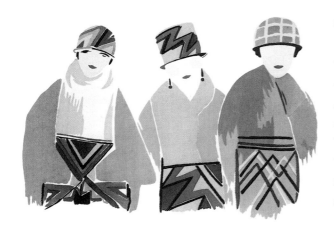

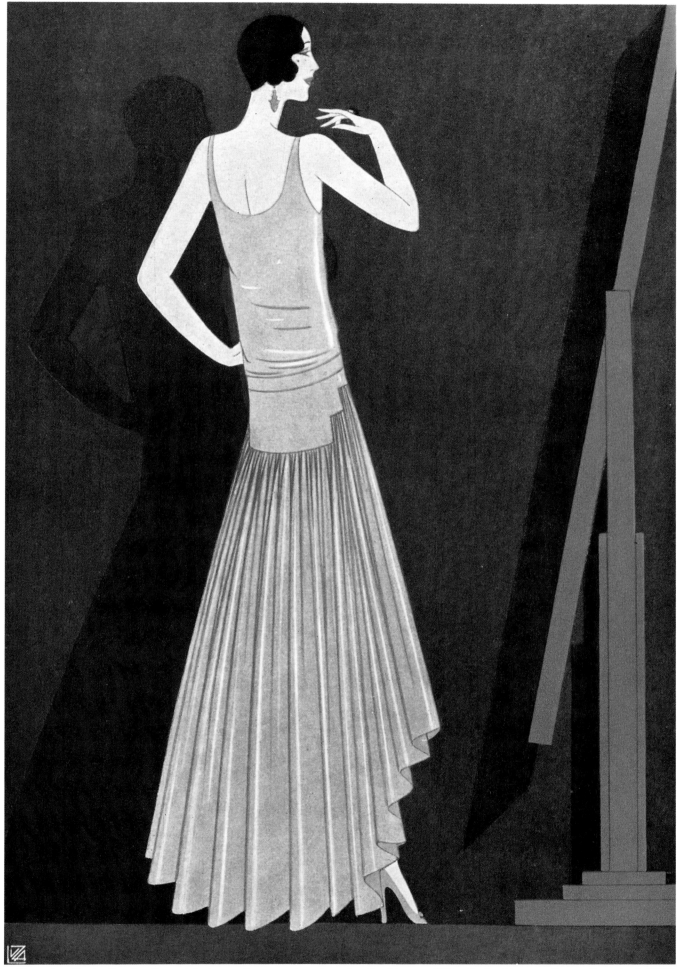

Magazine illustration by Reynaldo Luza of an evening dress by the House of Worth, for *Harpers Bazaar* (London). 1928.

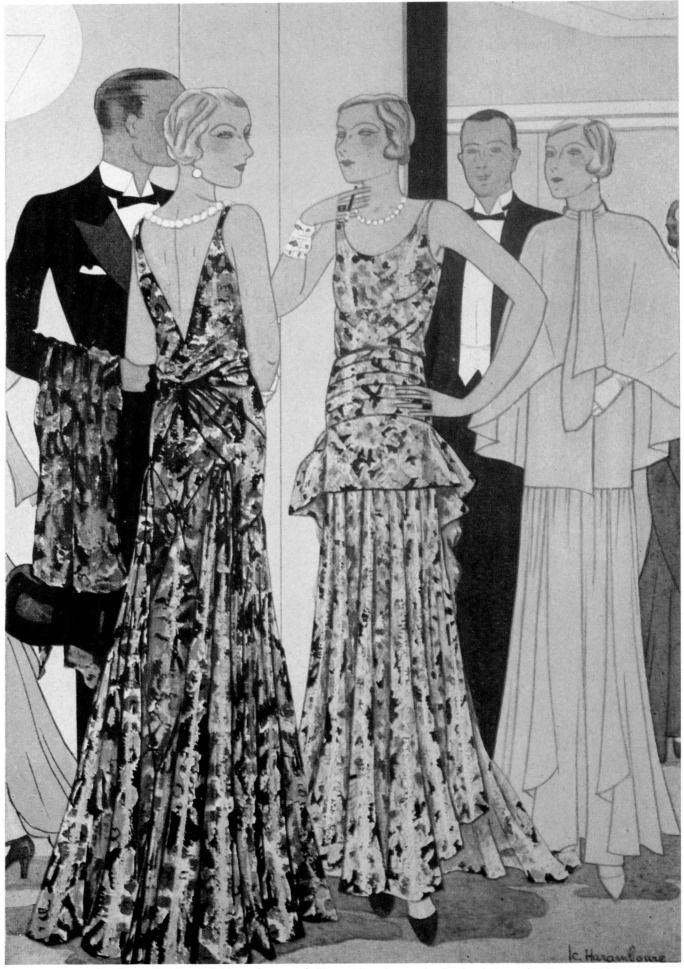

Magazine illustration by J. C. Haramboure of silk evening dresses by Lucien Lelong, for *Femina*. 1934.

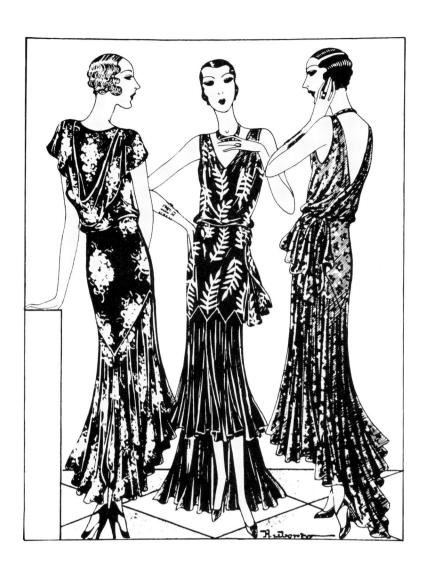

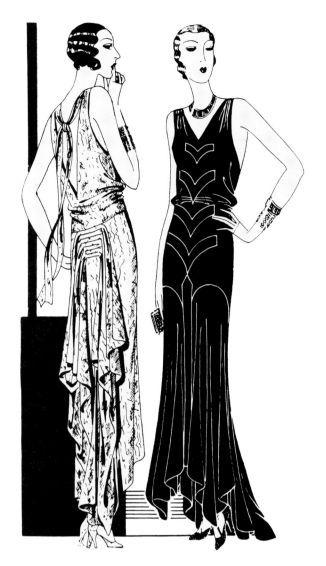

Madame Gerber was one of the three sisters, born in France of Russian ancestry, who presided over the house of Callot Soeurs. In 1895, after merging with the house of Ernest Raudnitz, they opened in the Rue Taitbout, remaining there until 1919 when they moved to the Avenue Matignon and then to the Avenue Montaigne in 1935. Throughout this time the house of Callot Soeurs was one of the utmost elegance, its clothes travelling gracefully through the various stages of fashion. During the Belle Epoque, Callot Soeurs' lace dresses were famous; in the years preceding World War I Callot Soeurs followed the new silhouette and the orientalia inspired by the Ballets Russes; and in the twenties, when legs were being seen from the knee down for the first time, Callot sheaths blossomed with the latest exotic motifs and framed the legs with beautiful hemlines, scalloped, panelled, encrusted with beading, tassels and embroidery.

Made of the finest silks, lamés, velvets, satins and crepes, Callot dresses were perfect in every detail. As if influenced by their Russian heritage, the sisters' embroideries glowed with exquisite oriental colour — the cool creams and pinks of lotuses on mauve and chartreuse, the greens of jade and emeralds, the blue of lapis lazuli, and the contrast of tangerine or orange against black. Yet, however colourful, heavily beaded or embroidered these wonderful clothes were, they were always characterised by a subtle restraint that endowed them with the timelessness and elegance for which they are so admired today.

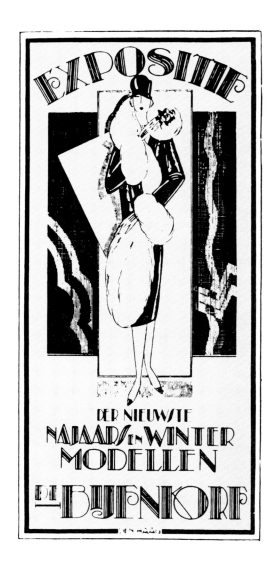

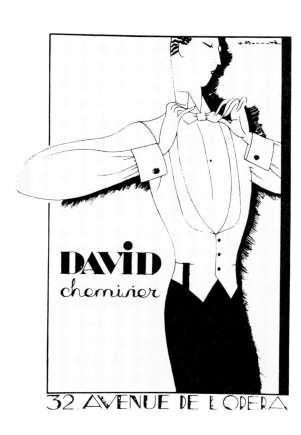

Madame Paquin also established her couture house in the 1890s, after training with Maison Rouff. Her opulent and elegant designs were an immediate success, and she soon commanded a large international clientele. In 1900 she was appointed president of the fashion exhibition, 'Toilettes de la Collectivité de la Couture', at the Paris Exposition Universelle. Her clothes were noted for their superb workmanship, as they were again at the Brussels International Exhibition of 1910. After the war, however, the house declined in popularity and eventually merged with the house of Worth.

Another well-known couturier was Jeanne Lanvin, who, like Chanel, started work in Paris as a milliner around the turn of the century. She also became famous

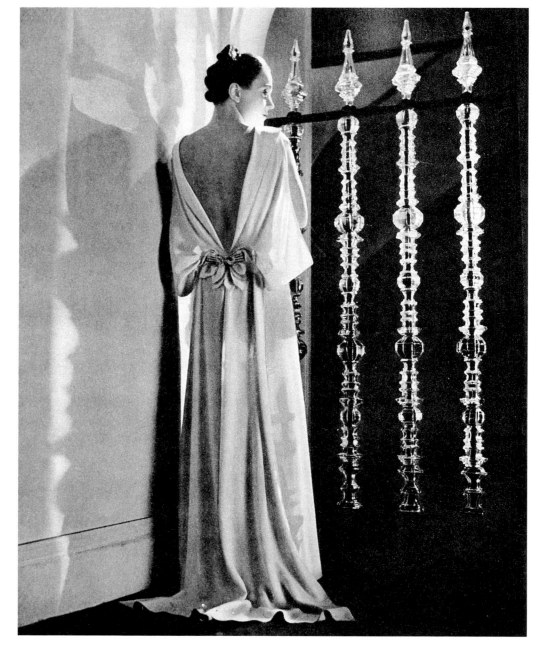

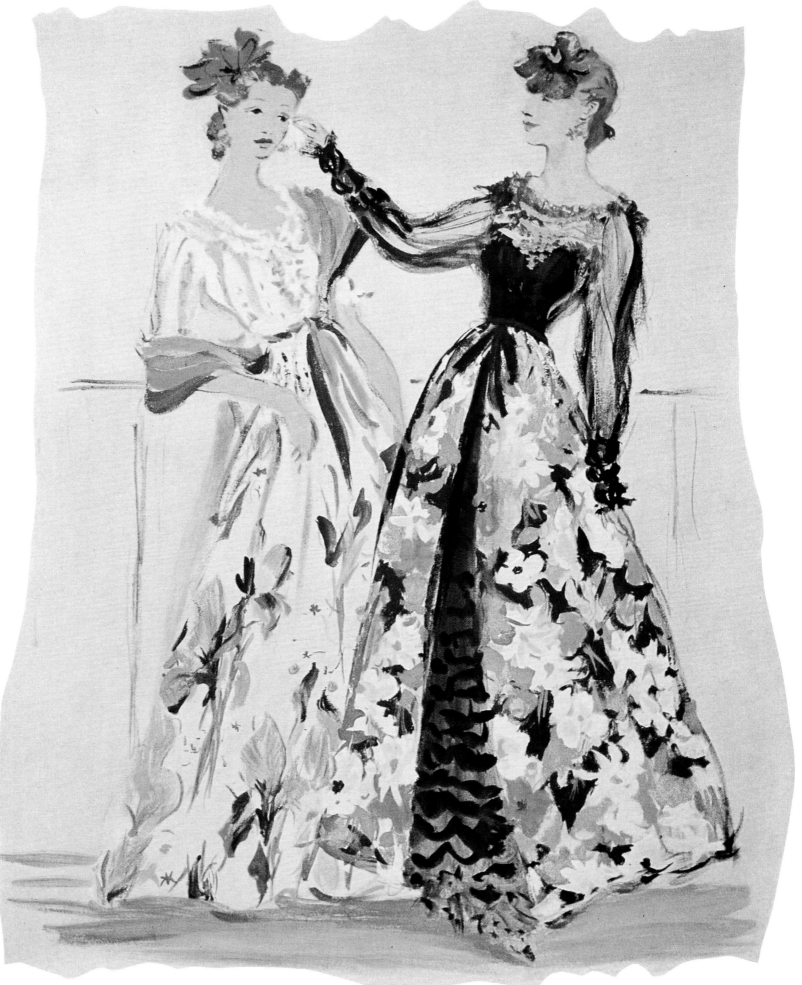

Magazine illustration by Vertès of silk taffeta, chiffon and lace evening dresses by Coco Chanel, for *Harpers Bazaar* (London). 1939.

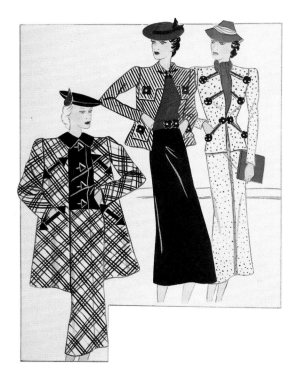

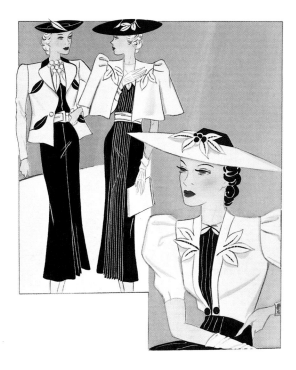

for her luxurious children's clothes and by 1910 had established a couture house in the Rue Royale, with a youthful and elegant clientele. Continuing throughout World War I and exhibiting in the famous Panama Pacific International Exhibition in 1915, she caught the mood of change with her designs and her house flourished throughout the 1920s, 1930s and well into the post World War II period.

The English houses of Redfern and Worth were also among the more important *maisons de couture* in the early twentieth century. Redfern has the distinction of being one of the few couturiers whose main business was in England, his Paris house being only one of several branches that he established in the late nineteenth century. The house of Redfern originated at Cowes on the Isle of Wight in the mid-1840s, specialising in traditional tailor-mades and yachting costumes. Although the range was extended when the founder's son opened London and Paris branches in the early 1880s, the mainstay remained tailored suits and sports clothes, and so great was this English speciality that by 1910 there were branches in New York and Chicago, as well as Cowes, London and Paris.

The House of Worth was founded by another English-born designer, Charles Frederick Worth, in 1858. It was the first of the really great couture houses of Paris and became famous internationally for its flamboyant crinoline styles worn by the Empress Eugénie and the ladies and demi-mondaines of the court of Napoleon III. By the early 1880s Worth had established branches in all the major European capitals and was dressing most of the courts of Europe. After his retirement in 1889 his sons Jean-Philippe (mainly responsible for the design) and Gaston (who saw to the organisation) carried on, and after them his grandsons maintained the splendour of the house's tradition until it closed in 1956.

In recent years the work of these couturiers and those who were to follow during the next twenty-five or so years has been the subject of re-evaluation by the major museums of the world and a number of retrospective exhibitions have been held since 1975, notably in Paris, London and New York. This has prompted many leading art historians to conclude that these couturiers were 'a new breed of artist, unique to the twentieth century, who now occupy a position in our culture unparalleled at any other time'. And the really great dresses made in Paris between 1905 and 1939 are at last finding a place in the art collections of the western world.

The dresses from the pre-World War I period were quite different from those of the 1920s. Much had happened during the four years and three months of bloody conflict which dramatically affected the way people wished to dress. The Paris couturiers absorbed the new influences and began to produce new ranges of fashionable attire that were more in tune with the changing times. A new group of couturiers also emerged whose designs were more suited to the increasingly important American and British outdoor lifestyles. They also realised that international travel was destined to become a major influence, as was jazz music, new dance crazes, new attitudes to sexuality, and the styles of Hollywood stars.

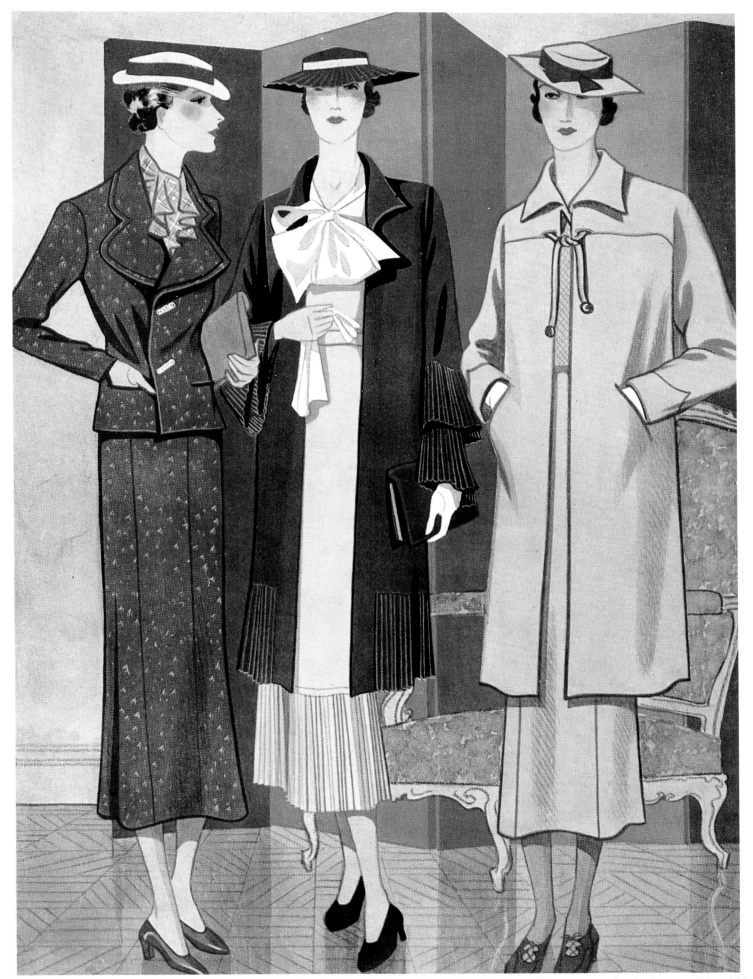

Offset litho magazine illustration by an unknown artist of tailored suits and coats by Estelle et Zimmermann, for *La Femme chic*. 1935.

Jean Patou was one of the most innovative and influential couturiers of the post-war period. Like Coco Chanel, he realised that the sporty, emancipated woman was the customer of the future and he devoted much of his creative energy to designing both active and spectator sportswear, beachwear and clothes that were casual but chic. Patou was very pro-American, admiring their business methods, and in 1925 he began to show his collections on American model girls, who wore his designs to advantage and greatly influenced his design work. He is probably best remembered by Cole Porter's line 'You're the tops, you're a dress by Patou', a line that so raised Chanel's anger that she never forgave Patou or Porter.

The young Irishman Captain Edward Molyneux also became a leading couturier in Paris during the early 1920s, designing clothes that appealed to the young members of the haut monde who had inherited their wealth, rather than having to work for it. His clothes brought a sense of restraint and propriety to the world of the jazz age — he was what H.W. Yoxall in *A Fashion of Life* (1966) described as 'a designer for ladies, when some of his competitors had, shall we say, broadened their appeal'.

All of the younger group of couturiers working in Paris during this time were aware that the age of the fashion autocrat had passed and that it was their task to respond to the changing needs and lifestyles of their clients. As one leading French journalist declared in 1925,

> Above all else, the couturiers of today must be professional innovators; it is their function in life to conceive that which will be worn tomorrow — today is already too late. They must always be able to foresee the demands of public taste and then, if they have any originality and skill, they must be able to direct public taste towards their ideas and be prepared to modify these ideas in order to fulfil the public's need. The new breed of couturiers are fully aware, however, that if they are successful their long hours of work will have only a fleeting existence — maybe today the designs which issue from their hands are a success; they are in vogue; they are a triumph! But tomorrow they will have been superseded by some other styles. This process is the natural evolution of fashion. Why should it be otherwise? How, indeed, could it be otherwise? . . . But therein lies the genius of the really talented couturier — to know how to light upon elements in their current collection with enough character to rise again one day from the past, with an ageless beauty and eternal youth.

This is exactly what the designs of the 1920s and those that followed in the 1930s were able to do and this is why they are now being so avidly collected by the major art galleries and museums around the world.

In the financial chaos that followed the collapse of the American Stock Market in October 1929, during the period known as the Great Depression, the rising stars of Hollywood began to change people's dreams and aspirations. They allowed an escape from the hunger and fears of the real world and this escapism greatly affected the way people wanted to look. Many women yearned to dress like their favourite movie star, and film fashions designed by the Americans

Magazine illustration by Count René Boute Willaumez of a cocktail suit by Bergdorf Goodman, New York, for American *Vogue*. 1941.

Magazine illustration by René Gruau of two evening dresses by Cristobal Balenciaga, for *Femina*. 1946.

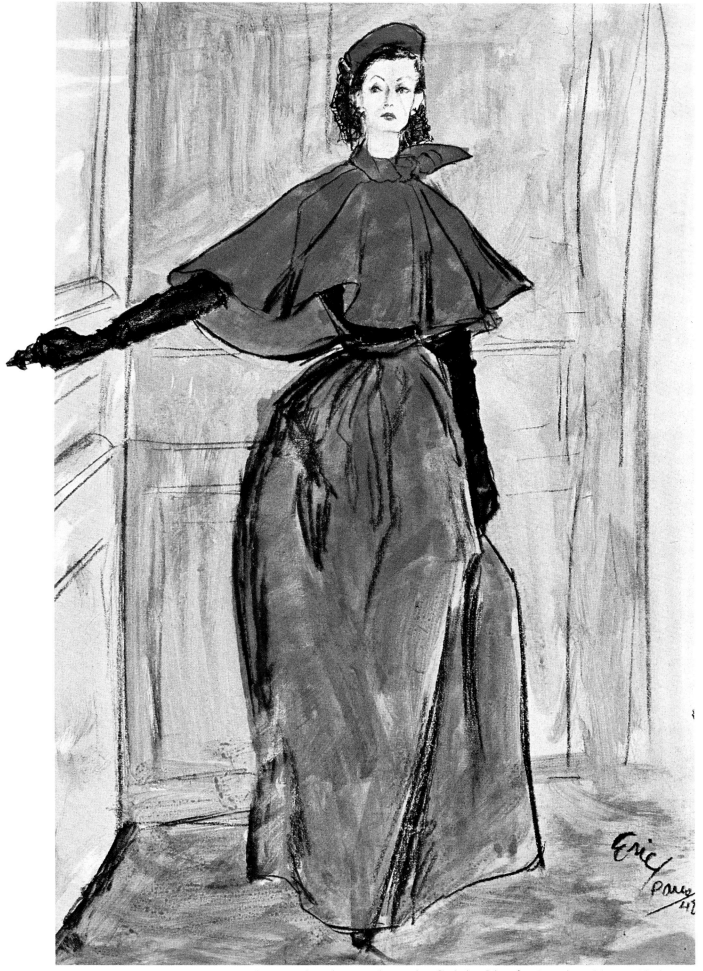

Magazine illustration by Eric of an evening dress and cape by Christian Dior, for American *Vogue*. 1948.

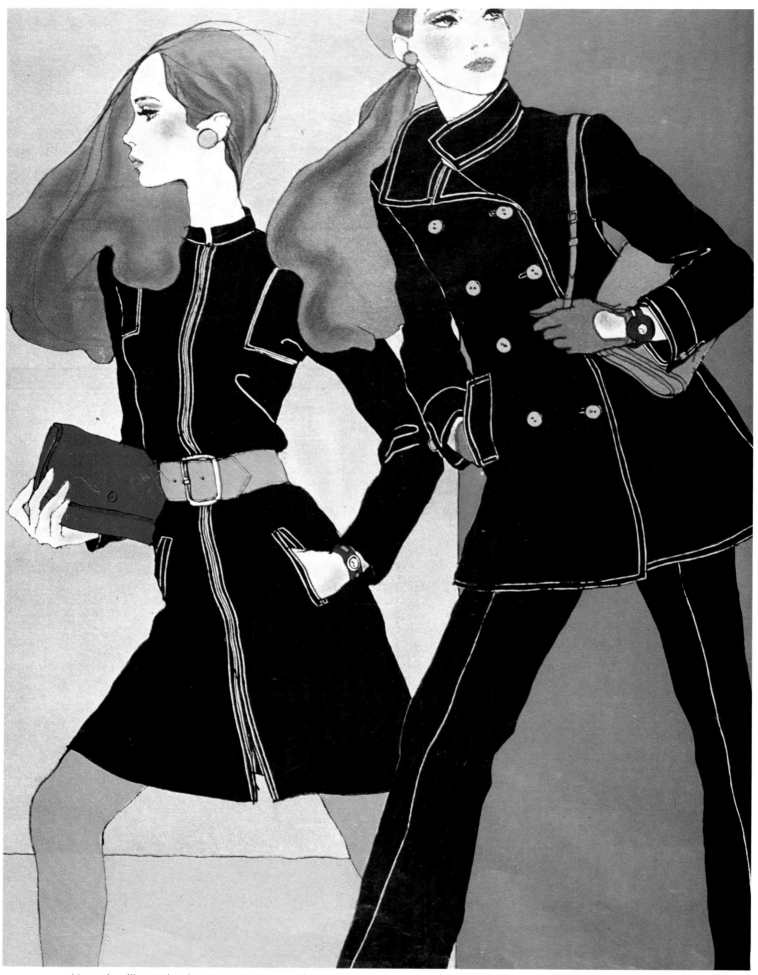

Magazine illustration by Antonio Lopez of French ready-to-wear designs by Emmanuelle Khanh, for *Elle*. 1967.

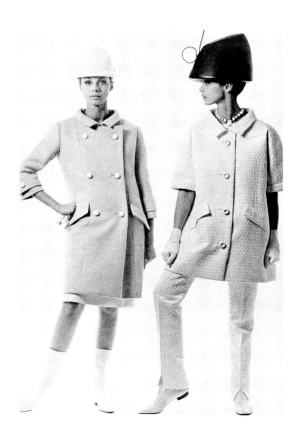

Adrian, Travis Banton, Howard Green, Milo Anderson and Walter Plunkett were being copied by manufacturers everywhere. In order to capitalise on this new trend Chanel, Lanvin, Patou and the new couturiers Schiaparelli, Madame Grès (known simply as Alex) and Maggie Rouff designed special garments for many of the leading female stars. A new fashion magazine called *Film Fashionland* was launched, the editor declaring, 'This new monthly fashion magazine is going to bring all of the charm and romance, all of the beauty and excitement of Hollywood into every woman's life'.

Included in the first edition were photographs of the latest in silk lingerie, an article entitled 'Film Fashions in the Making', instructions on 'How to Hitch Your Beauty to a Star', secrets of the use of Hollywood-style cosmetics, and advice about 'Keeping Fit' by Busby Berkeley's favourite chorus girl Toby Wing.

But the influence of Paris haute couture did not completely fade away. The Hollywood challenge brought to the fore many innovative designers, among them Cristobal Balenciaga, Jean Dessès, Nina Ricci, Jacques Fath, Mainbocher, Marcel Rochas, and a little later Christian Dior, Courrèges, Valentino and Yves Saint-Laurent. And talented designers and skilled craftsmen still carry on the centuries-old tradition of originality and fine workmanship in the couture houses that remain and in the new prêt-à-porter — expensive ready-to-wear fashions — that today are more important and more lucrative than haute couture ever was.

By the early 1960s the designers of ready-to-wear fashions had become as important as those working with Paris haute couture and the Hollywood film industry. A new range of skills had been developed which allowed the ready-to-wear designers to produce designs totally unlike any that had been marketed before.

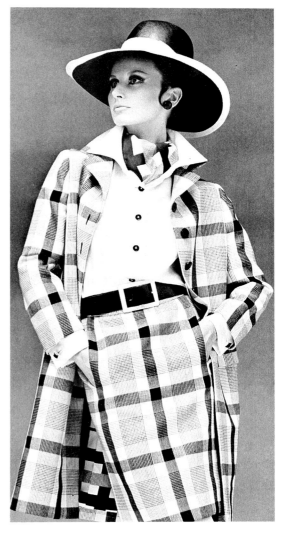

This was the period known as Swinging London, a time when the new breed of English ready-to-wear designers produced all of the new fashionable styles that most women in the Western world wished to purchase and wear. The baby-boomers of the immediate post-war years were now young women with plenty of available cash to spend on clothes and it was the designs produced for this group that came to symbolise the Swinging London era and gave birth to original styles based on the philosophy first propounded by Mary Quant, that 'the young no longer wish to dress like their mothers'. Many Mary Quant fashions were iconoclastic: she was not averse to promoting styles that defied traditional ideas of good taste but looked good on the young college students who frequented her King's Road shop and looked disastrous when worn by their mothers. She set a trend that has survived to this day.

By the beginning of the 1970s a new group of fashion designers had begun to emerge in most of the major cities of the Western world. Their diverse styles were well suited to the growing number of young people and their success was fuelled by the increased freedom and spending power of these new customers, who forced the trend away from the seriousness that had dominated the styles previously worn by the haut monde, the wealthy middle class and their followers.

THE REASONS FOR CHANGE

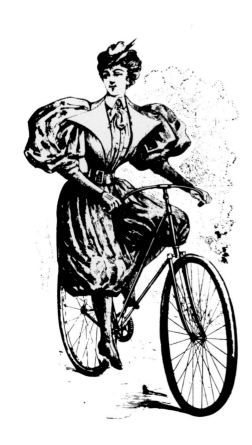

great many factors affect the clothing styles we choose — economics, aesthetics, morals, modes of manufacture, methods of transportation, new scientific discoveries, lifestyles, cultural traditions, the media — and the styles of each period seem perfectly suited to their origin. Despite the transient nature of the styles, or maybe because of it, each style always seems admirably suited to those who wore them, and no matter how incongruous they may seem to our eyes they would be even more incongruous if placed in any other time. Could you imagine, for instance, Henry VIII in any form of attire other than the bejewelled tunic, padded hose and protuberant codpiece that we have become accustomed to seeing in his portraits? Or who could imagine the Empress Eugénie wearing anything but an elaborate confection of the middle to late nineteenth century? The same question might also be asked of the ancient Romans or the more recent 'flappers' of the mid-1920s: would they not appear strange to us in anything other than a draped toga or a short beaded dress? Conversely, can you imagine living your current lifestyle dressed in the costume of Elizabeth I or Louis XIV?

The clothing styles we wear reflect the society and the age in which we live and we tend to change our external image as our hopes, aspirations, fears, and vision for the future change. But, even more than this, the individual styles we choose to wear within the currently accepted mode are part of an important code language that we use to communicate with others. We select these coded styles in order to look younger, prettier, more adventurous, wealthy, sexier, reliable, more athletic, intellectual, powerful, available, authoritative, or anything else that we wish to say about ourselves as individuals. And, like all other modes of human expression, the symbols used in our clothing styles continually change, just as the symbols used in painting, sculpture, poetry and literature continually change. We feel the need to constantly update our modes of dress so that we can be sure of transmitting the correct messages.

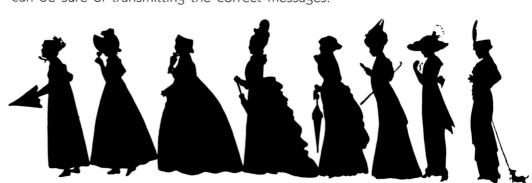

Empress Eugénie and Ladies, Winterhalter. (Courtesy Musée de Compagne, Paris).

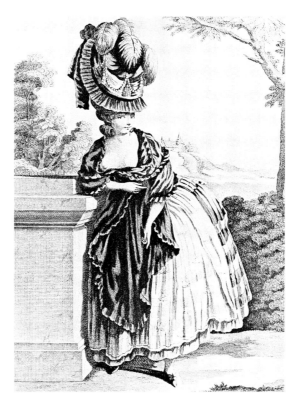

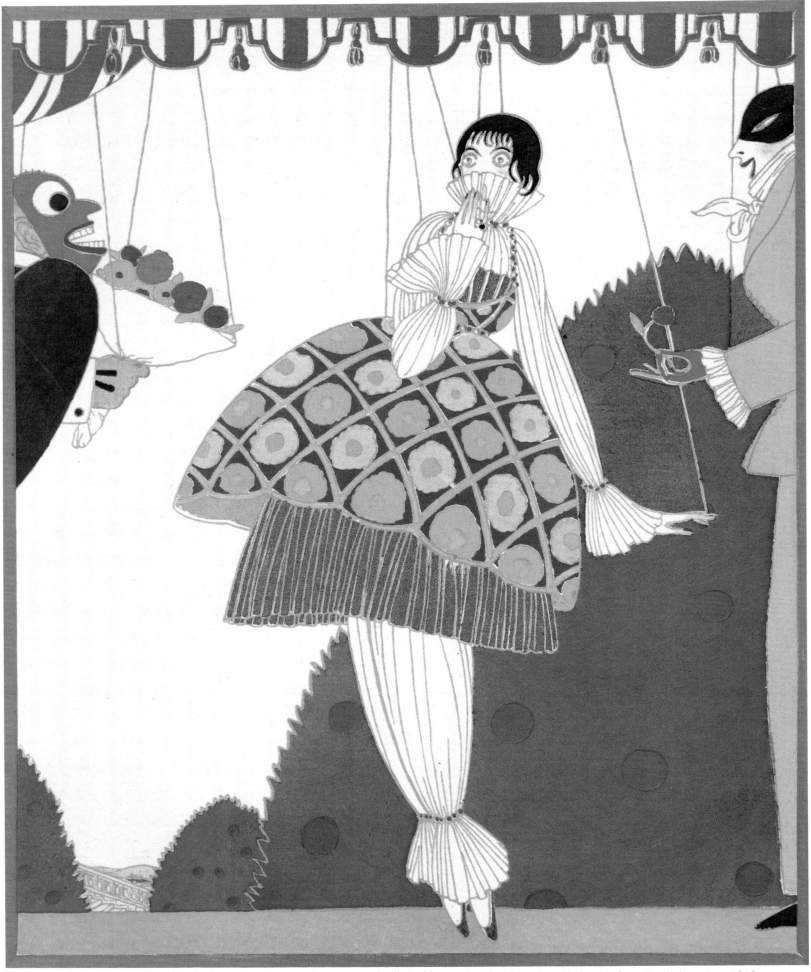

La Femme et les pantins designed by Georges Lepape and printed in *pochoir* by Jean Saudé, for *La Gazette du bon ton*. 1913.

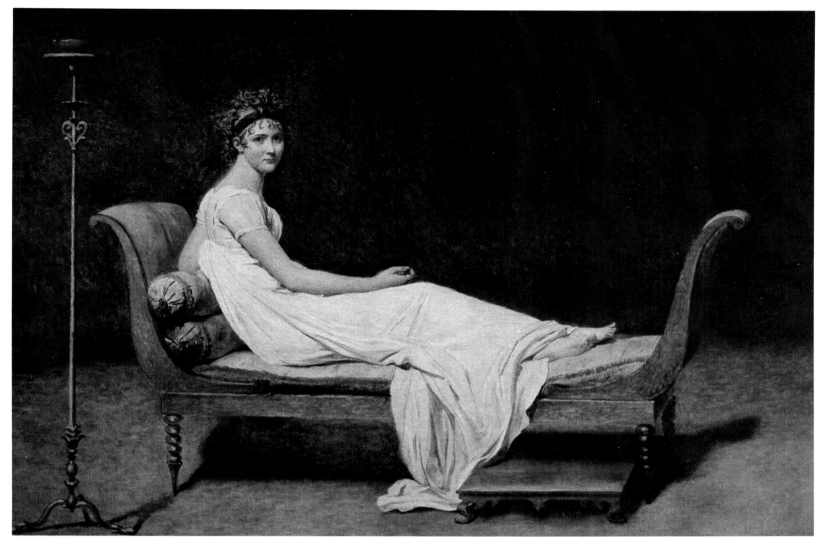

Mme Récamier by Jules David. (Courtesy of Le Louvre, Paris).

In the past, the rate of change in Western modes of dress fluctuated greatly: some styles appeared to remain 'in fashion' for many decades; others were fashionable for only a few months. The difference in these rates of change was a reflection of the amount of money available for purchasing new modes of dress, more money leading to a more rapid rate of change as the various strata of society, and individuals within each stratum, competed against each other for dominance. As Doris Langley Moore stated in *The Woman in Fashion* (1949), this is

> ... a phenomenon based on forms of class distinction that can operate only when the social order is fluid; when the structure of society is such that each stratum is able to take on the manner of life of another stratum which seems to have more advantages. The envied class wishes to maintain its separateness and tries to keep imitators at a distance by creating differences of dress which will establish the prestige of its members visibly and immediately.

Other factors, such as natural disasters, revolution and war, have also been important in changing our Western clothing styles. After the Black Death swept through Europe in the fourteenth century, killing more than one-third of the total population, the fashions for both men and women became quite immodest: many of those who remained were unmarried or had lost their spouse. They were actively seeking a mate.

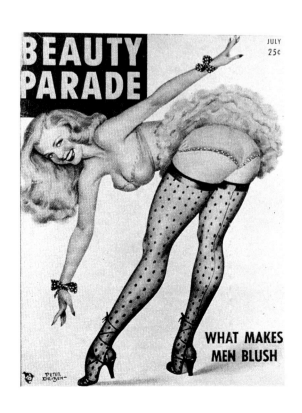

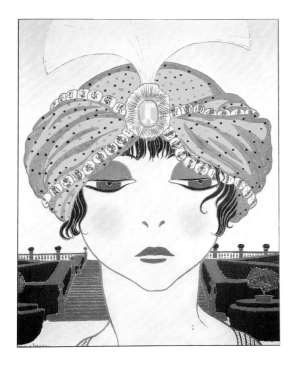

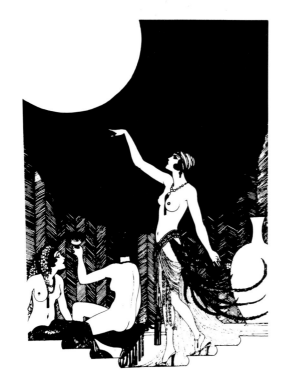

Historians have also noted the exaggerated immodesty of unmarried Athenian women after the long foreign wars had dramatically reduced the number of eligible young men. Unmarried women were aided in their quest for a mate by the State passing a law that allowed them to split their tunics from the hips downwards, so that they might display the full length of their legs when walking. A similar fashion was popular in Rome after the Punic Wars, again condoned by government. Immodesty in dress was also officially sanctioned in Germany after the Thirty Years' War, whilst the extravagance of the aristocrats of France in the 1780s was totally abandoned in favour of a very spartan mode of attire after the revolution of 1789.

Changes in religious or cultural attitudes have also affected well-established modes of dress during the past five hundred years. Sometimes the catalyst for change can be a single event, such as the 1910 Ballets Russes production of *Schéhérazade*, with music by Rimsky-Korsakov and costumes by Léon Bakst. This luxurious and erotic production featured a sequence in which dancers Ida Rubinstein and Vaslav Nijinsky appeared almost nude. The pious were aghast but the audiences were thrilled. The influence of this ballet on all aspects of the arts and design was immense; in the realm of fashionable clothing it sounded the death knell for the opulence of the Belle Epoque and heralded the much simpler, freer, more vibrant Art Deco style.

Sometimes changes in fashionable clothing can be controlled by those in authority, as happened during the early seventeenth century when Henry IV of France attempted to limit the luxury of new modes of attire in the courts by prohibiting the use of gold embroidery and expensive fur trimmings. He was, however, only partially successful for the law related only to external ornamentation. Women turned their attention instead to less obvious areas: they decorated their bodies with rouge, powder and scent and adorned their pubic hair with ribbons and jewels.

In 1947 the British Labour Government tried to stop clothing manufacturers introducing Christian Dior's New Look fashions to the British market, stating that 'in a time of consolidation and recovery' after the devastating effects of World War II, such frivolous clothing styles would be out of place, 'a total waste of valuable resources'. But once again this attempted censorship had an effect quite the reverse of the one desired: it gave enormous publicity to the new styles and their success was assured.

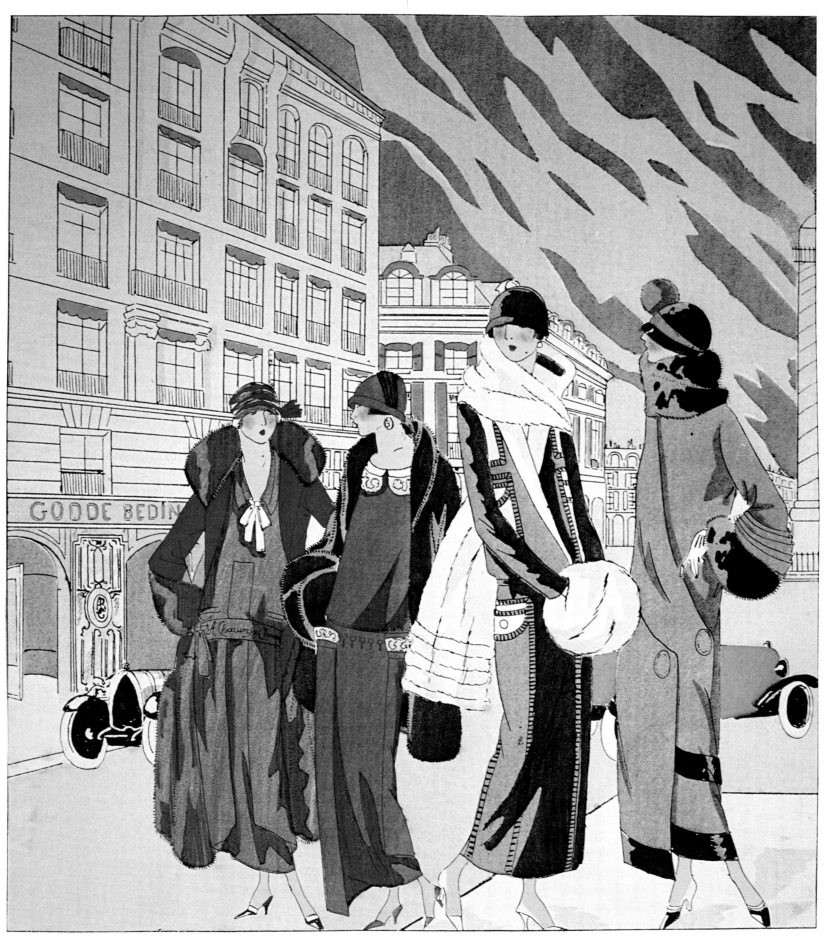

Pochoir fashion illustration by Robert Polack for *Art–Goût–Beauté*. 1922.

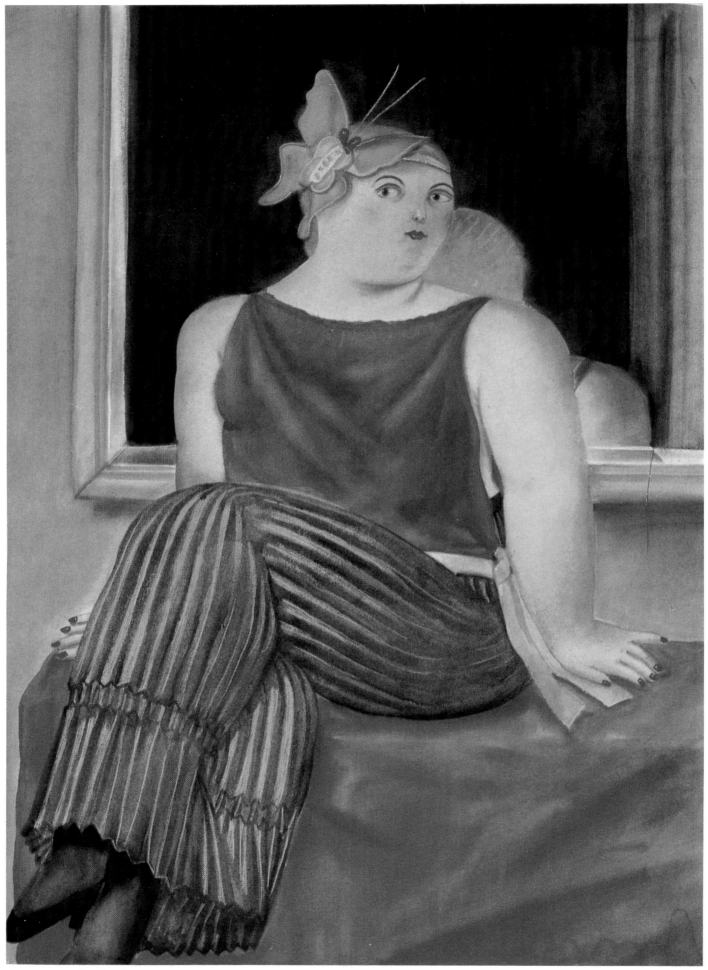

Fashion illustration of French haute couture clothing in 1982, by Fernando Betero for French *Vogue*.

Fashionable styles of dress worn by the populace at large can also change because of the styles worn by an individual or a small group of individuals. This happened in the early 1930s, when millions of women copied the styles worn by their favourite movie stars. One particular dress worn by Joan Crawford in the film _Letty Lynton_ was enormously popular and a chain of American department stores is reputed to have sold nearly half a million copies of it in New York alone. The styles worn by Josephine Baker, Mrs Wallis Simpson and the Gibson girls were also widely copied, as have been those worn by Jacqueline Kennedy, Brigitte Bardot and others of more recent times. The famous French beauty Madame Recamier was also instrumental in assuring the success of the Grecian and Empire fashions which helped to re-establish the Paris fashion industry after the popular uprising of 1789 and the subsequent Reign of Terror.

When writing of the late nineteenth century world of the demi-mondaine, professional adventuress and admired dancer Octave Uzanne mused,

> What a mass of costumes she must have, not so much to seduce men as to attract the envy of honest women whose jealousy helped to establish her reputation. Unlike most ordinary actresses, she is always on stage, obliged to rivet the attention by always astonishing us with her manner, her hair do's, her jewels, her dresses, her hats, her coats, her lace, indeed with her conquests too. From the moment that virtuous women say indignantly when speaking of her, 'It is only creatures such as these who can display such scandalous luxury!' her reputation is made.

The desire to attract the envy of other women is yet another motivating force in our ever-changing array of fashionable clothing. It is why the fashionable styles worn by women who are envied by other women are so frequently copied, regardless of whether the styles are admired by men.

Women's ideas of beauty can also be changed by an individual who appears at the right time in the right place, as happened in the mid-1920s when the Hollywood actress Colleen Moore bobbed her hair for the film _The Perfect Flapper_. Her hair style, which had been copied from an old Japanese doll, set the fashion for the next five years and she was dubbed 'the bob-haired jazz-baby'.

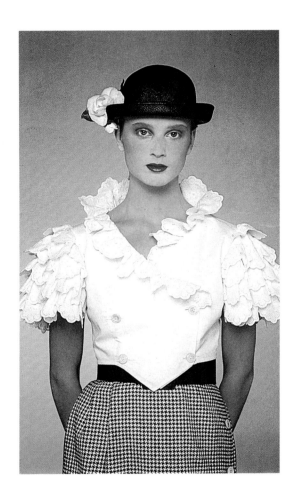

Individual illustrators and photographers have also created the atmosphere needed to make a new style fashionable. George Barbier's drawings for *La Gazette du bon ton* and other deluxe magazines had a great influence on women's ideas of beauty and on the fashions worn by the haut-monde of the period just after World War I. The photographer David Bailey did much the same thing for young English ready-to-wear fashions in the early 1960s, during the Swinging London era. He was ruthless in selecting the styles of garments to be worn by his girlfriend model Jean Shrimpton and their love affair shone through his photographs, making everything 'The Shrimp' wore almost irresistible.

Another important factor in our changing modes of dress is the change that occurs when one particular cultural group or nation becomes wealthier and hence more powerful than another. This occurred in the early 1920s when the United States, having accrued a trade surplus with Europe, began purchasing a great quantity of French fashions. Naturally, the French couturiers designed to suit and flatter their new customers. The American women had slimmer ankles and more attractive legs but they were not so pretty and lacked the shapely breasts of their French counterparts, so the new styles placed far less emphasis on the bustline and skirts became shorter so as to reveal more of the ankles and legs. This became the new fashion and women throughout Europe also adopted it even though it was not necessarily to their advantage. After the stock market collapse of 1929 many of the couturiers' American customers stopped buying and the fashion quickly became long again, concentrating on the face and bustline, which are traditionally regarded as a European woman's greatest physical asset.

In fact, as can be seen from the illustrations in this book, until well into the present century the vast majority of women's fashions have focussed attention on the face, neck, shoulders and cleavage. Our ancestors had selected these features as being distinctive for our racial type and they wished to promote them. This they achieved by covering the rest of the body with clothing styles that were so designed as not to detract from the centre of interest.

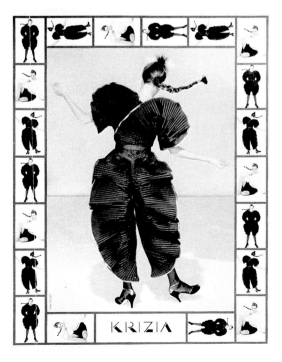

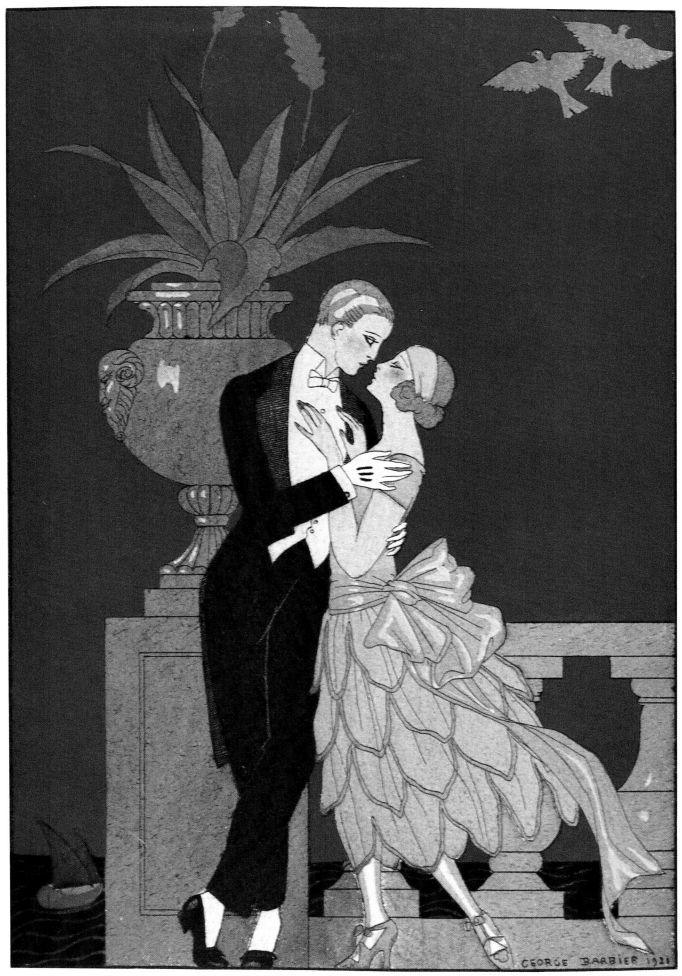

Pochoir illustration by George Barbier for *La Guirlande des mois.* 1921

An engaged girl from the Tugela Ferry area of South Africa, photographed by Aubrey Elliott, for *Sons of Zulu*. 1978.

Western society still clings to this traditional concept of beauty but its ideas are by no means universal: some cultures regard the display of the female face as most immodest; others prefer to place interest on the nape of the neck, the curve of the back, the plumpness of the thighs, or diminutive feet. Travellers earlier this century tell of Tahitian women saying, 'What a pity that white mothers keep pulling at their babies' noses — it makes them so long!'

The desire of racial or social groups to enhance their physical attributes when choosing clothing styles has long been noticed by travellers and historians and many have noted with interest that no single form of beauty appears to be constant in any society, let alone universally. Human beauty also seems to vary over time. This can be seen in the great paintings of the past: in both the male and female form the emphasis has varied considerably, changing to smaller heads, longer necks, tinier feet, more pronounced bosoms, narrower waists, more conspicuous genitals, broader shoulders, a more manly chest, less well defined facial features, a more ample derrière, and less body hair than is generally thought appealing today.

In some parts of Polynesia women still stain their lips a dark mauvish colour and paint their teeth black as a sign of beauty. They regard the European's white teeth and pink lips as 'ugly — like those of a dog'. In her book *The Sex Contract: The Evolution of Human Behaviour* (1982) Dr Helen E. Fisher stressed that people in every corner of the world have for thousands of years made extraordinary efforts to look beautiful and sexually attractive, according to their own customs. 'Even today', she writes,

> Ulithien women of the western Pacific tattoo the inner lips of their vulva to enhance their beauty. Men and women have long tattooed their bodies, scarred their faces, filed their teeth, inserted lip-plugs into their mouths, stretched their earlobes, and pierced their ears or noses.

All to achieve a culturally acceptable standard of beauty, what we call 'sex appeal'.

Ideals of both masculine and feminine beauty are very closely connected in the mind with the idea of sexual pleasure, just as are many forms of clothing. Sigmund Freud interested himself in this notion: 'I have no doubt that the concept of beauty is rooted in the soil of sexual stimulation and signified originally that which was sexually exciting'. Sir Kenneth Clark expressed a similar view in his book *The Nude* (1956), but continued,

> It is supposed that the naked human body is in itself an object upon which the eye dwells with pleasure and which we are glad to see depicted. But anyone who has frequented art schools . . . [or visited a nudist camp I might venture to add] *will know that this is an illusion.*

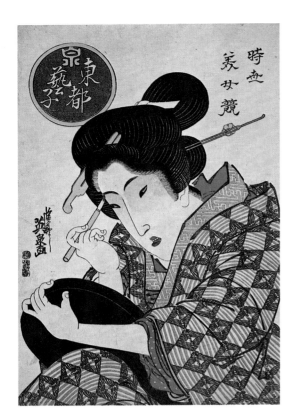

Hence the need for clothing. In total nudity an individual is only attractive within specific limits and at specific times. The only way in which the human body can be made permanently attractive to members of the opposite sex is to diminish its total impact and to emphasise just one or two characteristics at a time. This is exactly what fashion sets out to do. It becomes a game in which concealment and revelation play hide-and-seek.

Fashion can bare the arms, drape the hips, exaggerate or abolish the bosom. Fashion may say, as James Laver so clearly put it, 'Look! Here is a piece of anatomy you have forgotten about, a feature neglected for too long. This is why all new fashions are considered daring: the observer's interest is directed towards a feature that has been hidden long enough to have accumulated erotic capital.' It is also the reason why recently discarded fashions appear dowdy: the feature they are drawing attention to has become familiar and no longer excites desire.

Of course, not all people wear clothes to be sexually alluring; sometimes they wear them as a display of personal wealth, or as a sign of rank and social position. Sometimes other factors are involved — occupation, modesty, protection from the elements, nationality, a means of displaying sexual deviation, a defence against the effects of magic, or any one of a dozen other reasons. However, most experts agree with Professor Flugel, who in his book *The Psychology of Clothes* (1929) maintains that 'of all the motives for the wearing of clothes those connected with the sexual life have an altogether predominant position'.

But regardless of how we actually view the clothing styles we wear, very few of us deliberately use our modes of dress to make ourselves unattractive or to make the worst of our physical attributes and sexual characteristics. We have, it would seem, inextricably linked our ideas of beauty with those of clothing and adornment, and we often mistake that which is fashionable for that which is beautiful. This has been noted by many writers, including Goethe, who observed, 'We exclaim "What a beautiful little foot!" when we have merely seen a pretty shoe. We admire a lovely waist when nothing has met our eyes but an elegant girdle'.

190

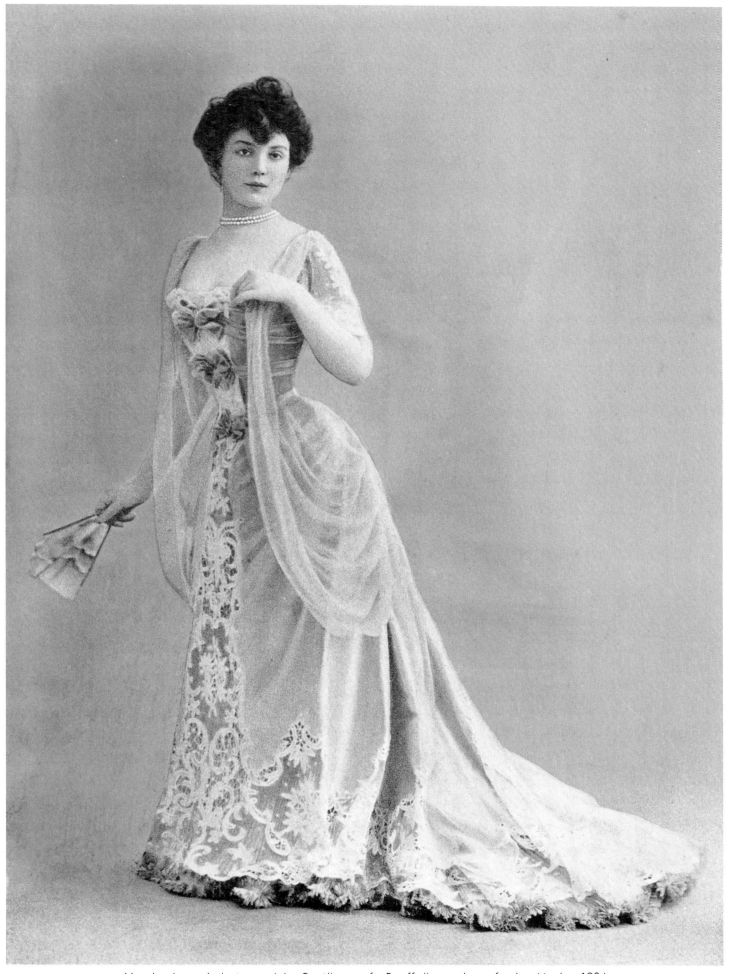

Hand-coloured photograph by Reutlinger of a Rouff dinner dress, for *Les Modes*. 1904.

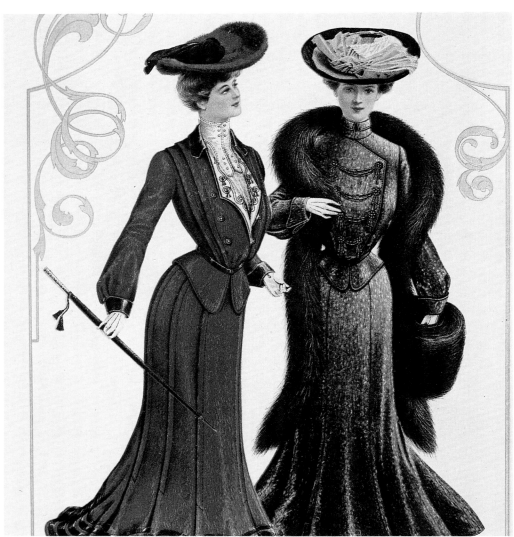

Chromo-litho illustration of American ready-to-wear fashions, the *Delineator & Designer* (New York). 1903.

The media have of course been extremely influential in the formulation of our ideas about beauty and have closely linked such beauty to our changing modes of dress. In 1806, for instance, we read in a copy of *The Lady's Magazine* that 'a young woman of sixteen who strives not to please by the manner of her dress, although she may possess a fine complexion and beautiful features, will be nothing more than a slut and a shrew at twenty-five'. The *Handbook for Ladies* (1861), pondered the morality of augmenting our beauty by the use of fine dresses and cosmetic aids:

It is a question which has created a very great amount of heated discussion, and opinions differ widely. On the one hand it is urged that, nature being beautiful, women have a right and a duty to follow nature as closely as possible, and that any means they take with that end in view is justifiable and worthy of all applause. Others, who oppose all kinds of toilette and other aids on religious and moral grounds, say that all toilette aid is a deception and that, being therefore an untruth, it is immoral . . . The use of toilette aids in England is the art of concealing this art, whilst in France the ladies of the court go to great excess in the use of powder and paint. For instance, no English lady would dream of blackening the skin immediately below the eye-lashes in order to give an increased brilliancy to the eyes, but this is frequently practised amongst the ladies who attend the Empress of France. And the Empress herself not only blackens her eyes and uses rouge to excess, but is also given to powdering her hair with atoms of gold dust to increase its glossiness.

Chromo-litho illustration by E. V. Boyle for *Beauty and the Beast,* published by Sampson Low, Marston, Low & Searle. 1861.

The American magazine, *Demorest's Monthly Magazine and Mirror of Fashion*, also published in the early 1860s, observed that 'whilst the French ladies are using cosmetics to aid their beauty, the ladies in England are once again wearing low-necked dresses which display the full rounds of their breasts'. American ladies, however, 'fired with Puritan spirit, have reacted strongly against both of these trends' and instead devised a fashion of their own to gain the attention of members of the opposite sex and the envy of members of their own sex. They tilted their crinoline skirts to display their ankles and the lace edging around their underdrawers and petticoats. The display of the ankles, and gradually more and more leg, became a characteristic of American fashions, even though this practice was denounced by ecclesiastics and moralists.

By the early 1920s, when fashion began to respond to the desires of ordinary American women, it became fashionable to wear far fewer clothes than had been the norm for well over one hundred years. However, readers were advised,

Even the most beautiful woman in the world would quickly bore most men if she was quite naked all the time. The wisdom of all civilised nations is in accord on this subject. The Chinese, for example, who understand the art of presentation, know very well what they are doing. When they give a present they enclose it first in a tiny box, which they put in a second box a little larger, that is then contained in a third, and then into a fourth, which is enclosed in a fifth and so on, with each being neatly wrapped and tied. Unwrapping this succession of containers and fastenings, the curiosity is aroused, the pleasure is multiplied by the waiting, and the value of the surprise is increased by impatience. This is why I find the modern American women lacking in the art of femininity when they appear décolleté almost as far as the navel, whilst their skirts rise above the knee. The fashionable women of the Edwardian era were quite right with their full length dresses, high collars, leather boots, tightly laced corsets and layers of frilly underclothing.

Somewhat later, in the mid-1950s, Pearl Binder noted that the greatest influence on Western concepts of fashion and beauty was the cinema. She observed,

Hollywood, more than ever on the prowl for types of female beauty which embody the ordinary man's dream, has concentrated on women with overdeveloped mammary attributes, to the exclusion of almost all other attributes . . . The ideal seems to be a childish body, baby face, a little-girl voice, small waist and narrow hips — with the addition of an astonishingly large bust . . . The influence of the cinema is paramount. Girls consciously model themselves, their face, voice, dress and behaviour on the female stars they adore, with an almost religious attachment. Moreover, they urge their boyfriends to resemble, in face, voice, dress and behaviour, the male film stars of their choice.

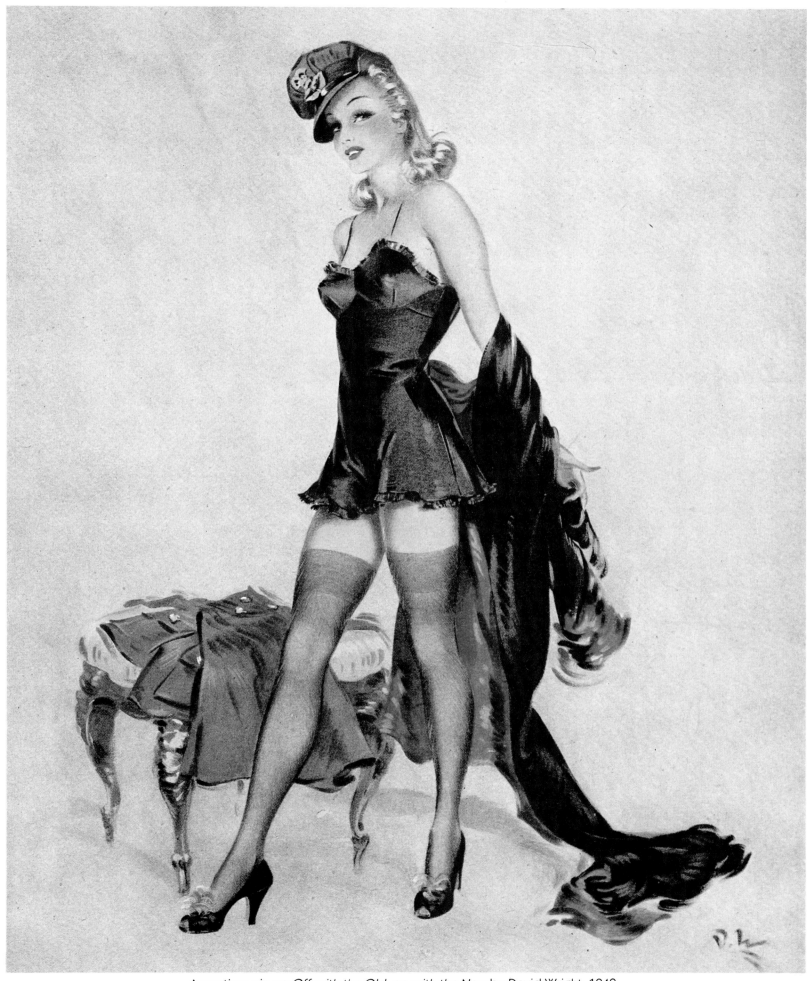

A wartime pin-up *Off with the Old, on with the New* by David Wright. 1942.

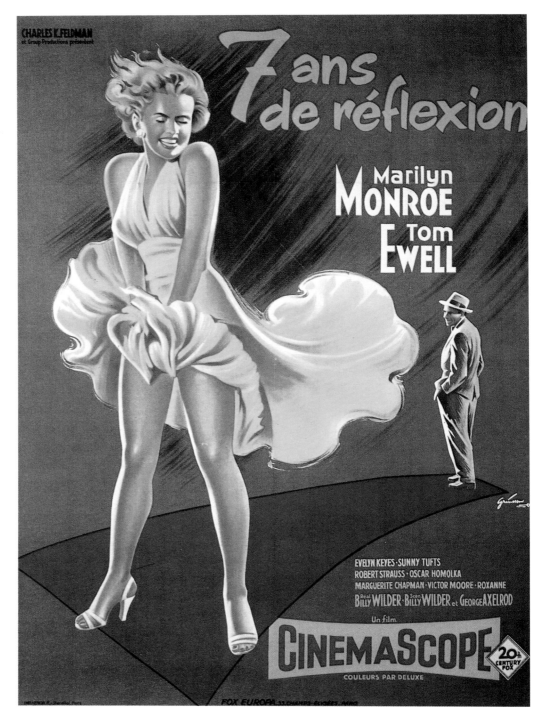

The power of the mass media should never be underestimated. After all, the media has a vested interest in maintaining a state of change. It enables it to continually pronounce on all aspects of current and future modes, which in turn increases profits. This profit-making by means of promoting and popularising new fashions tends to trivialise certain forms of fashion and sensationalise others; it can even promote fake fashions. But at least it helps us all to move our ideas away from the stultifying influences of tradition and out-of-date modes of thought.

It is largely due to the influence of the mass media that we now have a wider range of fashionable choices than ever before. As Yves Saint-Laurent said in the early 1980s, 'Establishment fashion is now dead'. We now have the choice of following those styles that we feel are most suited to our ideas, lifestyles, fantasies, thoughts and aspirations. We can choose whatever takes our fancy.

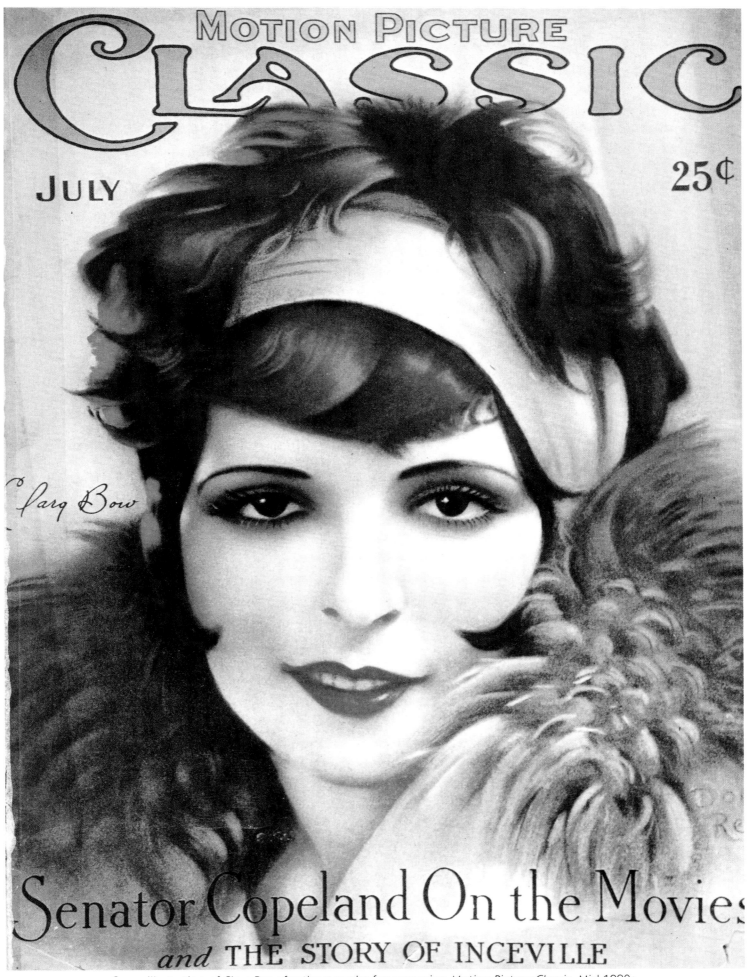

Cover illustration of Clara Bow for the popular fan magazine *Motion Picture Classic*. Mid-1920s.

PUBLICATIONS A. LOUCHEL
8, RUE HALÉVY — PARIS·IX°
(Place de l'Opéra)

REVUE MENSUELLE
NUMÉRO 389 — OCTOBRE 1943
FRANCE : 18 FRANCS

PUBLICATION PÉRIODIQUE

French wartime fashion drawn by J. C. Horamboure, as displayed on the cover of *La Femme chic*. October 1943.

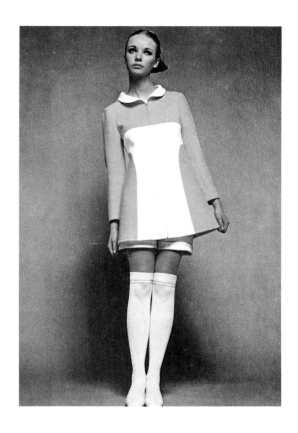

It has been suggested, of course, that our emphasis on concealment evolved because we are dissatisfied with our evolutionary shape and, being relentless inventors, we wish to right the mistakes we have inherited from our progenitors. Maybe each new fashion is an indication that we are still pursuing a tantalising image of ourselves as we think we ought to be and that we are sure would be possible to attain if only we can find the right combination. Or is it, as Darwin noted, that since there is not in the mind of man 'any universal standard of beauty' we are simply exercising our desire for variety — but being members of a conformist society we have a perverse tendency to express that desire for variety in unison, a unison we call fashion.

However not all people who live in the Western world are conformists. Individuals are free to build up an ideal of beauty and of fashionable clothing that is entirely their own. This individual ideal often includes the unusual and the exotic, and it sometimes borders on fetishism. In turn, this individual tendency towards fetishism also seems to influence ideals of beauty in Western society as a whole. How else can we explain why our forebears appeared to declare all women with long straight hair beautiful in one generation, yet all beautiful women had to have short curly hair only ten years later? There was even a time when it was considered beautiful to have no hair at all. Small feet have also been greatly admired for a variety of reasons, but in the Middle Ages there were times when extremely long feet were a sign of beauty. Sometimes it has been the height of beauty and fashion to be plump and at other times it has been fashionable to be as skinny as a rake. Some generations have preferred men to wear their facial hair in a variety of styles; the next generation have expected them to be clean shaven.

The advent of mass air travel has dramatically affected the world's clothing styles. Styles that originated in the temperate zones of the northern hemisphere are now being worn by many local people in the tropics because they aspire to a Western way of life and reveal this by saying 'I belong' in these clothing styles. Conversely, many Westerners now wear adaptations of Japanese, Indian, Mexican or Turkish dress and exotic styles inspire Western designers. As Japan's influence has increased in the Western-oriented commercial world so has the influence of its fashion designers: many of the leading designers now working in Paris and New York are Japanese. It reminds one of the role the Japanese civilisation played during the Art Nouveau and Art Deco periods.

Sport has been another potent force affecting Western modes of dress in recent years — it reflects a society with more leisure time than ever before. This is also the reason why pop star fashions are so influential, especially with the younger members of society. The greater ethnic mix of people in Western cities has led to a wider variety of clothing styles being worn, particularly since many members of these ethnic communities now have sufficient pride in their origins to display them openly by wearing the costume of their previous country, even if only on festive occasions.

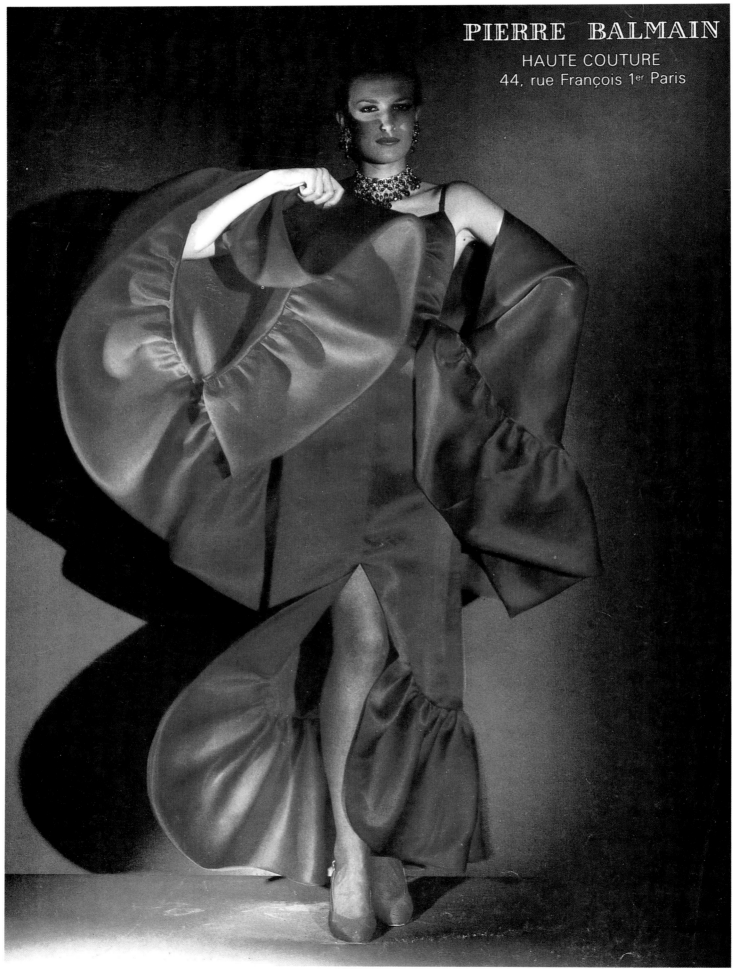

PIERRE BALMAIN
HAUTE COUTURE
44, rue François 1er Paris

Magazine advertisement for Pierre Balmain, photo by Horst. 1982.

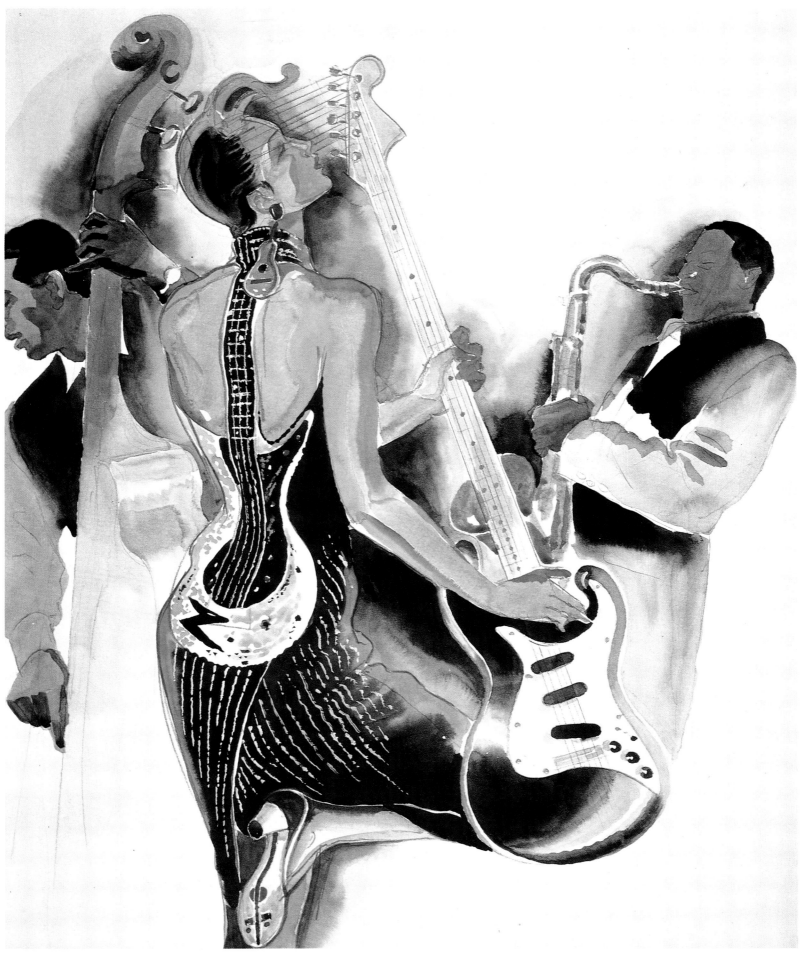

Magazine illustration by Antonio Lopez of a bejewelled dress designed by Karl Lagerfeld for the Chloé prêt-à-porter collection. 1986

Illustration by Tealdo of latex clothing featured in the *Centurian Latex Annual*, published by Centurian Publishing Co., California. 1982.

Television has also played its part. Its travelogues have shown us that not all people have a Western attitude to the naked body. Some even glorify their nakedness. This message has been further strengthened by an array of books and magazines that feature the clothing styles and modes of body decoration of an enormous number of ethnic peoples from around the world. Our imaginations are fuelled with a fascinating array of alternative ways of adorning and displaying our bodies. These books on ethnic styles, together with those that feature our own clothing heritage, show that all modes of human adornment are worthy of serious consideration. They represent a unique form of aesthetic expression which rightly ranks alongside all other forms of human artistic expression as a reflection of our unique human culture and our ceaseless inventiveness.

The garments we choose to wear today are more varied than ever before. They have become much more personal, and the laws of etiquette and social acceptance laid down by the wealthy elite of our Western society no longer dictate to us who should be allowed to wear which particular garment, when that

Shop window display featured in the Italian magazine *Domus Moda*. 1981.

garment should be worn, and its fabric, colour and mode of trimming. The fashion parades of Paris, London and New York no longer compel us to change our mode of dress each spring and autumn along with everyone else, and we view whatever changes we do decide to make as being our unquestioned right.

The styles chosen by most of our city-dwelling teenagers, although markedly different from earlier styles, are nevertheless still within the tradition of Western-style dressing and they establish very clearly that these teenagers are members of an egalitarian society which allows them freedom of choice within that clothing tradition. These styles are, of course, just as full of the signs, symbols and portents as were the clothing styles of the 1920s or the 1960s and they are just as exciting to the younger members of the opposite sex.

All the modes of dress worn this century have developed from the stimulus of a changing society, fired by new discoveries and a zest for the new and different. It would appear that even more dramatic change will soon occur in our clothing styles, the effects of which will be far-reaching. The most dramatic changes in our forebears' modes of dress came about during periods of great social and economic change, the social struggle itself being sufficient to bring forth general acceptance of new ideas. Indeed, such periods in history have usually resulted in the development of a new lifestyle for many people, fuelled by new ambitions, new moral attitudes, and a new dream about themselves. Such change has always manifested itself in the most conspicuous of the mechanisms by which we hope to alter ourselves — the clothing styles we choose to wear.

Many of today's styles are intended to dress our psyche rather than our bodies and this is fully understood by the new designers, whose influence will become increasingly more potent as we approach the new century. Their novel ideas are already beginning to reshape our ways of thinking about our bodies and the clothes we choose to cover ourselves. They have grown up in an industrialised world and they are aware that our senses have tired of the constant barrage of sexual signals transmitted by television, films, magazines, billboards, and daily newspapers. They are also aware, however, that sexual attractiveness is very important to the Western tradition.

As we approach the end of the present century we will witness the emergence of a new form of experimentation in our styles of dressing, which will be free from the out-dated constrictions and inhibitions to which many people continue to cling. This experimental style will be faithfully recorded and promoted by the young journalists and image-makers who are beginning to make their names in this absorbing profession. Hopefully they will point out the difference between adorning and just covering the body, and hopefully they will persuade their readers or viewers to stress their individuality and personal attributes. In this way we can all celebrate the aesthetic statements made by our new modes of dress, free from the inhibitions of the past. Such garments will be honest expressions of our culture and creativity worthy of taking their place among the exciting achievements of this modern industrialised age.

Trans-figuration by Vera Lehndorff and Holger Trülzsch, showing the art of photography combined with body painting and airbrush techniques, *Veruschka Trans-figurations.* 1986.

ᴵNDEX

NOTE: a–top left
b–top right
c–bottom right
d–bottom left
Page numbers in italic type indicate illustrations. The others refer to mention in the text.

Ackermann, Rudolph 6, 94, 100, *101*
Adams, A M 108, *110*
Adrian 70, 144, 177
advertisements *86*, 141, *200*
advertisers 137
Aghion, Janine *70d*, *130a*, 137
Alais, William Wolfe *39*, *104*
Album de la mode du Figaro 142
Allier, Paul 131
American fashion 70, *139*, 143, 172, 177, 186, 194
Anderson, Milo 177
André-Ani 70
anti-fashion laws 16, 20, 37, 182
aquatints 102, 106
Arnoux, Guy *7*
Art Deco
period 60, 63, 137, 182, 199
illustrations 121–26, 132
publications 6, 122, 124–26, 130, 132, 137
art directors 141
Art et décoration 60, 126
Art-Goût-Beauté 78, 158, 160, 183
Art Nouveau 13, 56, 60, 116, 118, 199
publications 121
Au Fil vos heures Mesdames par Renault 30

Bailey, David 186
Bakst, Léon *64*, 126, 132, 182
Balenciaga, Cristobal 80, 84, 144, *174*, 177
Ballets Russes 64, *64*, 124, 157, 167, 182
Balmain, Pierre *142*, *145*, *200*
Banton, Travis 70, 177
Barbier, George *6*, *8*, *27*, 60, *62*, *65*, 94, 122, *124*, *125*, 130, 132, 134, 137, *156*, 186, *187*
Beardsley, Aubrey 116, 134, *192d*
Beaton, Cecil 138, 141
beauty, concept of 35, 46, 188, 189, 190, 192, 194, 199
ankles 35, 186, 194
breasts 26, 35, 44, 63, 84, 186, 194
derrière 26, 35, 84
face 35, 186
legs 186, 194
Beauty and the Beast 193
Beer 156
Bell, John *39*, *45*, 94, 100
Belle Epoque 13, 161, 164, 167, 182
Bénédictus, Edouard 137
Bénigni, Léon *83*, *158*
Bénito, Edouard 124, 137, *162d*
Bertin, Rose 43, *91*, 94, 144
bias cut 164
Bilibin, Ivan 134
Binder, Pearl 194
Bisilliat, Maureen 20
Black Death 181
Blackwood's Lady's Magazine 48
Blumenfeld, Erwin 141
Bodin et Carrache *109*, *113*

Bohan, Marc 144
Boldini *58*
Bonfils, Robert *123*, 124
Bonnotte, Léon *161b*
Bosse, Abraham *38a & d*, *179d*
Boucherie et Guelle, Mlle *113*
Boutet de Monvel, Bernard 70, 124, 126, 138
Boyer 118
Braque 6
Brissaud, Pierre *67c*, 124, 126, 138, *146*, *161c*
broad-shouldered look 80
Bruegel, Pieter 13
Brunelleschi, Umberto 97, 124, 126, *150*
bustle 26, *109*, 116, 152

Cabinet des modes ou les modes nouvelles 88, 94
Callot Soeurs 56, 144, 151, *160*, 164, 167
Carlyle, Thomas 32
Carnegie, Hattie *139*
Centurian Latex Annual 202
Chaillot, A *109*
Challamel, M Augustin 14, 15
Chalon, J *114d*
Chanel, Coco 76, 144, 161–62, *169*, 177
changing fashion 178, 181–82, 185–86, 189–90, 192, 194, 196, 199, 202, 204
Chaussures des Pinet 71
Chéruit, Madame 56, 130, 137, *150*, 151, 152
children's fashions
eighteenth century 92
nineteenth century *18*, *110*
twentieth century *111*
Chloé 201
chromo-litho process 134
cinema fashions *see* film fashions
Cito, M *118a*
Clark, Sir Kenneth 189
Clark, Ossie 144
Cocteau, Jean 125
Collot, Marthe *75*, *127*
Compte-Calix, François-Claudius *22*
copperplate engravings 88, 92
copperplate line engravings 97, 100
Corrard, Pierre 130
corset 48, 60, 63, 105, 152, 164
Costumes civils actuels de tous les peuples connus 33, 34, 40, 41, 89
couture houses 56, 59, 143, 147–48, 151, 177
couturiers *see* designers
Cox, David 70
Crane, Walter 116, 134
crinoline 48, *49*, *50*, *52*, 116, 152, 170, 194
Curtis Publishing Co *2*, *11*

Daedalus 35
Dalziel brothers 134
Dammy, Robert 124
dandies 52
Daragnes, Gabrielle *70a*
Darwin, Charles 32, 199
David, Jules *49*, *108*, *181*
de Brunhoff, Michel 141
de Bruyn, Abraham 88
de Closménil, Madame Florensa *48*, *105*

de Nouvion, Jacques 130
de Saint-Igny, Jean *23c*
de Saint Jean, J D *23b*
de Solar, Marie *51*
de Taverne, A *19*, *47*, 108
Debucourt, Philippe-Louis 100
Delaunay, Sonia 124, 126, *132a & d*, 137, 138, 144, *164d*
Delineator & Designer 111, *192*
Demachy, Jacques *136*, 137, 138
DeMeyer, Baron Gayne *80a*, 137, 138
demi-mondaines 59, 67, 147, 170, 185
Demorest's Monthly Magazine and Mirror of Fashion 194
Deshayes, Magdeleine 74
design schools *see* fashion and design schools
designers 144–77
American 70, 172, 177
French 144–177
present day 177, 204
Desjardins, J *102*, *103*
Desmarais, M A *25*
Desrais, Claude-Louis *33*, *34*, *40*, 92, *93*, 94, *179c*
Dessès, Jean 144, 177
Devis, Arthur William *44a*, *45*, 94, *95*
Dior, Christian 84, 144, *175*, 177, 182
Diversarum Nationum Ornatus 88
Doeuillet 56, 130, 144, *148*, *149*, 151
Domus Moda 203
Doucet, Jacques 56, 60, *125*, 130, 137, 151, 152, 161, 164
Doyle, Richard 116
Drecoll 63
Drésa, Jacques 130
Drian, Etienne 132
Dufy, Raoul 124, *125*, 161
Duhamel *33*, *34*, 40, *41*, 100
Dukes, Jacques *63*
Dulac, Jean 137

Edwardian era 194
egalitarian fashions 37, 43, 202, 204
eighteenth century 17, 38, 40, 43, 88, 92
Elle 31, *176*
Elliott, Aubrey 188
Ellis, Havelock 32
Emanuel brothers 144
Empire style 44, 144, 154, 185
Empress Eugéne 179
Empress of France 192
Englishwoman's Domestic Magazine 6, 112
Eric *84*, 137, 138, *140*, *175*
Erté 124, 126, 137, *137c*, 138, *152d*, 137, 161
Esnaut, Jacques *17*, 90, *91*, *93*
Establishment fashion 37, 38, 196, 202, 204
Estelle et Zimmerman *171*
etchings 102
ethnic influence 26, 188, 199, 202
Evans, Edmund *115*, 116, 134
Every Girl's Annual 115
Excelsior Modes 6, 137
exhibitions 15, 56, 60, 116, 147, 168, 170
retrospective 170

Fabri, Alexandro 88
fabric prints *see* textile design
Falbalas et Fanfreluches 125, 137

fashion and design schools 126, 130, 144, 147, 161
Fashion Drawing 138
fashion illustrations 88–118
see also pochoir method
as art form 8, 94, 97
colour-printing 116
colouring by hand 88, 92, 106, 108, 114, 118
creative peak 97
decline in quality 108, 114
design details 92, 94
early 88
initialled 100
invented designs 30, 114
printing 106, 108, 114
seam placement 92, 94
signed 100, 134
fashion magazines
American 118, 137, 194
Art Deco 6, 132, 137
Britain 88, 92
deluxe 60, 121, 122, 130, 132, 134, 137, 185
French 6, 88, 92, 106
German 88, 92
glossy 137, 138
increased demand 112, 114, 137
introduction 38–40, 88
men's 38
pochoir 130, 132, 134, 137
signed 134
fashion parade 148, 204
fashion photography 116, 118, 138, 141, 143
fashion publicity 141, 143
Fath, Jacques 84, 144, 177
Femina 6, *81*, 126, *136*, 137, *166*, *174*
fifteenth century 16
film fashions 63, 69, *69*, 72, *72*, *73*, 76, 144, 172, 177, 185, *194*, *197*
men's 70
Film Fashionland 177
First Empire 44
Fisher, Harrison *2*, *11*
Fisher, Dr Helen E 189
fittings 148
Flugel, Professor 32, 190
'flying a kite' 143
Foale 144
Folies Bergères 68, *68*
fourteenth century 23, 181
foyer display cards 73
French Revolution 43–4, 46
post-revolution 182
pre-revolution *89*, *91*
French supremacy 14, 56, 143, 147
Freud, Sigmund 189
Frissell, Toni 141

Gallé 59, 116
Gallery of Fashion 6, *42*, *94*, 100, 112
Gatin, Georges-Jacques *96*, 100
Gavarni, Paul *48a*, *51b*, *106a*
Gentleman's Magazine of Fashion 104
Gerber, Madame 164, 167
Gibb, Bill 144
Gibson, Charles Dana *67d*
Ginsburg, Madeleine 147
Givenchy 144
gloves 116
Godey 6
Goethe 190
Goodman, Bergdorf 84, *173*
Gosé, Francesco Javier 124, 126, 130, *153*

Graham's Magazine 108
Grasset, Eugène 59, 116, 121
Great Depression 172, 186
Great War 67
Grecian style 44, 46, 63, 185
Green, Howard 70, 177
Greenaway, Kate 116, 134
Grès, Madame 144, 177
Gruau, René *142*, *174*
Guimard 116

Habiti Antichi et Moderni di Tutto il Mondo 88
hairstyles 48, 126, 185
Haldane, J B S 35
Handbook for Ladies 192
Haramboure, J C *166*, *198*
Harpers Bazaar 6, 118, *135*, 137, 138, *139*, *165*, 169
Haslewood, Constance *112b*, 116
hats *91*, *113*, *126*, *127*, *147*, *152*, *154*
haut couture *78*, 147, 177, 184
haut monde 13–15, 59, 177, 186
Hiert, M *24a*
Hiler, Hilaire 32
Hodgkin, Eliot 138, 141
Hollywood fashions 69, 70, 72, 73, 172, 177, 185, 194
Hopwood, William *107*
Horst, Horst P 138, *200*
Hoyningen-Heune, George 138
Hurlock, Elizabeth B 32, 44

ice skating clothes 54
illustrators 141 *see also pochoir illustrators*
Industrial Revolution 37, 60
Iribe, Paul 94, *117*, 118, 124, 125, 154, 161

Japanese influence 56, 116, 199
Japanese stencil printing 121
Japanese *ukiyo-e* prints *29*, 116, 121
jazz age 170, 172
Joffé *141b*
Journal der Luxus und dei Moden 88
Journal des dames 100, 114
Journal des dames et des modes 43
Journal des modes and Court Magazine 51
Jules 138

Kenzo 144
Khanh, Emmanuelle *31*, 144, *176*
King of Fashion 63
Klein, Calvin 144
Kronheim *29*, 134

La Belle Assemblée 6, *45*, *46*, 94, *95*, 100
La Belle Assemblée & Record of the Beau-Monde 99
La Belle Editions 133
La Dernière Lettre persane 137
La Femme chic 6, *74*, *79*, *85*, *86*, 137, *171*, *198*
La Gazette du bon ton 6, *57*, 60, *61*, *70*, *75*, *120*, *122*, 124, *126*, *127*, 130, 132, 134, 137, 141, *146*, *149*, *150*, *153*, *155*, *156*, *159*, 161, *163*, *180*
La Grande Maison de blanc 133
La Guirlande d'art et de la littérature 6, *125*, 137
La Guirlande des mois *27*, 125, *187*
La Journée de Mado 77
La Mèsangère, Pierre 43, 94, 100, 114, 130

La Vie parisienne 125
Laboureur, Jean-Emile *164a*
Ladies Monthly Museum 43
Lady's Book & Magazine 6
Lagerfeld, Karl 144, *201*
Langner, Lawrence 35, 37
Lanvin, Jeanne 120, 130, 137, 144, *146*, 151, 168, 170, 177
L'Art et la mode 6
L'Assiette au Beurre 125
latex clothing *202*
Laver, James 32, 35, 190
Le Bon Ton: journal des modes 48
Le Bonheur du jour ou les grâces à la mode 122, *124*, 125
Le Cabinet des modes ou les modes nouvelles 6, *40*, 90, *91*
Le Clèrc, Pierre-Thomas 36, 40, *89*, *92*, 94
Le Goût du jour 137
Le Jardin des modes 137, 138, 141, 145
Le Journal des dames et des modes 6, *25*, 60, *62*, *66*, 94, *96*, 122, *124*, 130, 132, 134, 141
Le Journal des demoiselles 109, 113
Le Lion 22
Le Magasin des demoiselles 102, 103
Le Magasin des modes nouvelles françaises et anglaises 6, 40
Le Moniteur de la mode 108
Le Petit Courrier des dames 12, 19, *47*, *105*, 107
Le Témoin 125
Leloir, Héloïse *50*
Lelong, Lucien 76, 144, *166*
LeMair, Charles 70
Lepape, Georges 60, *61*, 94, 118, *119*, *120*, 124, 126, 130, 134, 137, 138, *151*, 161, *180*
Leroy 144
Les Choses de Paul Poiret 118, 126, *151*, 161
Les Douze Mois de l'année 121, 137
Les Elégances parisiennes 137
Les Femmes de ce temps 7
Les Feuillets d'art 124, 126, 137, 141
Les Modes 58, *59*, 60, *63*, *148*, *191*
Les Modes de l'enfance 110
Les Robes de Paul Poiret 116, *117*, 118, 122, 125, 154
Lhote, Sam and André 125
L'Illustration des modes 137
Lipnitzki *82d*, *141c*, *168c*
L'Observateur des modes 98
L'Officiel *83*, 137
London Daily News 52
Lopez, Antonio *31*, *176*, *201*
Louchel, Pierre *5*, *85*, *86*
Lutétia, Galerie *77*, *131*
Luxe de Paris *9*, 130

Magasin des modes nouvelles françaises et anglaises 36, 88, *93*
Mainbocher 144, 177
maisons de couture *see* couture houses Manset, Régis 74
Martial et Armand *9*
Martin, Charles 60, *71*, 94, 124, *128*, *129*, 130, 132, 134, 137, 138, *155*, 161
Martinet, Pierre *44d*, *98*
Marty, André *75*, 124, *127*, 130, *130d*, 137, 138, *149*
Matisse 161
media role 192, 196

Meerson, Harry 138, 141
men's fashions 37
 Belle Epoque 13
 eighteenth century *38*, 92
 fourteenth century 23, *23*
 nineteenth century 13, *22*, *39*, *46–8*, *46*, *48*, *104*, *108*
 three-piece suit 48
 twentieth century 70, 87
 wigs 90
Méras, Paul *57*, *114c*, 130
Mitan, James *45*, *95*, 100
Miyake, Issey 144
Modes et manières d'aujourd'hui 6, 60, *65*, *119*, *123*, 125, 126, 130, *132*, 134
Mods and Rockers 87
Moisson 137
Molyneux, Captain Edward 144, 172
 Montana, Claude 144
Moral, Luza *143b*
Mori, Hanae 144
Morris, Desmond 32, 35
Morris, William 116
Motion Picture Classic 197
Mourgue, Pierre 81, 137, 138, *163*
Mucha 116
Muir, Jean 144
Munkasci, Martin 141

Nadar, Paul *62d*, 118
nakedness 20, 28, 44, 46, 52, 64, 189–90, 202
 film actresses 68, 70, 72
 performers 52, 164, 182
Nast, Condé 137
native costume *32*, *33*, *34*, *188*
New Look 84, 182
New Modernism 82
nineteenth century 13, 44–52
 early nineteenth century 44, 46
 late nineteenth century 56, 164, 185
 mid nineteenth century 114
Nister, Ernest 116

O'Doyé 137
Omnium Poene Gentium 88
oriental influence 13, 116, 157, 161, 167

Pall Mall Gazette 52
Paquin, Madame 56, 137, 151, *153*, 168
Parrish, Maxfield 134
Patou, Jean 76, 80, *83*, *158*, 172, 177
Pauquet, Mlle A *12*
perfume *86*, 161, 162
Persian influence 157, 161
Perugia *163*
petticoat 52, 154
see also crinoline
photographers 137, 138, 141 *see also* fashion photography
Picasso 125, 137, 138
Piquet, Robert 144
Plunkett, Walter 70, 177
pochoir
 illustrators 137–38, 141
 method 60, 108, 118, 121–24, 137
 publications 130, 132, 134, 137
 studios 138
Poiret, Paul 60, *61*, 63, *117*, 118, 126, 130, 137, 144, 151, *151*, 152, 154, 157, 161, 162
Polack, Robert *160*, *183*

Premet *160*
prêt-à-porter *see* ready to wear fashion
Préval, E *107*
Preval, Marie *14*, *15*
Price, Anthony 144
prostitutes 59
Provost, Jan *24b*
psychology of fashion 20, 26, 28, 35, 37, 92, 178, 190, 204
Pugin, M A *92a*

Quant, Mary 177

Raudnitz, Ernest 167
Ray, Man *138a*, 141
ready-to-wear fashion 79, 147, 161, 176, 177, 186, *192*, *201*
Récamier, Madame 181, 185
Redfern 56, 130, 144, 151, 170
Reilly, Kate 162, 164
Repository of Arts 6, 94, 100, *101*
Reutlinger 63, 118, 138, *148*, *191*
Rhodes, Zandra 144
Ricci, Nina 80, 144, 177
Ridley, Henry *46d*, 104
Rochas, Marcel *81*, 177
Roman Gallery of Fashion 94
Romme, Martha 94, *121b*, *121d*, 137
Rosenberg, Lev Samoilovich 64
Rouff, Maggy 168, 177, *191*
Rouquet, G *138c*
Roux, Edmonde Charles 162

Saad, Georges 138
Sabrain, Guy 30
Saint-Laurent, Yves 144, 177, *196*
salons *see* couture houses
Sampson Low, Marston, Low & Searle 193
Sandoz, Jean Dieu *54*
Sartor Resartus 32
Saudé Jean *9*, *27*, *65*, *70*, *71*, *117*, 118, *119*, *121d*, *123*, *124*, *125*, *128*, *129*, 134, *151*, *180*
Schéhérazade 64, 124, 182
Schiaparelli, Elsa 72, 80, *135*, 144, 177
Schild, Marie *51*
Schmid, D A *26*
Seeberger brothers 137, 138, 141
seventeenth century 182
sexuality 23, 26, 32, 35, 44, 60, 63, 68, 84, 87, 181, 182, 189, 190, 194, 204
 concealment 20, 23, 28, 84, 199
 men's fashions 23, 37
shoes 116, 134, *163*
shop window display 203
silk lingerie 56, 177
Siméon, Fernand *122a*
Simon, Marie 137, 138
Simont, J *76c*
sixteenth century 20, 88
Skinheads 87
skirts
 hobble 152
 knee-high 167, 194
 nineteenth century 48
 twentieth century 15–6, 67, 80, 186, 194
slashing 20
Smith, Helen 137, 138
Sons of Zulu 188
Sports et divertissements 128, 129, 137
sportswear 54, 80, *81*, 99, 172

sporty look 76, 161–62, 170, 172
stage actresses 59, 67, 72, 147
Steichen, Edward 60, 126, 137, 138, 157c
Stevenson, Edward 70
Stothard, Thomas 94
stratified fashion 44–8, 52
Swinging London era 177, 186

Talbot 63, 147c
Taquoy, Maurice 124
Teddy Boys 87
textile design 138, 161
Thayaht 126d, 159
The Englishwoman's Domestic Magazine 49
The Essence of the Mode of the Day 137
The Girls Own Annual 29
The Gentleman's Monthly Magazine 38
The Gentleman's Magazine of Fashion 39
The History of Fashion in France 14, 15
The Importance of Wearing Clothes 35
The Ladies' Companion & Monthly Magazine 50
The Ladies' Gazette of Fashion 54
The Lady's Magazine 6, 36, 38, 88, 192

The Lady's Monthly Museum 94
The Nude 189
The Queen 18
The Psychology of Clothes 190
The Psychology of Dress 44
The Sex Contract: The Evolution of Human Behaviour 189
The Woman in Fashion 177
theatre coats 153, 158
theatre personalities see stage actresses
theatre programs 64, 68
thirteenth century 16
Toudouze, Adéle Anaïs 102, 103, 108, 110
Toudouze, Isabelle 18
Toulouse-Lautrec 116
Trachtenfibel: the costumes of Old Switzerland 26
Traité d'enluminure d'art au pochoir 121
trans-figurations 205
Très Parisien 6
Tuffin 144
twentieth century 15, 56–87, 204
 early twentieth century 15, 64, 97, 118, 147, 152–72, 194
 1930s 72–82, 170, 172, 185
 1940s 143
 1960s 177, 186
 present day 28, 30, 196, 204

Valentino 144, 177
Vallée, Armand 132
van Brock, Jacques 66, 132
Vecellio, Dicesare 88
vendeuses 151
Vernet, Horace 35c, 92, 94, 96, 132
Verneuil, M P 121, 137
Vernor & Hood 43, 94
Veruschka Trans-figurations 205
Vincent 162
Vionnet, Madeleine 60, 80, 151, 159, 162, 164
Vogel, Lucien 64, 97, 126, 130, 134, 137, 141
Vogue (American) 84, 116, 118, 137, 138, 140, 154, 173, 175
Vogue (French) 6, 126, 184
von Anni Offterdinger, Zeichnung 126a
von Heideloff, Niklaus Wilhelm Innocentius 6, 42, 94, 94, 100, 112
von Hesse-Wartegg, Ernst 21
Vreeland, Diana 147

Wakeling, Gwen 70
war
 effect on fashion 67, 82, 143, 170, 182
 wartime fashions 83, 84, 85, 140, 195, 198
Ward, Marcus 116

Watteau, François-Louis-Joseph 17, 35b, 41, 90, 91, 92, 94
wealthy influence see stratified fashion
wedding dresses 51, 120
West, Vera 70
whalebone corset 48, 60, 63
Whittaker, George B 99
wigs 90
Willes-Maddox, R 114a, 115
wood-coloured prints 116, 134
Woolman Chase, Edna 130
World War 1 15, 67, 161, 164
 post-war 170, 172, 186
World War II 82, 83, 84, 85, 140, 143
 post-war 84, 87, 170, 182
Worth, Jean 56, 57, 130, 144, 151, 154, 161, 164, 165, 168, 170
Wright, David 195

yachting fashion 81, 170
Yamamoto, Kensai 144
Yoxall, H W 172
youth of today 177, 204

\mathcal{A}CKNOWLEDGEMENTS

Every possible effort has been made to locate and credit the original sources of illustrations and quotations used in this book. Both the author and the publisher tender an apology for any accidental infringement where copyright has proved untraceable. Any information about possible errors or omissions would be welcomed.

For permission to use material the author and publisher would like to thank the following:
Page 20 Maureen Bisilliat
Pages 84 & 140 Illustrations by Carl Erickson © 1941 by The Condé Nast Publications Inc.
Page 135 Illustration by Van Dongen reproduced courtesy of Harper's Bazaar (British Edition)

Page 139 Illustration by Sudakes reproduced courtesy of Harper's Bazaar (British Edition)
Page 165 Illustration by Luze reproduced courtesy of Harper's Bazaar (British Edition)
Page 169 Illustration by Vertes reproduced courtesy of Harper's Bazaar (British Edition)
Page 173 Illustration by Count René Boute Willaumez © 1941 by The Condé Nast Publications Inc.
Page 175 Illustration by Carl Erickson © 1948 by The Condé Nast Publications Inc.
Pages 188 & 189 Photographs from Sons of Zulu, Aubrey Elliott, Collins Vaal Pty Ltd, Johannesburg